Graphis Inc. is committed to celebrating exceptional work in Design, Advertising, Photography & Art/Illustration internatior

Published by **Graphis** | Publisher & Creative Director: **B. Martin Pedersen** | Design Director: **Hee Ra Kim** | Designer: **Hie Won Sohn**

Editor: **Brittney Feit** | Design Intern: **Erin McGowan** | Editorial Intern: **Zoe Young** | Account/Production: **Leslie Taylor**

Graphis Poster Annual 2020

Published by:
Graphis Inc.
389 Fifth Avenue., Suite 1105
New York, NY 10016
Phone: 212-532-9387
www.graphis.com
help@graphis.com

Distributed by:
National Book Networks, Inc.
15200 NBN Way
Blue Ridge Summit, PA 17214
Toll Free (U.S.): 800-462-6420
Toll Free Fax (U.S.): 800-338-4550
Email orders or Inquiries:
customercare@nbnbooks.com

Legal Counsel: John M. Roth
4349 Aldrich Avenue, South
Minneapolis, MN 55409
Phone: 612-360-4054
johnrothattorney@gmail.com

ISBN 13: 978-1-931241-81-6
ISBN 10: 1-931241-81-3

We extend our heartfelt thanks to
the international contributors
who have made it possible to publish
a wide spectrum of the best work
in Design, Advertising, Photography,
and Art / Illustration.
Anyone is welcome to submit
work at www.graphis.com.

Contents

Graphis Masters

Graphis Masters Stephan Bundi, Melchoir Imboden, Taku Satoh, and Shin Matsunaga each won Platinum in the Poster Annual 2010 competition. One decade later, these award-winning designers are still an important part of inspiring the community.

We are excited to present Stephan Bundi with yet another Platinum award. See page 29.

What makes Graphis Annuals and Journals visually inspiring is the work that we receive from the ever-evolving great talents from our Call for Entries.

All winners including Honorable Mentions, where most of us have started, are equally honored and presented. Very few of us make it to Platinum status, however, what is most important no matter what level you are performing at is that you have a passion and love for what you do.

To be considered for an article in our Graphis Journal, we need to see your work. Generally, our first loyalty has to remain with the consistent entrants in our Annuals. Some of these elevate to become Masters, as shown on the following pages.

We're continuously building our Master collection of these special talents and are aware that there are more in our archives for consideration. This is a continuous process.

The Masters shown below have been Platinum & Gold winners who set the standard of excellence in their professions.

ADVERTISING MASTERS

VIEW ALL 16 ADVERTISING MASTERS

Doug Lloyd | Lewis Communications | Zulu Alpha Kilo | The Richards Group

DESIGN MASTERS

VIEW ALL 80 DESIGN MASTERS

Atlas (Astrid Stavro & Pablo Martín) | KMS TEAM GmbH | Ikko Tanaka | ARSONAL

ART / ILLUSTRATION MASTERS

VIEW ALL 24 ART / ILLUSTRATION MASTERS

Peter Kraemer | Guy Billout | Michael Pantuso | Craig Frazier

PHOTOGRAPHY MASTERS

VIEW ALL 44 PHOTOGRAPHY MASTERS

Phil Marco | Jonathan Knowles | Adam Voorhes | Nick Knight

JOSEPH HAYDN

BIEL AB
12|09|2008
BIENNE DÈS LE
12|09|2008

SOLOTHURN AB
20|09|2008

L' I S O L A D I S A B I T A T A

THEATERTᴀꓱHT
BIEL SOLOTHURN BIENNE SOLEURE

L' Isola Disabitata | **Theater Biel Solothurn** | **Atelier Bundi**

APRIL 8 – 30 2008 OPENING APRIL 7 12H PHOENIX GALLERY

8-4-3F SHUANGLIU ZHUANTANG TOWN WEST LAKE DISTRICT 310012 HANGZHOU

Designerportraits Melchior Imboden | Phoenix Gallery | Melchoir Imboden

Age of Metal Collar | SHOGAKUKAN INC. | Shin Matsunaga Design Inc.

Platinum, Poster Annual 2010

PLEATS
PLEASE
ISSEY MIYAKE

PLEATS PLEASE ISSEY MIYAKE http://store.pleatsplease.com AVAILABLE ON LINE, DELIVERY IN JAPAN ONLY
TOKYO = Place Minami-Aoyama 3-13-21 Minami-Aoyama, Minato-ku, Tokyo Phone:03.5772.7750 • PARIS = 201
Boulevard Saint Germain, 75007 Paris Phone:01.45.48.10.44 = 3Bis Rue des Rosiers, 75004 Paris Phone:01.40.29.99.66
• NEW YORK = 128 Wooster Street, New York, NY 10012 Phone:212.226.3600 = tribeca ISSEY MIYAKE 119 Hudson Street,
New York, NY 10013 Phone:212.226.0100 • LONDON = 20 Brook Street, London W1K 5DE Phone:020.7495.2306

PLEATS
PLEASE
ISSEY MIYAKE

PLEATS PLEASE ISSEY MIYAKE http://store.pleatsplease.com AVAILABLE ON LINE, DELIVERY IN JAPAN ONLY
TOKYO = Place Minami-Aoyama 3-13-21 Minami-Aoyama, Minato-ku, Tokyo Phone:03.5772.7750 • PARIS = 201
Boulevard Saint Germain, 75007 Paris Phone:01.45.48.10.44 = 3Bis Rue des Rosiers, 75004 Paris Phone:01.40.29.99.66
• NEW YORK = 128 Wooster Street, New York, NY 10012 Phone:212.226.3600 = tribeca ISSEY MIYAKE 119 Hudson Street,
New York, NY 10013 Phone:212.226.0100 • LONDON = 20 Brook Street, London W1K 5DE Phone:020.7495.2306

PLEATS
PLEASE
ISSEY MIYAKE

PLEATS PLEASE ISSEY MIYAKE http://store.pleatsplease.com AVAILABLE ON LINE, DELIVERY IN JAPAN ONLY
TOKYO = Place Minami-Aoyama 3-13-21 Minami-Aoyama, Minato-ku, Tokyo Phone:03.5772.7750 • PARIS = 201
Boulevard Saint Germain, 75007 Paris Phone:01.45.48.10.44 = 3Bis Rue des Rosiers, 75004 Paris Phone:01.40.29.99.66
• NEW YORK = 128 Wooster Street, New York, NY 10012 Phone:212.226.3600 = tribeca ISSEY MIYAKE 119 Hudson Street,
New York, NY 10013 Phone:212.226.0100 • LONDON = 20 Brook Street, London W1K 5DE Phone:020.7495.2306

PLEATS
PLEASE
ISSEY MIYAKE

PLEATS PLEASE ISSEY MIYAKE http://store.pleatsplease.com AVAILABLE ON LINE, DELIVERY IN JAPAN ONLY
TOKYO = Place Minami-Aoyama 3-13-21 Minami-Aoyama, Minato-ku, Tokyo Phone:03.5772.7750 • PARIS = 201
Boulevard Saint Germain, 75007 Paris Phone:01.45.48.10.44 = 3Bis Rue des Rosiers, 75004 Paris Phone:01.40.29.99.66
• NEW YORK = 128 Wooster Street, New York, NY 10012 Phone:212.226.3600 = tribeca ISSEY MIYAKE 119 Hudson Street,
New York, NY 10013 Phone:212.226.0100 • LONDON = 20 Brook Street, London W1K 5DE Phone:020.7495.2306

THE AMERICAS

Art Institute of Chicago
www.artic.edu
111 South Michigan Ave.
Chicago, IL 60603-6404
United States
Tel 312 443 3600

Asian Art Museum
www.asianart.org
200 Larkin St.
San Francisco, CA 94102
United States
Tel 415 581 3500

Canadian War Museum
www.warmuseum.ca
1 Vimy Place
Ottawa, Ontario K1A 0M8
Canada
Tel 800 555 5621

**Center for the Study of
Political Graphics**
www.politicalgraphics.org
3916 Sepulveda Blvd., Suite 103
Culver City, CA 90230
United States
Tel 310 397 3100

Chicago Design Museum
www.chidm.com
Block Thirty Seven
108 N State St., 3rd Floor
Chicago, IL 60602
United States
Tel 312 894 6263

Cooper Hewitt
www.cooperhewitt.org
2 E. 91st St.
New York, NY 10128
United States
Tel 212 849 8400

Dallas Museum of Art
www.dma.org
1717 North Harwood
Dallas, TX 75201
United States
Tel 214 922 1200

Denver Art Museum
www.denverartmuseum.org
100 W 14th Ave. Parkway
Denver, CO 80204
United States
Tel 720 865 5000

Figge Art Museum
www.figgeartmuseum.org
225 W. 2nd St.
Davenport, IA 52801
United States
Tel 563 326 7804
vbenson@figgeartmuseum.org

High Museum of Art
www.high.org
1280 Peachtree St., N.E.
Atlanta, GA 30309
United States
Tel 404 733 4400

J. Paul Getty Museum
www.getty.edu
1200 Getty Center Drive
Los Angeles, CA 90049-1687
United States
Tel 310 440 7330

The Los Angeles County Museum of Art
www.lacma.org
5905 Wilshire Blvd.
Los Angeles, CA 90036
United States
Tel 323 857-6000

Los Angeles Contemporary Exhibitions
www.welcometolace.org
6522 Hollywood Blvd.
Los Angeles, CA 90028
United States
Tel 323 957 1777

The Metropolitan Museum of Art
www.metmuseum.org
1000 5th Ave.
New York, NY 10028
United States
Tel 212 535 7710

Minneapolis Museum of Art
www.new.artsmia.org
2400 Third Ave. South
Minneapolis, MN 55404
United States
Tel 612 870 3000

Museum of Arts and Design
www.madmuseum.org
Jerome and Simona Chazen Building
2 Columbus Circle
New York, NY 10019
United States
Tel 212 299 7777

Museum of Fine Arts Boston
www.mfa.org
Avenue of the Arts
465 Huntington Ave.
Boston, MA 02115
United States
Tel 617 267 9300

Museum of the City of New York
www.mcny.org
1220 Fifth Avenue (at 103rd St.)
New York, NY 10029
United States
Tel 212 534 1672

MUMEDI - Museo Mexicano del Diseño
www.mumedi.mx
Avenida Francisco I. Madero 74
Centro, Cuauhtémoc
06000 Ciudad de México, D.F.,
Mexico
Tel +52 55 5510 8609

Norman Rockwell Museum
www.nrm.org
9 Glendale Road
Route 183
P.O. Box 308
Stockbridge, MA 01262
United States
Tel 413 298 4100

North Carolina Museum of Art
www.ncartmuseum.org
2110 Blue Ridge Road
Raleigh, NC 27607
United States
Tel 919 839 6262

Oakland Museum of California
www.museumca.org
1000 Oak St.
Oakland, CA 94607
United States
Tel 510 318 8400

Philadelphia Museum of Art
www.philamuseum.org
2600 Benjamin Franklin Parkway
Philadelphia, PA 19130
United States
Tel 215 763 8100

Poster House
www.posterhouse.org
119 W 23rd St.
New York, NY 10011
United States

The Poster Museum
www.postermuseum.com
122 Chambers St.
New York, NY 10007
United States
Tel 212 513 0313

Saint Louis Art Museum
www.slam.org
One Fine Arts Drive
Forest Park
St. Louis, MO 63110-1380
United States
Tel 314 721 0072

The Seattle Art Museum
www.seattleartmuseum.org
1300 First Avenue
Seattle, WA 98101
United States
Tel 206 654 3100

Solomon R. Guggenheim Museum
www.guggenheim.org
1071 Fifth Avenue
New York, NY 10128
United States
Tel 212 423 3575

Speed Art Museum
www.speedmuseum.org
2035 South Third St.
Louisville, KY 40208
United States
Tel 502 634-2700

The Taft Museum of Art
www.taftmuseum.org
316 Pike St.
Cincinnati, OH 45202
United States
Tel 513 241-0343

U.S. Navy Poster Museum
411 Main St.
Point Pleasant, WV 25550
United States
Tel 304 675 4989

Walker Art Museum
www.walkerart.org
1750 Hennepin Ave.
Minneapolis, MN 55403
United States
Tel 612 375 7600

Whitney Museum of American Art
www.whitney.org
99 Gansevoort St.
New York, NY 10014
United States
Tel 212 570-3600

EUROPE & AFRICA

Affiche Dutch Poster Museum
www.affichemuseum.nl
Grote Oost 2-4
1621 BW Hoorn
Netherlands
Tel +31 229 29 98 46

Artifiche
www.artifiche.com
Zeltweg 10
CH-8032, Zürich
Switzerland
Tel +41 44 387 40 44

Bauhaus Archives (Bauhaus-Archiv)
www.bauhaus.de
Klingelhöferstraße 14
10785 Berlin
Germany
Tel +49 30 2540020

The Berardo Collection Museum
www.berardocollection.com
Praça do Império
1449-003 Lisboa
Portugal
Tel +351 21 361 2878

Dansk Plakatmuseum
www.plakatmuseum.dk
Viborgvej 2
8000 Aarhus
Denmark
Tel +45 86 15 33 45

Designmuseum Danmark
www.designmuseum.dk
Bredgade 68
1260 Kobenhavn
Denmark
Tel +45 33 18 56 56

Design Museum
www.designmuseum.org
28 Shad Thames
London SE1 2YD
United Kingdom
Tel +44 20 7403 6933

Deutsches Plakat Museum
www.museum-folkwang.de
Museumsplatz 1
45128 Essen
Germany
Tel +49 201 884 51 08

Die Neue Sammlung
www.dnstdm.de
Barerstrasse 40
80333 München
Germany
Tel +49 89 2727250

Galeria Plakatu - Poster Gallery
www.cracowpostergallery.com
31-043 Kraków
Kramy Dominikańskie
ul. Stolarska 8-10
Poland
Tel +48 12 421 26 40

Gemeentemuseum Den Haag
www.gemeentemuseum.nl
Stadhouderslaan 41
2517 HV Den Haag
The Netherlands
Tel +31 7033 81 111

Kunsthaus Zürich
www.kunsthaus.ch
Heimplatz 1
CH-8001 Zürich
Switzerland
Tel +41 44 253 84 84

Kunsthalle Basel
www.kunsthallebasel.ch
Steinenberg 7
CH-4001 Basel
Switzerland
Tel +41 61 206 99 00

Lahti Art Museum
www.lahdenmuseot.fi
Vesijärvenkatu 11 A
Box 113
FIN-15111 Lahti
Finland
Tel +358 3 814 4547

**MAK Austrian Museum of
Applied Arts/Contemporary Art**
www.mak.at
Stubenring 5
1010 Wien
Austria
Tel +43 1 711360

Moderna Museet (Malmö)
www.modernamuseet.se
Ola Billgrens plats 2-4
SE-211 29 Malmö
Sweden
Tel +46 40 685 79 37

Moscow Design Museum
www.moscowdesignmuseum.ru
125009, Moscow
Manege Square, 1
Russia
Tel +7 495 991 90 42

**MUSAC - Museo de Arte
Contemporáneo de Castilla y Léon**
www.musac.es
Avenida Reyes Leoneses
24 24008 Léon
Spain
Tel +34 987 09 00 00

Musée de la Publicité
www.lesartdecoratifs.fr
107, rue de Rivoli
75001 Paris
France
Tel +33 1 44 55 57 50

Museum Boijmans
www.boijmans.nl
Museumpark 18
3015 CX Rotterdam
The Netherlands
Tel +31 10 441 9400

Museum Fur Gestaltung
www.museum-gestaltung.ch
Toni-Areal, Pfingstweidstrasse 96
CH-8005 Zürich
Switzerland
Tel +41 43 446 67 67

Museum Haus Konstruktiv
www.hauskonstruktiv.ch
Selnaustrasse 25
CH-8001 Zürich
Switzerland
Tel +41 44 217 70 80

Museo d'Orsay
www.musee-orsay.fr
62, rue de Lille
75343 Paris Cedex 07
France
Tel +33 (0)1 40 49 48 14

National Centre for Contemporary Arts
www.ncca.ru
123242, Moscow
Zoologicheskaya str., 13
Russia
Tel +7 499 254 06 74

Pinakothek Der Moderne
www.pinakothek.de
Barer Straße 29
80333 Müenchen
Germany
Tel +49 89 23805360

Poster Museum at Wilanów
www.postermuseum.pl
St. Kostki Potockiego 10/16 Street
PL 02-958 Warsaw
Poland
Tel +48 22 842 26 06

Saatchi Gallery
www.saatchigallery.com
Duke of York's HQ
King's Road
London SW3 4RY
United Kingdom
Tel +44 20 7811 3070

Stedelijk Museum Amsterdam
www.stedelijk.nl
Museumplein 10, 1071 DJ
Amsterdam
Netherlands
Tel +31 (0)20 5732 911

Stedelijk Museum Breda
www.stedelijkmuseumbreda.nl
Stedelijkmuseumbreda.nl
Boschstraat 22, 4811 GH
T 076 – 529 99 00
info@stedelijkmuseumbreda.nl

Swiss Poster Museum
www.swisspostermuseum.com
Manessestrasse 170
CH-8045 Zürich
Switzerland
Tel +41 (0)78 750 77 07

Tate Modern (London)
www.tate.org.uk
Bankside
London SE1 9TG
United Kingdom
Tel +44 20 7887 8888

Triennale di Milano
www.triennale.org
Viale Alemagna, 6
2012 Milano
Italy
Tel +39 02 724341

Victoria and Albert Museum
www.vam.ac.uk
Cromwell Road
London SW7 2RL
United Kingdom
Tel +44 020 7942 2000

ASIA & OCEANIA

Auckland Art Gallery Toi o Tāmaki
www.aucklandartgallery.com
Wellesley St E
Auckland, 1010
New Zealand
Tel +64 9 379 1349

Australian Museum
www.australianmuseum.net.au
1 William Street
Sydney NSW 2010
Australia
Tel +61 2 9320 6000

Chi-Mei Museum
www.chimeimuseum.org
No. 66, Sec. 2, Wenhua Rd.,
Rende Dist., Tainan City 71755,
Taiwan
Tel +886 6 2660808

Fukuoka Art Museum
www.fukuoka-art-museum.jp
Chuo-ku Ohori Park 1-6
Fukuoka-shi, Fukuoka,
Japan
Tel +81 92 714 6051

Hong-Gah Museum
www.hong-gah.org.tw
11F., No.166, Daye Road,
Beitou District,
Taipei City 11268
Taiwan
Tel + 886 22894 2272

Metropolitan Museum of Manila
www.metmuseum.ph
Bangko Sentral ng Pilipinas Complex,
Roxas Boulevard,
Malate-Manila (1554),
Philippines
Tel +02 708 7828

Mori Art Museum
www.mori.art.museum
53F Roppongi Hills Mori Tower,
6-10-1 Roppongi
Minato-ku,Tokyo
Japan
Tel +81 3 5777 8600

**Museum of Art
Seoul National University**
www.snumoa.org
1 Gwanak-ro, Gwanak-Gu
Seoul 08826
South Korea
Tel +82 (2) 800 9504

Museum of Contemporary Art Australia
www.mca.com.au
140 George St.
The Rocks NSW 2000
Australia
Tel +61 2 9245 2400

Museum of Contemporary Art, Shanghai
www.mocashanghai.org
Gate 7 People's Park, 2
31 Nanjing West Road,
Shanghai, PR.China
Tel +86 216 6327 9900

National Art Gallery
www.artgallery.gov.my
No. 2, Jalan Temerloh,
Titiwangsa, 53200 Kuala Lumpur,
Wilayah Persekutuan Kuala Lumpur,
Malaysia
Tel +60 3-4026 7000

National Gallery of Armenia
www.gallery.am/hy/
1 Aram Street,
Yerevan 0010,
Armenia
Tel + 374 10 567472

National Gallery Singapore
www.nationalgallery.sg
1 St Andrew's Rd,
Singapore 178957
Tel +65 6271 7000

**National Museum of Modern
and Contemporary Art, Korea**
30 Samcheong-ro
Sogyeok-dong, Jongno-gu
Seoul 03062
South Korea
Tel + 82 (2) 3701 9500

National Portrait Gallery
www.portrait.gov.au
King Edward Terrace,
Parkes ACT 2600
Australia
Tel + 61 2 6102 7000

Seoul Museum of Art
www.sema.seoul.go.kr
61 Deoksugung-gil
Seosomun-dong, Jung-gu
Seoul 04515
South Korea
Tel +82 (2) 2124 8800

Shanghai Propaganda Poster Art Center
www.shanghaipropagandaart.com
868 Huashan Road
Xuhui, Shanghai
China
Tel +86 21 6211 1845

Taipei Fine Arts Museum
www.tfam.museum/
No. 181, Section 3,
Zhongshan N Rd,
Zhongshan District, Taipei City,
Taiwan 10461
Tel + 886 2259 57656

Additional Museums:
*If you are a museum that collects
posters and are not listed above, please
contact us for inclusion in our
next Annual at help@graphis.com.*

Takashi Akiyama | Director, Takashi Akiyama Poster & Professor, Tama Art Univ. | Takashi Akiyama Poster Museum Nagaoka
Biography: Born in Nagaoka-shi, Niigata, Japan in 1952 / B.A. Tama Art University, Tokyo / M.A. Tokyo National University of Fine Arts and Music. ■ Awards: Gold Prize in The Warsaw International Poster Biennial, 1986, Poland / Artia Prize in Brono International Graphic Design Biennial, 1986, Czechoslovakia/Honorary Mention Award in Mexico International Biennial of the Poster, 1992, Mexico /Distinctive Merit Award in N.Y. Art Directors Club Exhibition, 1993, U.S.A/Encouraging Prize in 2nd International Exhibition of Graphic Art and Poster-4th Block, 1994, Ukraine/Honourable Mention in Helsinki International Poster Biennial, 1997, Finland / "International Nature Film Festival-Golden Ibex-", First Prize in Cogne International Nature Film Poster Competition Italy, 1997/ Poster "No More Nuclear Testing by India", The UNDPI Awards in United Nations DPI, The New York Festivals, 1999, and more.
Commentary: 1. The Poster is a silent voice. 2. We can understand the illustration through reading the drawings. 3. The process is mysterious and interesting. 4. "Message Illustration" is not a word but "a message bomb." 5. We should be aware of the message from illustrations. 6. We have to understand the standpoint and situation of the audience, in order to capture their heart.

Rikke Hansen | Designer | Wheels & Waves
Biography: Rikke Hansen was born in Denmark in 1975. Graphic Designer and Educator: Works and teaches in the intersection between language, culture and space. She has a passion for graphic design and typography, and for working with design methods that provide students with ways to fundamentally understand society and its stakeholders' needs, and how to drive these processes to useful results. For several years she has been working with product development, branding, and consulting for companies and organizations, and as Head of Communication Design Department at the University Design School Kolding she played a significant role in developing new educational programs for the future. She is an external Associate Professor at the University of Southern Denmark. Currently she teaches a variety of design courses at different design schools and universities in Denmark and abroad. She works on and researches design development projects and has her own design studio doing print and digital design. She is a owner of a letter-press workshop. Vice Chairman at the Danish Association for Book Crafting. Member of C-IDEA, China. Appointed External Examiner at the higher artistic educational programmes by the Ministry of Higher Education and Science. Juror at the 14th BICM, International Poster Biennial Mexico. Juror at Cyprus Poster Triennial, Graphis Talent Award, Ukranian Design: The Best of and the BICeBé, International Poster Biennial Bolivia 2019. COFOD Excellence Award winner. Graphis Platinum, Gold and Silver Award winner. She has been exhibiting, giving lectures and workshops internationally in Chile, South Korea, Mexico, Jordan, Israel, Syria, Thailand, Gambia, Malaysia, India, Sri Lanka, Netherlands, Portugal, Czech Republic, US & China. ■ More info at www.wheelsandwaves.dk

Dermot Mac Cormack | Co-founder | 21xdesign
Biography: Dermot Mac Cormack co-founded 21xdesign in 1997. His work has been honored with national and international design awards and has been exhibited in various countries. Originally from Ireland (where he studied at the National College of Art & Design, in Dublin), Dermot worked in various design studios in Ireland and in the US, working mostly in the corporate design field before becoming involved in design for the screen. He is also the Chair of the Graphic & Interactive Design Department in Tyler School of Art, Temple University in Philadelphia. Dermot has been designing posters, alongside Patricia McElroy, for several years and he is truly honored to be a part of this wonderful process and publication.
Commentary: For me personally, I gravitated towards work that was conceptually driven, extremely well executed, and had something to say, and there were many entries that fit into those criteria. I've also long been an admirer of design from Asia and was impressed with the submissions from Japan, Korea, and especially China. Overall, while I don't think there was a single trend evident in the submissions, I was nonetheless struck by the range of topics and the meticulous attention to detail that was evident in many of the winning posters. While the role of the poster in our society has certainly changed, I think that this publication demonstrates that at the end of the day, thoughtful, considered design will always shine through and that poster design in the 21st century still has much to say and is evolving alongside our networked world.

Patricia McElroy | Co-founder | 21xdesign
Biography: Patricia McElroy was born in Philadelphia, USA, but spent her formative years in Dublin, Ireland. She moved back to Philadelphia where she co-founded 21xdesign in 1997 with Dermot Mac Cormack. The studio has built a reputation for developing creative branding in print and interactive experiences. With Patricia's extensive publishing and design experience, 21xdesign has been honored with national and international design awards, and has been exhibited in many countries.
Commentary: Graphis always reminds me of my younger self and how the Graphis magazine and the annuals always made me strive to be the best designer I could be. It has been an honor to be a part of the judging process and to allow myself the time to examine in detail this collection of posters. It impressed on me how important poster design still is today in the realm of pushing ideas into the public forum and how influential they are to our visual world. Reviewing the collection with my partner Dermot also gave rise to interesting discourse before final judgment.

Gunter Rambow | Graphic Designer, Photographer | Gunter Rambow
Biography: Gunter Rambow studied glass painting before he started his main studies, graphic design at HBK Kassel in Germany. Rambow created numerous photo books and designed poster series for literature, theatre and social topics. He has won many silver, gold and platinum medals at poster festivals, biennials and triennals in Warsawa, Chaumont, Lahti, Brno, Toyama and New York. Between 1974 and 2004 he taught as a professor for visual communication at the university of Kassel and later at the HfG Karlsruhe. Today he lives and works together with his wife Angelika in Guestrow where he also runs a poster gallery.
Commentary: Franz Mon said, "A poster is a surface that jumps into one's eye" ■ Based on this quote, I tried to discover good posters among the Poster Design 2020 competition and I succeeded. ■ I was able to discover many "schools" and the designers developed them further and made them individually different. ■ Also, this year I noticed that national peculiarities play a major role.

Hajime Tsushima | Designer | Tsushima Design
Biography: Born in Hiroshima, Japan in 1970, Tsushima worked in his design studio on advertising, packaging, editorial and branding design. He is an associate professor at Osaka University of Arts Junior College where he teaches Graphic Design. Tsushima received high marks and won numerous awards at the International Poster Competition and has received many Graphis Platinum, Gold and Silver awards.
Commentary: I spent many hours judging and saw a lot of great, high quality works. I was was amazed at the new designs and expressions. There were a lot of new attempts, and I was happily able to make an examination.
I think that the visual expression of posters will be the basis of design for young designers and will play an important role in the future. A new technology such as A.I. will come out, and I think it will be more and more advanced in the graphic design area.
I think that the competition is very important because it offers the joy of exploring beautiful expression and will continue to be very meaningful for young designers.

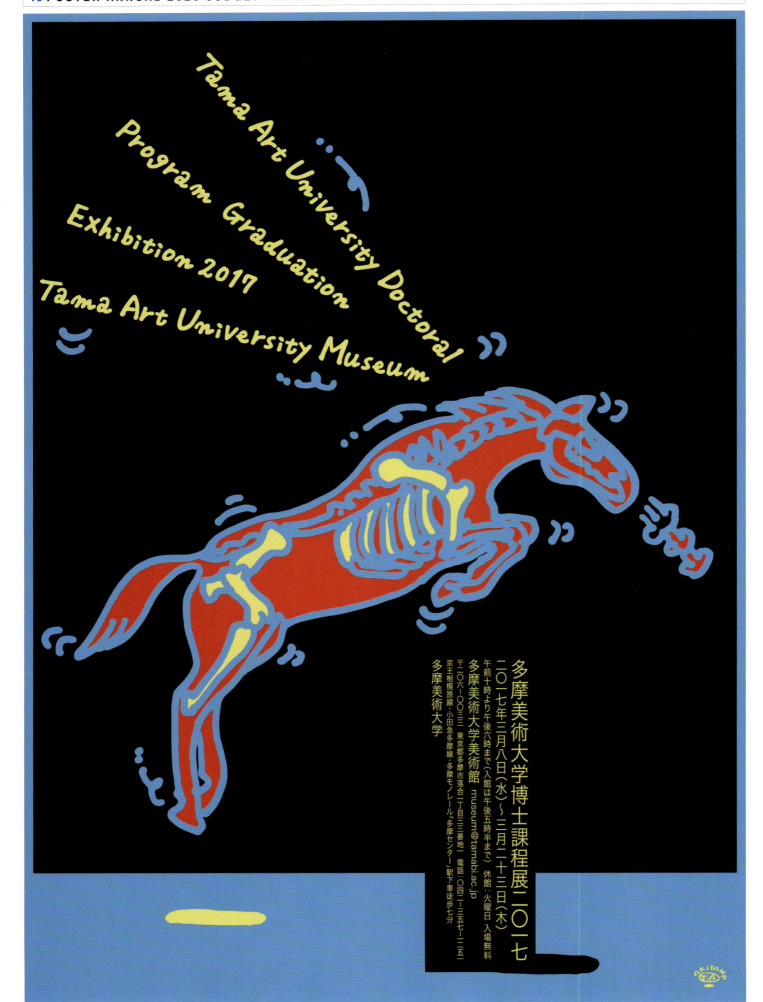

Homage to Umberto Eco | BICeBé and National Museum of Art, La Paz | **Rikke Hansen**

GUN CONTROL ?

ORLANDO – 06.12.16

#NEVERAGAIN

PARKLAND — 02.14.18

SIMON BOCCANEGRA Giuseppe Verdi

WIEDERAUFNAHME: FREITAG, 24. APRIL 2015
WEITERE VORSTELLUNGEN:
2., 9., 17., 31. MAI; 6., 12. JUNI 2015
TICKETS 069 212 49 49 4

Oper Frankfurt

RAMBOW 2014

Simon Boccanegra | Oper Frankfurt | Gunter Rambow

Studio Zen Wallcoverings | Studio Zen Wallcoverings | Tsushima Design

Spencer Till | **Lewis Communications** | Senior VP/Executive Creative Director | www.lewiscommunications.com | Page: 26

Biography: Spencer Till's relentless passion is the driving force behind the creative at Lewis Communications, one of the South's most awarded branding and advertising firms. After graduating from Auburn with double majors in Design and Illustration and working a few years in Atlanta, Spencer joined Lewis' original office in Mobile as an art director. Sensing an opportunity to build a truly creative-driven agency, he and Larry Norris spearheaded the founding of the Birmingham office which today serves as the agency's headquarters, as well as a fast-growing office in Nashville. Lewis' work has appeared in the Graphis Advertising, Design and Photography Annuals more than a dozen times, with numerous Platinum, Gold and Silver honors, as well as multiple honors from Communication Arts, the national ADDY competition, and other national and international honors. Under his leadership, Lewis has also been named in Graphis' 100 Best in Advertising and 100 Best in Photography competitions.

ARSONAL | www.arsonal.com | Page: 27

Biography: Brad Johnson and Ethan Archer have spent their entire careers creating key art for the entertainment industry. They partnered in 2007 to start ARSONAL, a collaborative agency of people that share their passion for design and advertising. ARSONAL primarily focuses on print and digital solutions for studios, networks, and brands.

ARSONAL has been behind some of the most eye-catching and successful campaigns in their field, and they have been recognized as a leader in entertainment advertising with clients that include, 20th Century Fox, A&E, ABC, Amazon, Bravo, Cinemax, Fandango, Focus Features, FOX, FX Networks, HBO, History Channel, Hulu, IFC, Nat Geo, NBC, Netflix, Showtime, Sony, Starz, TBS, The CW, TNT, TruTV, Universal and Warner Bros.

João Machado | **João Machado Design** | Designer | www.joaomachado.com | Page: 28

Biography: Born in Coimbra, João Machado graduated in Sculpture at the Porto School of Fine Arts, but it is in Graphic Design that he is unique and internationally recognized. He was a teacher at ESBAP (1976-1981), but soon decided to dedicate himself exclusively to graphic design and to open his own studio in 1981. Since then, he has participated in numerous collective and solo exhibitions that have brought him several national and international awards, such as the Icograda Excellence Award in 1999, as well as his appointment as one of the Graphis Design Masters.

Stephan Bundi | Designer and Art Director | Page: 29

Biography: As a designer and art director for film producers, concert promoters, museums, theatres, and publishers, Stephan Bundi combines unconventional ideas with practical Swiss tradition. His clients include international corporations such as Swissair, Nikon, and IBM, as well as smaller firms, publishing houses and institutions. The content being conveyed and the visualization of the message are paramount to his work. To achieve this, he chooses the technique that can be used best to interpret the content, be it typography, drawing, painting or photography. He returned to working by himself in his studio since 2015.

Bundi has taught at several universities, has held lectures and workshops around the world and was a professor at Bern University of the Arts from 1999–2014. He has had one-man shows and exhibitions all over the world. Since the 1980s, Bundi has regularly taken part in the most important international poster exhibitions and has been member of many international juries. Bundi won first place prizes in Chicago, Mexico, Mons (Belgium), New York, Sofia, Vienna, the ICOGRADA Excellence Award in Warsaw, and the Swiss Poster Award several times. His posters are part of public collections worldwide.

Carmit Makler Haller | **Carmit Design Studio** | Designer, Owner of Carmit Design Studio | www.creativehotlist.com/challer | Page: 30

Biography: Carmit Makler Haller graduated from the Academy of Art University, San Francisco, CA in 2001 with a degree in Computer Arts/New Media and is now owner of a boutique design studio. For several years she has been working in the fields of consumer market, high-tech startups and luxury real estate. Her passion lies in poster design and typography. Haller addresses cultural, social and political issues with a strong and thought provoking point of view. She is influenced by Josef Müller-Brockmann, Stephan Bundi, Gunter Rambow and the Swiss Design masters. Her works won awards with Graphis as well as in Rockport Publishing. Currently, she resides in San Francisco, CA.

Gunter Rambow | **Gunter Rambow** | Graphic Designer and Photographer | www.gunter-rambow.com | Page: 31

Biography: Gunter Rambow studied glass painting before he started his main study of graphic design at HBK Kassel. Rambow created numerous photo books and designed poster series for literature, theatre, and social topics. He has won many silver, gold and platinum medals at poster festivals, biennials and triennials in Warsawa, Chaumont, Lahti, Brno, Toyama and New York. Between 1974 and 2004 he taught as a professor for visual communication at the University of Kassel and later at the HfG Karlsruhe. Today he lives and works together with his wife Angelika in Guestrow where he also runs a poster gallery.

Kit Hinrichs | **Studio Hinrichs** | Founder and Creative Director at Studio Hinrichs | www.studio-hinrichs.com | Page: 32

Biography: Since graduating from ArtCenter College of Design in 1963, Kit Hinrichs has served as the principal of design firms in New York and San Francisco. His longest tenure was twenty three years (1986-2009) as a partner of Pentagram. In 2009, he left Pentagram to open Studio Hinrichs in San Francisco, CA. Kit Hinrichs' design experience spans a wide range of assignments, from brand identities and packaging to exhibition design.

Hinrichs is a recipient of the AIGA Medal. His work is included in the permanent collections of the Museum of Modern Art, New York and San Francisco, the Los Angeles County Museum of Art, and the Denver Museum of Art. He is co-author of five design and typography books, a member of Alliance Graphique Internationale, and a trustee of ArtCenter College of Design.

Pekka Loiri | **Studio Pekka Loiri** | Graphic Designer | **www.originalloiri.fi** | Page: **33**

Biography: Loiri has been awarded dozens of prizes in graphic design and as a Poster Designer at home and abroad. He has been awarded e.g. in the Lahti Poster Biennial, ISPAA Theatre Poster Competition New York, the Colorado Poster Biennial, Osnabruck Theatre Poster Competition, Affish in Linner, Mexico Poster Biennial, Solidarity Poster Exhibition in Prague, in Trnava Poster Triennial, in The Gabrovo Biennial, in Ningbo Poster Biennial, in Graphis Posters competitions and in AUG design Exhibition. He has also been granted the Icocrada Excellence Award. Loiri has received the government's Industrial Art Award in Finland, and the award of the Finnish Culture Foundation. He's been elected as the Graphic Designer of the Year in Finland and has received the Platinum Top by the Graphic Designer's Association in Finland. Pro Com Association of Communications Professionals has granted Loiri the lifetime achievement award.

Loiri has been involved in education, working e.g. at the University of Art and Design in Helsinki and as the principal at the MG school in Helsinki. He has been giving lectures and workshops at a number of universities of art and design all over the world. Loiri works as a visiting professor at the Shanghai Academy of Fine Arts. He has been invited as an honorary member of the Aalto University in Finland, as well as a member of the Honorary Council of BICM / Mexico. He is also a Honorary member of the Union of Designers. Pekka Loiri has been awarded the Pro Finlandia medal.

From the year 2004 he has been working as the President of the Lahti Poster Biennial (nowadays Triennial) in Finland.

FX Networks | **www.fxnetworks.com** | Page: **34**

Biography: The FX Networks Print Design Department, part of FX Marketing, creates original and unparalleled print advertising for all of FX Networks' original programming. The team aims to push the boundaries of entertainment advertising and commercial art in general. In years past, FX Print Design has created award-winning campaigns for shows like Nip/Tuck, American Horror Story, Sons of Anarchy, Atlanta, Taboo, and Fargo, among numerous others. The FX Marketing team is the winner of the Clio Key Art Awards' "Network of the Year" three years running and Promax/BDA "Marketing Team of the Year" all seven years the award has been presented.

Marcos Minini | **Marcos Minini Design** | Principal and Owner at Marcos Minini Design | **www.marcosminini.com** | Page: **35**

Biography: Marcos Minini studied Graphic Design at UFPR (Curitiba-Brazil). Over the last 30 years he worked at different advertising agencies and design studios, like Lumen Design, Master Comunicação, Brainbox Branding 360, and Aurora Branding. Since August 2018 he is running his own studio. Minini is one of the founders of Creative Club of Paraná and Prodesign PR (Paraná Design Association). He teaches Poster Design at RedHook School and also runs lectures and workshops on creativity. He has designed projects for the Brazilian Ministry of Health, Banco do Brasil, Curitiba City Hall, Subway, O Boticário, TIM, among many other clients. He has also earned prestige for his identity projects and poster design in the cultural area. His works are present in poster and design biennials like Teheran, China, Bolivia, Equador, Italy, Lahti, Warsaw, México, ADG Brazil, Moscow, Sofia and Budapest. He also has works published in books and magazines in both Brazil and other countries.

Youhei Ogawa | **OGAWAYOUHEI DESIGN** | Graphic Designer and Art Director | **www.ogawayouhei.com** | Page: **36**

Biography: Japanese graphic designer and art director, Ogawa lived in Kobe until he was 18 before moving to Osaka and entering an arts university. He started working as a graphic designer directly upon graduating. Ogawa received the Best Work award for Applied Typography (Japan Typography Association) three times, and has also taken other design awards on 48 different occasions. Specialties include logotype and symbol mark design, and main work includes corporate CI and VI, branding, logo designs for small stores and companies, design work for art museums, performing arts and other concert posters.

Pablo Delcán | **Visual Arts Press, Ltd.** | Designer, Founder of Delcan & Company, SVA Faculty Member | **www.delcan.co** | Page: **37**

Biography: Designer, SVA alumnus, and current faculty member Pablo Delcán created "Art is!" as part of the College's legendary and long-standing subway campaign. "The idea that ten years after graduating, I am creating the poster that represents the school, was really exciting for me," Delcán says, "I immediately went into the subway and started sketching in my sketchbook. The whole story came full circle."

Delcán, an award-winning graphic designer and art director from Spain, founded Delcán & Company, a design studio based in New York City in 2014. He is a visual contributor to The New York Times Magazine, and has designed book covers, animated videos, and a host of other projects for clients around the world.

In my judging, I looked at the purpose of the poster and how the use of colors, fonts and graphics complemented the information and how this had been synthesized in a contemporary, clever, and thoughtful way.

Rikke Hansen, *Designer, Wheels & Waves*

Visit our Credits & Commentary section in the back of the book to read the full assignments, approaches and results from this year's Platinum Winners.

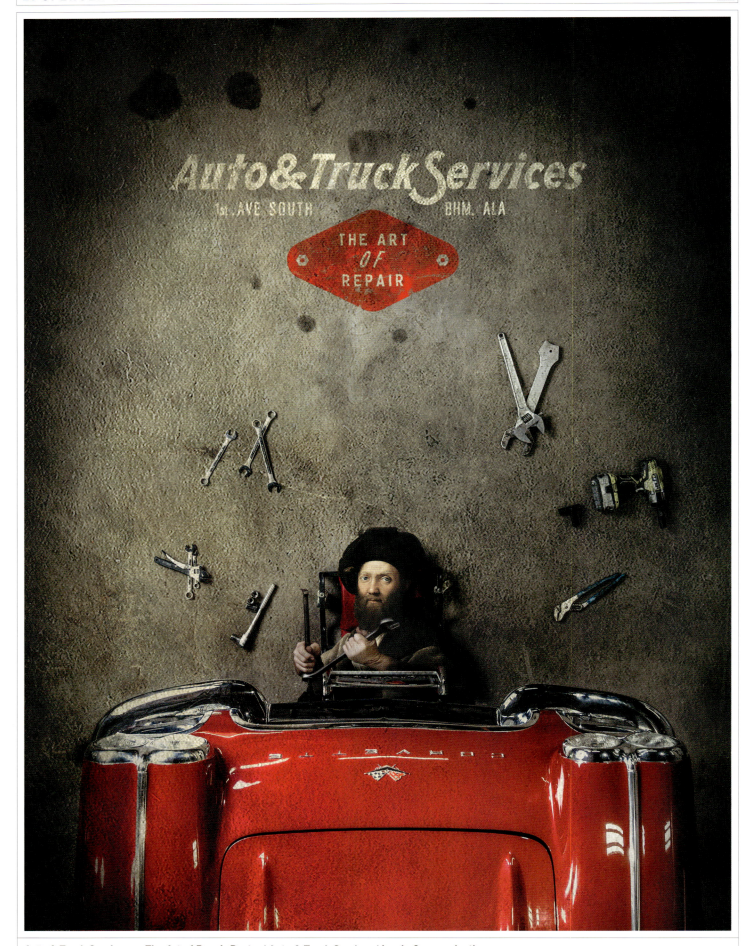

Auto & Truck Services — The Art of Repair Poster | Auto & Truck Services | Lewis Communications

Assignment: For 5 years, Auto and Truck Services ran campaigns, posters and more to distinguish themselves as "The Art of repair."
Approach: We enlisted part photography and part old master's paintings to bring the artists (mechanics) to life.
Results: Service on cars is up 76% over last year, against their new target audience of women motorists.

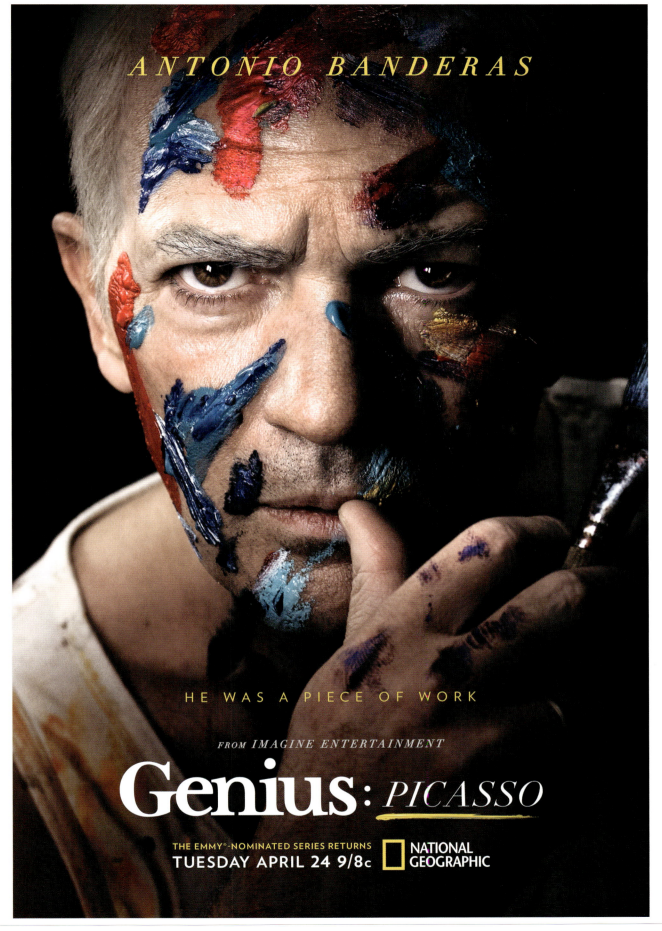

Genius: Picasso | National Geographic | **ARSONAL**

Visit website to view full series

Assignment: Tonally, our goal was to present Picasso as modern rebel, living a bohemian lifestyle, with a punk rock personality.
Approach: The final direction utilized paint swatches and strokes applied to Picasso himself, making the artist the art.
Results: The client was extremely happy with the creative.

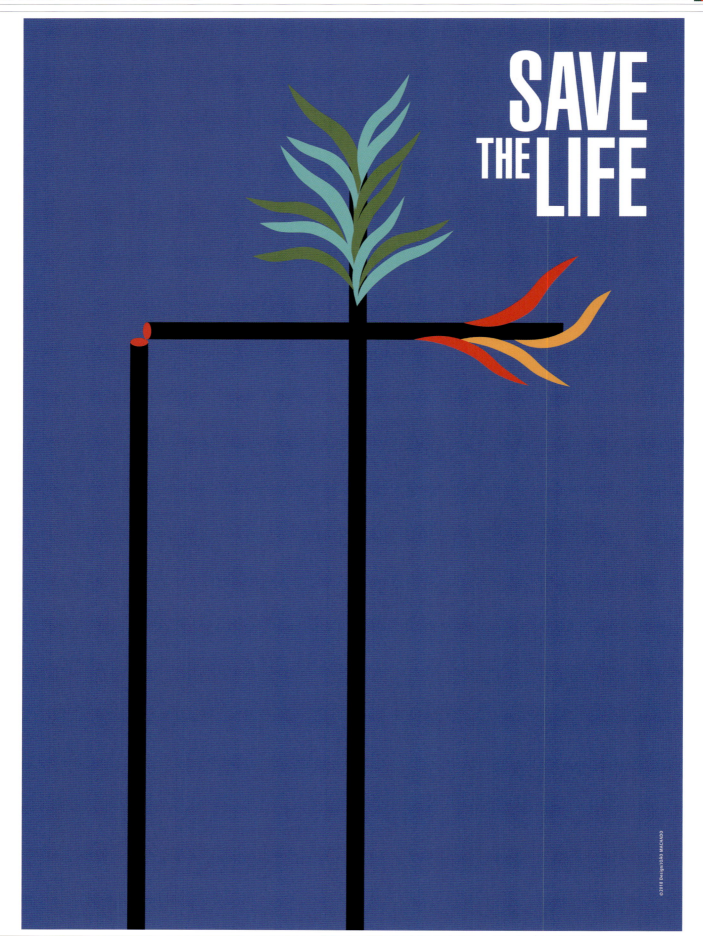

Save the Life | UnknownDesign | João Machado Design

Assignment: Over the years I've been working on the environmental subject for the brand UNKNOWNdesign. The purpose of this work was to call attention to all the problems related to promoting better forest management and conservation as well as protection of the animal life habitat.
Approach: The human negligence and lack of forestry policy has been a real threat to the preservation of our forests.

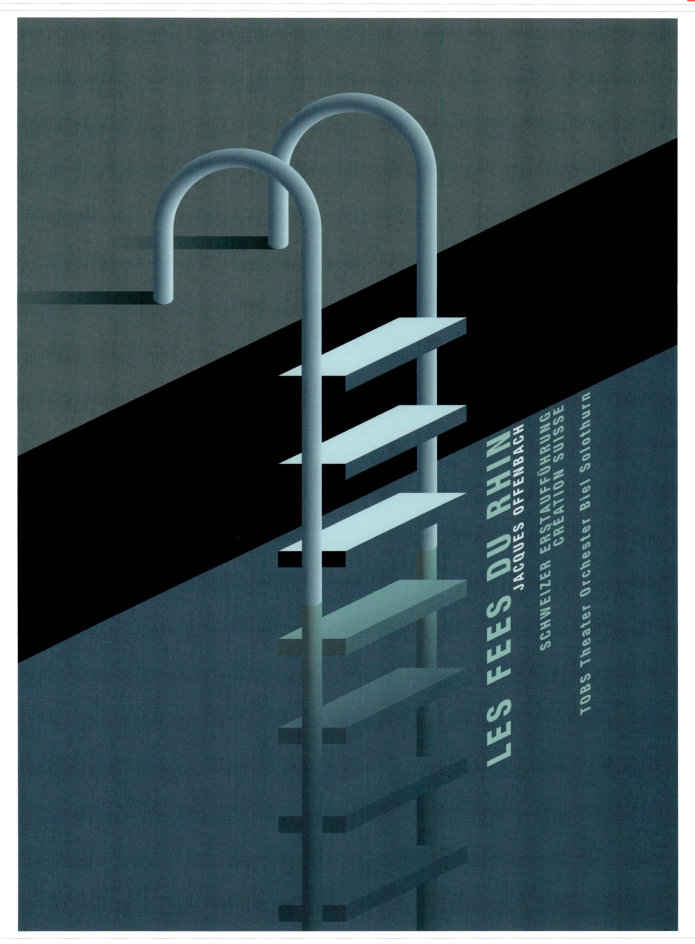

Les Fées du Rhin | Theater Orchester Biel Solothurn | **Stephan Bundi**

Assignment: A pacifist opera in which the Rhine mermaids intervene in the action, silence the struggles and make love triumph over violence.
Approach: The dangerous depth of the Rhine.
Results: The poster was used for all advertising material, and there was also an animated version for the website.

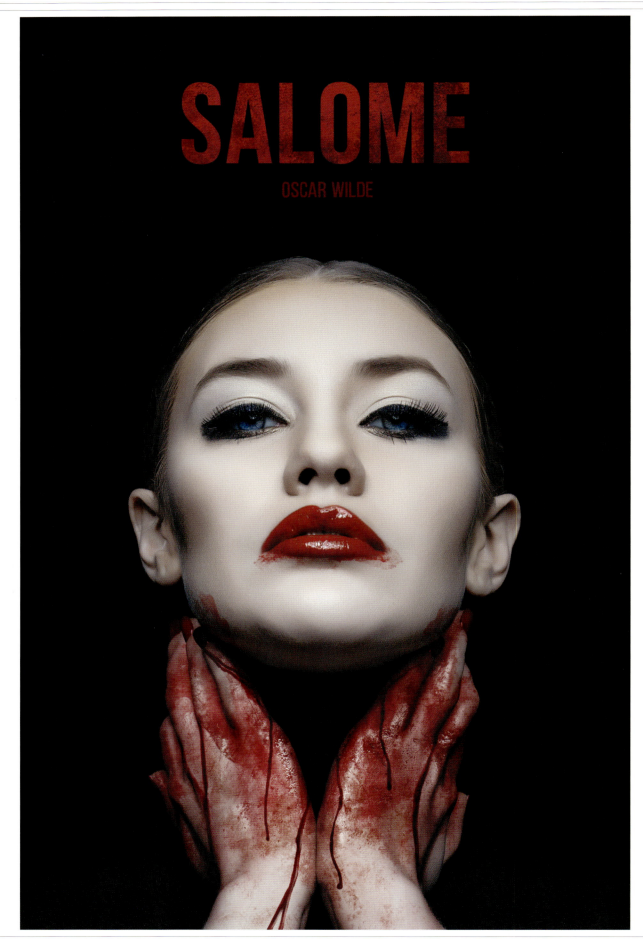

SALOME | Haller Metalwerks | Carmit Design Studio

Assignment: Oscar Wilde's play tells in one act the Biblical story of Salome.
Approach: Salome is the virgin princess of Judah: royal, powerful, beautiful, seductive, naive, mesmerizing—yet unaware of her consequences. Her contradicting characteristics are displayed in this scene, depicting the climax of the play.

Toleranz | Tolerance Travelling Show by Mirko Ilic, New York | **Gunter Rambow**

Assignment: Part of "Tolerance Travelling Show by Mirko Ilic, New York"; invited artists to create an image with their own language.

EIGHTH AMENDMENT TO THE UNITED STATES CONSTITUTION

UNRELENTING BEATINGS • ABUSIVE PENALTIES

Excessive bail shall not be required, nor excessive fines imposed, nor **cruel** and **unusual punishments** inflicted.

SOLITARY CONFINEMENT

EXCESSIVE WORK HOURS

EXCESSIVE COLD • LOUD NOISE

SLEEP & FOOD DEPRIVATION

OVERCROWDING • POOR HEALTH CARE

8th Amendment of the Constitution Poster | We The People | Studio Hinrichs

Assignment: In celebration of the 230th anniversary of the US Constitution, 10 designers were asked to create a visualization of the Bill of Rights.
Approach: The 8th amendment, which prohibits cruel and unusual punishment, was visualized as a human peering out from behind a mask of metal.
Results: An exhibition was presented in New York City, with wild postings of the group of 10 posters all over the city.

PEKKA LOIRI | CLIMATE EMERGENCY 2018

Tocsin | The mankind | Studio Pekka Loiri

Assignment: This poster is my personal statement. It is made for future generations.
Approach: I am very concerned about the global climate and for all the children of the world.
Results: That remains to be seen, but the hurry has begun!

AHS: Cult – Bee Eyes | **FX Networks** | **FX Networks/Iconisus**

Assignment: A cult culture relinquishes individuality in favor of a single leader.
Approach: This series explored the hive mind and bees, hexagons, patterns, immersion and control.
Results: The "hive" mentality creates the illusion of power as part of a larger purpose for the trapped individual and absolute power for the leader.

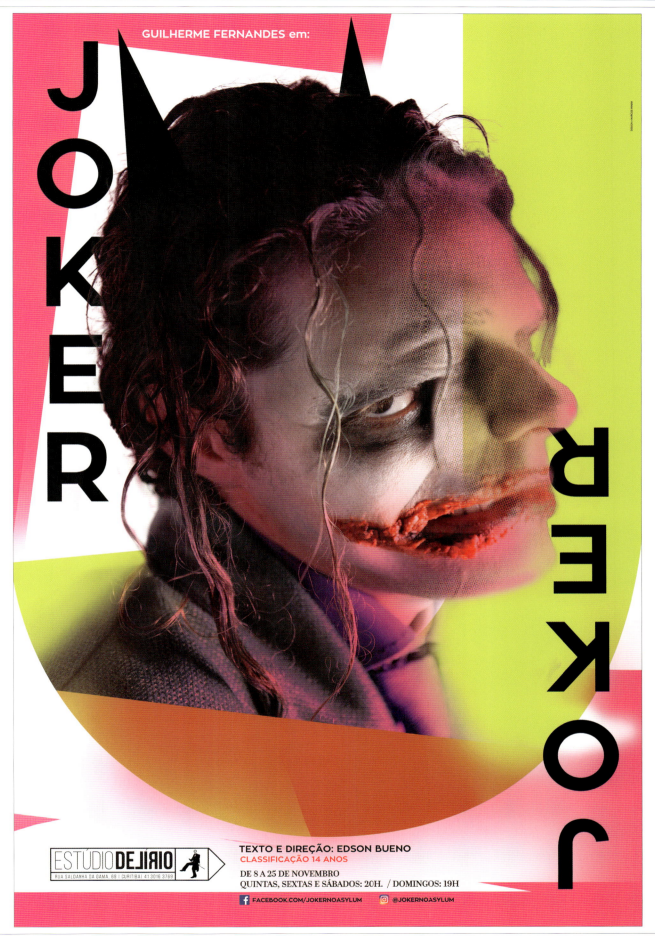

GUILHERME FERNANDES em:

JOKER

TEXTO E DIREÇÃO: EDSON BUENO
CLASSIFICAÇÃO 14 ANOS
DE 8 A 25 DE NOVEMBRO
QUINTAS, SEXTAS E SÁBADOS: 20H. / DOMINGOS: 19H

ESTÚDIO DELIRIO
RUA SALDANHA DA GAMA, 69 | CURITIBA| 41 3016 3769

FACEBOOK.COM/JOKERNOASYLUM @JOKERNOASYLUM

Joker | Guilherme Fernandes | **Marcos Minini Design**

Assignment: It's a monologue play about the villain at arkham asylum.
Approach: Image depicts the joker with two faces to show his many personalities and ability to confuse with words to dominate the audience.
Results: The season had a full audience most nights and will return in February.

Contemporary Noh Onmyoji-Abeno Seimei | **DANCE WEST** | **OGAWAYOUHEI DESIGN**

Assignment: Contemporary Noh plays.
Approach: Expressing the strength of Abe Seikei by typography wrapped in flames of Abe Hideaki.
Results: Packed full, tickets sold out.

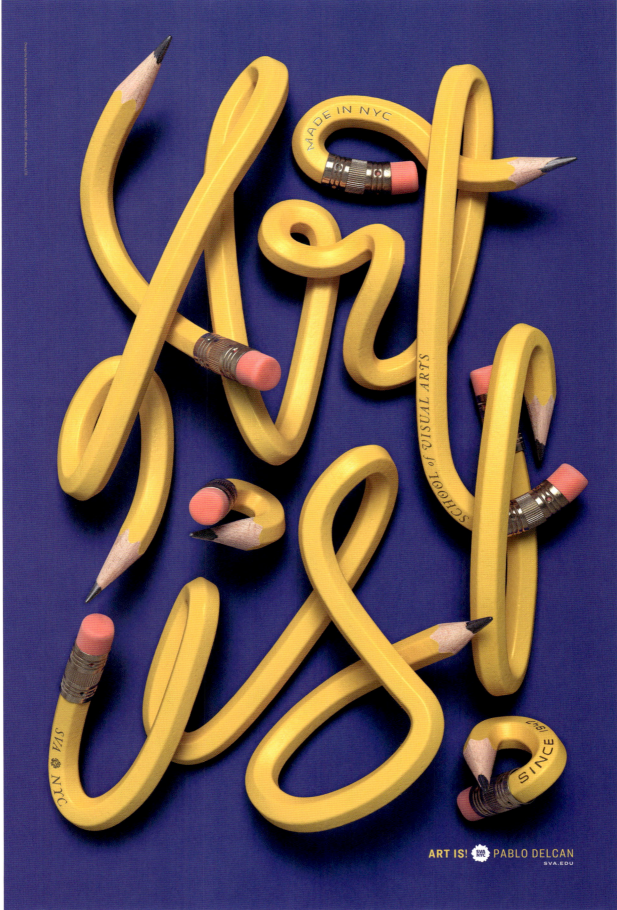

2018 SVA Subway Poster | School of Visual Arts | **Visual Arts Press, Ltd., Delcan & Company**

Assignment: Since the 1950s, SVA commissioned contemporary designers and illustrators to create NYC subway posters to advertise the college.
Approach: Starting in 2018, the college began asking the artists it commissioned to use the prompt "Art Is!" to create their poster.
Results: Pablo Delcan's solution was the first in this series.

Architektur, abseits

Vortragsreihe Herbst 2018
je 19:00 Uhr
im Kornhausforum Bern,
Informationen:
architekturforum-bern.ch

Architektur**Forum** Bern

Architektur, abseits (Architecture, offside) | Architekturforum Bern | **Stephan Bundi**

AIA NY Global Dialogues
January 11, 2018
6:00 – 8:00 PM

Center for Architecture
536 LaGuardia Place
New York, NY 10012

**Leaning Out V:
Women in Academic
Leadership Now**

The Final Event of
the Global Dialogues
'Displacements' Series

Moderator
Mabel O Wilson
*Professor, Columbia
GSAPP;
Co-Director,
Global Africa Lab*

**Global Dialogue
Chairs**
Elie Gamburg
Director, KPF

Ben Gilmartin
Partner, DS+R

Event Chair
Hana Kassem
Principal, KPF

Speakers
J. Meejin Yoon
*Head of the
Department of
Architecture, MIT*

Michelle Addington
*Dean of The University
of Texas at Austin
School of Architecture*

Erika Hinrichs
*Chairperson of
Undergraduate
Architecture,
Pratt Institute*

Patrice Derrington
*Director of the
Center for Urban
Real Estate (CURE),
Columbia University
GSAPP*

1.5 CES credits available

LEANING
OUT V
WOMEN
IN
ACADEMIC
LEADERSHIP
NOW
JANUARY 11
6 ———— 8 PM
CENTER
FOR
ARCHITECTURE
NEW
YORK

AIA
New York

Design: W&CO

The
New
20's

The New 20s | UnknownDesign | João Machado Design

PASTPORT 67

Making Alabama Poster Series | Alabama Humanities Foundation | **Tatum Design**

Visit website to view full series

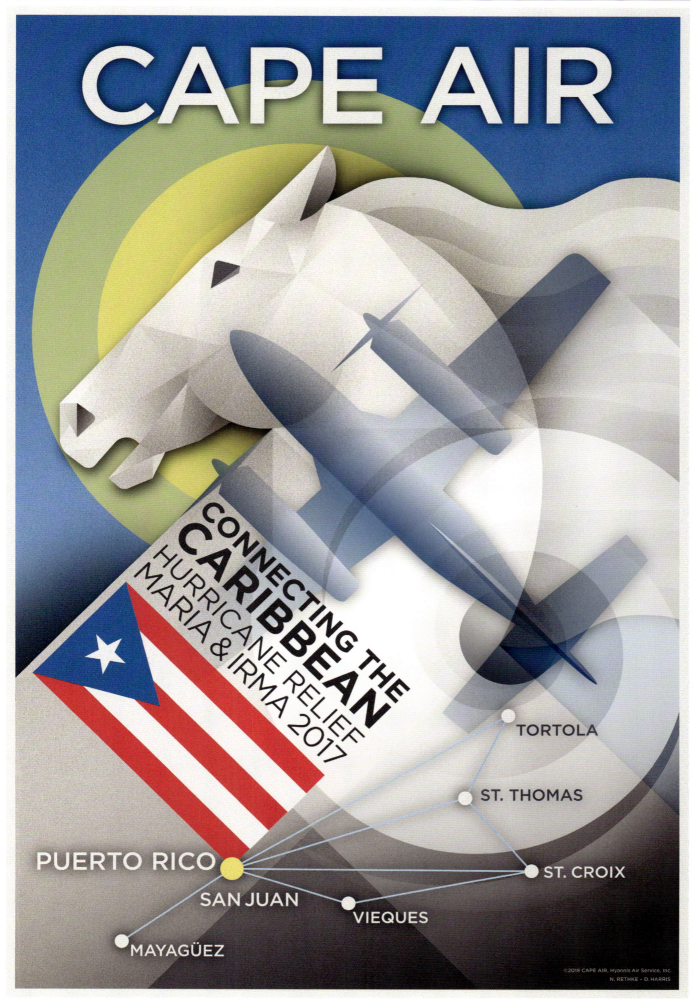

Cape Air: Connecting the Caribbean, Hurricane Relief, Maria & Irma 2017 | Cape Air, Hyannis Air Service, Inc. | **Photon Snow LLC**

The Legend Of Sleepy Hollow | Black Dragon Press | Peter Diamond Illustration

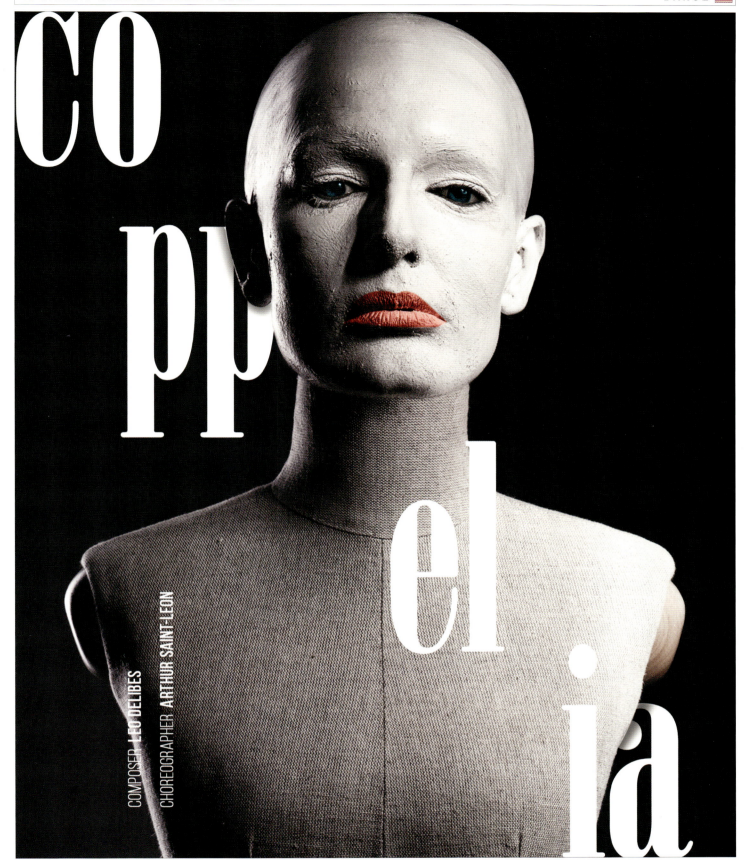

co pp el ia

COMPOSER LEO DELIBES

CHOREOGRAPHER ARTHUR SAINT-LEON

Produce the best beauty designer

Learn scientific skin care

Complete systematic practice

We create beauty
Department of Beauty Design, Woosuk University

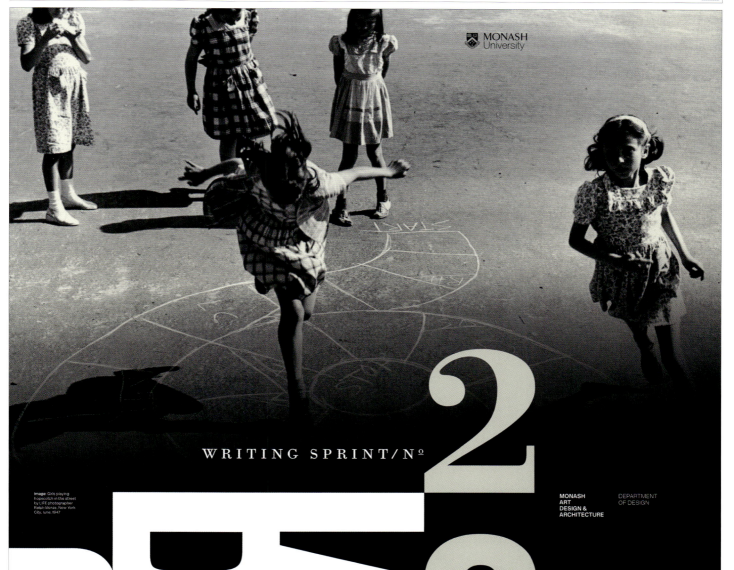

WRITING SPRINT/Nº **2**

MONASH University

MONASH ART DESIGN & ARCHITECTURE

DEPARTMENT OF DESIGN

DRaW

GATHERING

DRaW is pleased to announce the second writing sprint and panel discussion for 2018. As usual there will be time dedicated to writing—in a space away from your usual day so you can work on your writing with a group facilitator for support and a period for optional peer review and feedback with one another.

Immediately before the writing sprint is a chance to engage with some of our colleague's research and have lunch together.

Through a panel discussion we are hoping to relate some of our successes and failures, and share with other faculty members who have less experience in specific areas. For our second event we would like to invite you to the panel discussion, *Collecting data from workshops*

This event occurs during the Wonderlab intensive, and we look forward to welcoming both its local and international cohort to the discussion.

TOPIC:

Collecting data from workshops

—

Panel Discussion:
Tina Dinh
Alli Edwards
Ilya Fridman

Chair:
Gene Bawden

WORKSHOP

Friday 27 April 2018
Teaching Room 4
4th Floor, Caulfield Library
—
11:15—1:00:
Workshop data DRaW panel discussion
(Morning tea and lunch provided)
—
1:30—3:30:
Writing Sprint

DESIGN RESEARCH AND WRITING

DATA

DESIGN SUMMER 10

DESIGN SUMMER 10 IN HANGZHOU 2018 | DESIGN: KARI PIIPPO

中國科技大學 視覺傳達設計系108學年度碩士班甄試招生〈視覺傳達設計領域、數位媒體設計領域、文化創意設計領域、插畫繪本設計領域、數位音樂設計領域〉

China University of Technology Graduate Institute of Visual Communication and Design

報名時間 /
2018.11.19–12.14

推薦入學獎助學金>>台北校區**1**萬元、新竹校區**3**萬元（需於報名截止前交入學推薦表至招生中心，或上就讀意願填寫系統留下資料）
台北 **02-2931-3416#2126** 新竹 **03-699-1111#1010** **www.cute.edu.tw**

Design is language | China University of Technology | hufax arts

7 September
2018

hansung
university
design & arts
Institute
212, F1

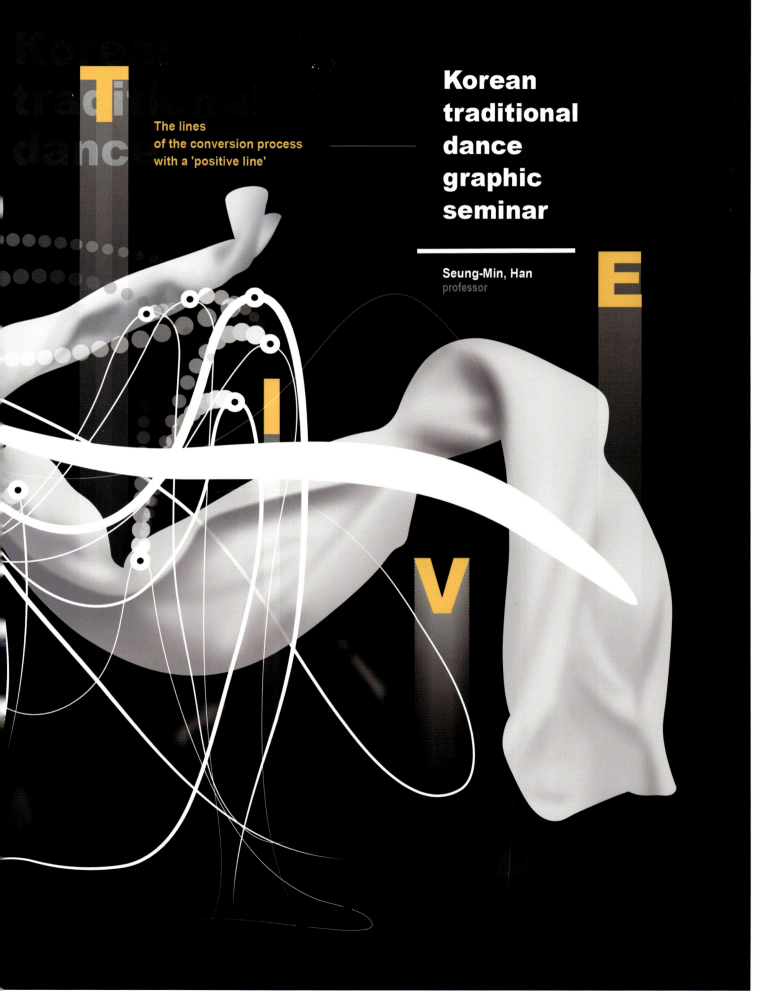

T
The lines
of the conversion process
with a 'positive line'

Korean
traditional
dance
graphic
seminar

Seung-Min, Han
professor

E

I

V

PERSON

CULTURE

September 9, 2019 >> 9.10. Andong Culture and Arts Center, Korea Mental Cultural Foundation
The 21st Korean Culture Forum will be held from September 5th to 10th. culture, tradition, Harmony, future, fusion.
It will be held at the Andong Culture and Arts Hall.
Traditional value participation sessions to communicate with citizens, people of world scholars, culture, tradition.
And 'Cultural Values Practice Session' of academic sessions.

The Korea Mental and Cultural Foundation holds this forum and conducts forum evaluations and surveys. The questionnaire surveyed and evaluated all four categories of participant classification, satisfaction analysis, major improvement opinions, and expert suggestions. The evaluation will raise the value of the forum's culture and tradition in the global era and propose various tasks in the various fields. We look forward to lots of participation from experts and the general public.

TRADITION

HARMONY

FUTURE

FUSION

21ST CENTURY KOREAN CULTURE FORUM

21st Century Korean Culture Forum | Korea Foundation for Cultures and Ethics | Woosuk University

齊天大聖
The Monkey King

GREAT SAGE EQUALLING HEAVEN

Great Sage Equalling Heaven Handsome Monkey King

Great Sage Equalling Heaven | Heiwa Court | Dalian RYCX Advertising Co., Ltd.

Fillmore Jazz Drummer | Steven Restivo Event Service, LLC | **Michael Schwab Studio**

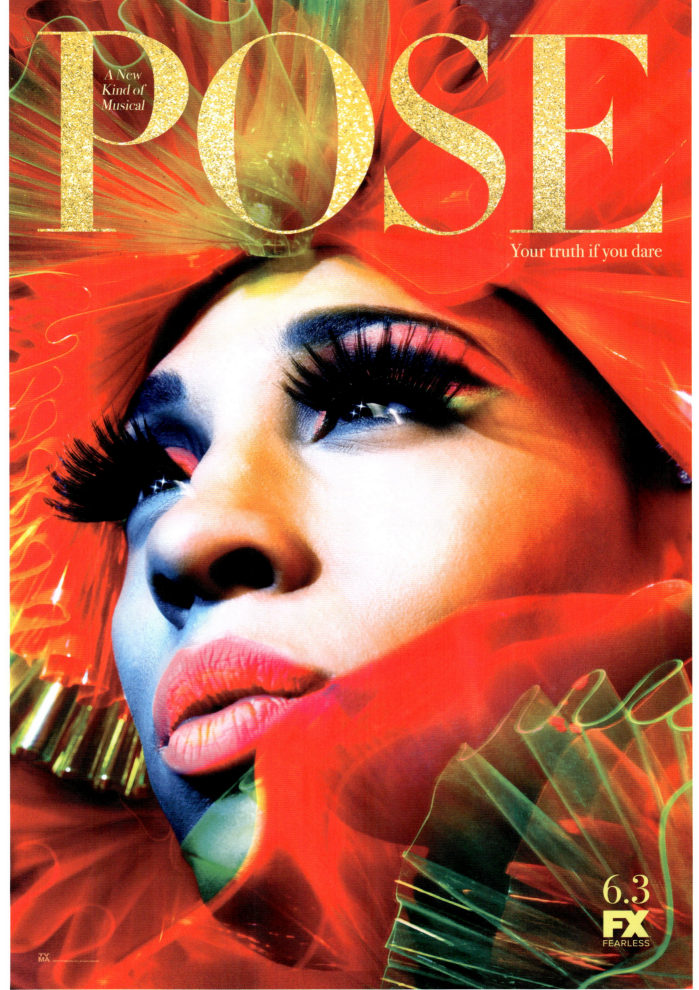

POSE

*A New
Kind of
Musical*

Your truth if you dare

6.3
FX
FEARLESS

Pose - Blanca | **FX Networks** | **Icon Arts**

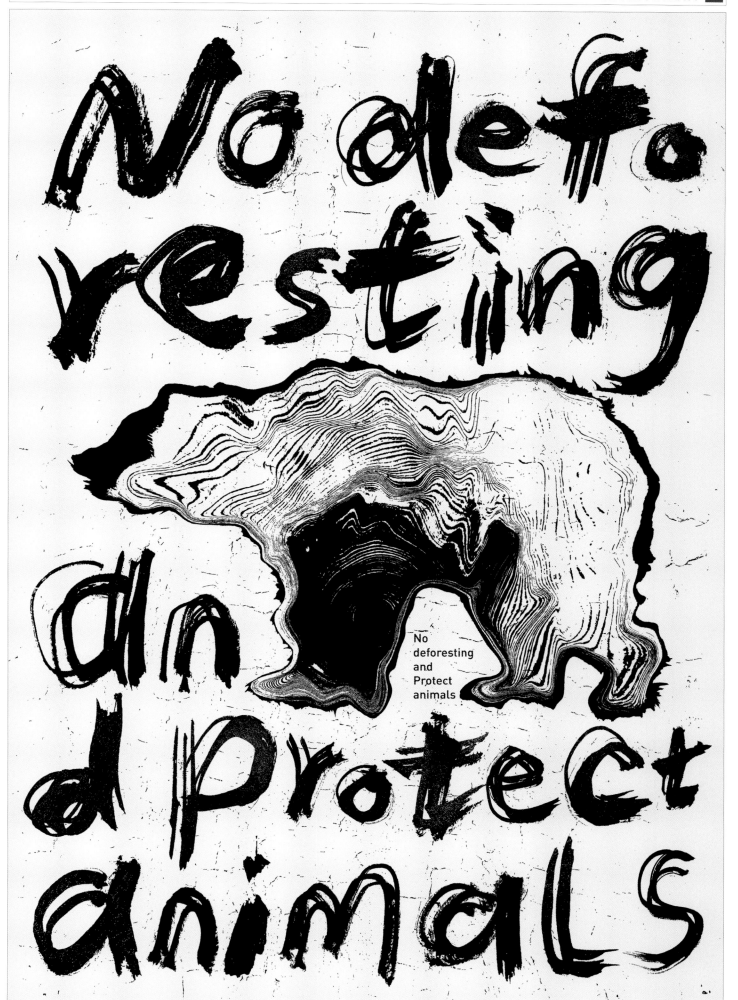

No
deforesting
and
Protect
animals

Water that has frozen has melted due to global warming The human being must live together with nature well.

LIFE&PEACE OF FROZEN 氷結

It is said that the birth of the life is from the sea Many lives have been suddenly lost by natural disasters so far.

golf
CHAMPIONSHIP
FLEISHMANHILLARD

September 16 | Norman K. Probstein Course in Forest Park | 7:30 am

The True Story of Ah Q | Japan Book Design Award 2018 | Daisuke Kashiwa

**2019 San Francisco
Antiquarian Book
Print & Paper Fair**®

February 9th—10th

Saturday 9am—6pm

Sunday 10am—5pm

South San Francisco

Conference Center

Exhibitors Featuring:

Antiquarian & Rare Books on

All Subjects • First Editions

• Modern Literature •

Manuscripts • Children's Books

• Illustrations & Art •

Antique & Modern Prints

• Vintage Photographs •

Posters • Autographs

• Postcards • Ephemera •

Maps & Exploration

• Gastronomy •

California & The West

• Typography

• Science Fiction

Nancy Johnson Events Management

$12 Admission • 650-773-4824 • sfbookandpaperfair.com

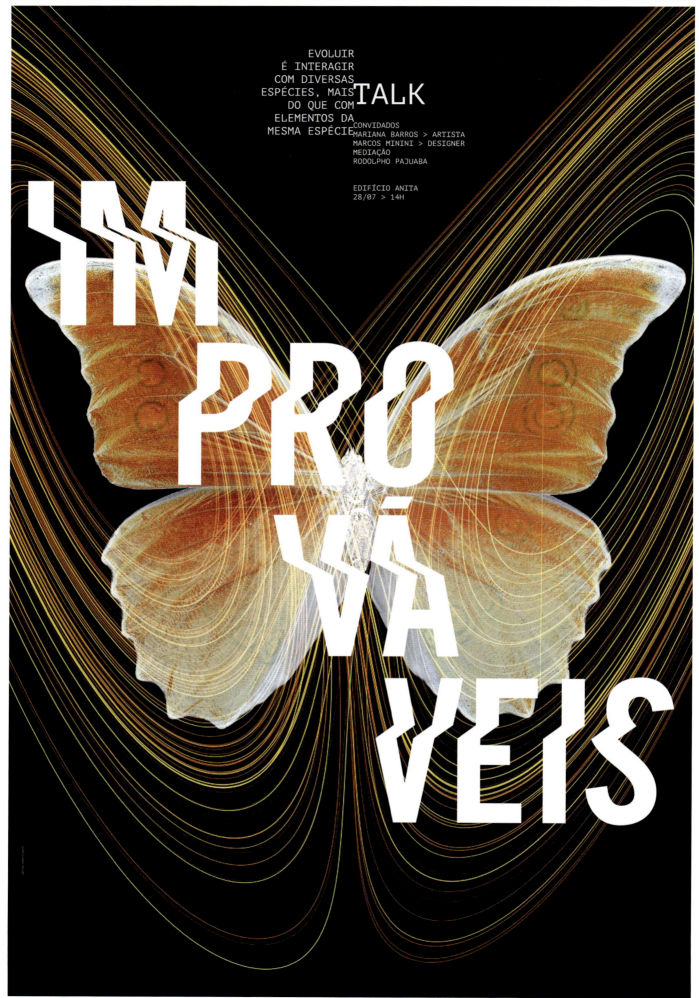

EVOLUIR
É INTERAGIR
COM DIVERSAS
ESPÉCIES, MAIS TALK
DO QUE COM
ELEMENTOS DA
MESMA ESPÉCIE CONVIDADOS
MARIANA BARROS > ARTISTA
MARCOS MININI > DESIGNER
MEDIAÇÃO
RODOLPHO PAJUABA

EDIFÍCIO ANITA
28/07 > 14H

IMPROVÁVEIS

The annual **HIGH SCHOOL** to **ART SCHOOL** Alumni **EXHIBITION** — Featured Artists: **EUGENE CHANG** (Parsons School of Design), **CHANTAL FEITOSA** (Rhode Island School of Design), **KIMBERLY YUNKER** (Cooper Union), **JANINE WANG** (Rhode Island School of Design), **PETER SHEEHAN** (Carnegie Mellon), **KEVIN CHAO** (Pratt Institute) **OPENING:** Saturday, 08.19 | 11AM–5PM at the **EXPERIMENTAL SPACE** at **REIS** studios **LOCATED AT:** 43-01 22nd St, 3rd FL, Long Island City, NY 11101 —

HS2AS

TIME & LOCATION
EXPERIMENTAL SPACE at **REIS** studios
43-01 22ND ST, 3RD FLOOR
LONG ISLAND CITY, NY 11101

ONE DAY ONLY
AUGUST 19
11AM – 5PM
REFRESHMENTS WILL BE SERVED

THIS EXHIBITION IS SPONSORED BY

Council on the Arts
The BILTON and SALLY ASCRP ARTS FOUNDATION, INC.
EUGENIA FOUNDATION
TWO WEST
The Pinkerton Foundation
conEdison
NYC Cultural Affairs
QCA

TDC Phenotypes Exhibition Poster | Type Directors Club | Attic Child Press, Inc.

Keep Moving

/ 50

Beyond | Toyama Invited Poster Exhibition | **Melchior Imboden**

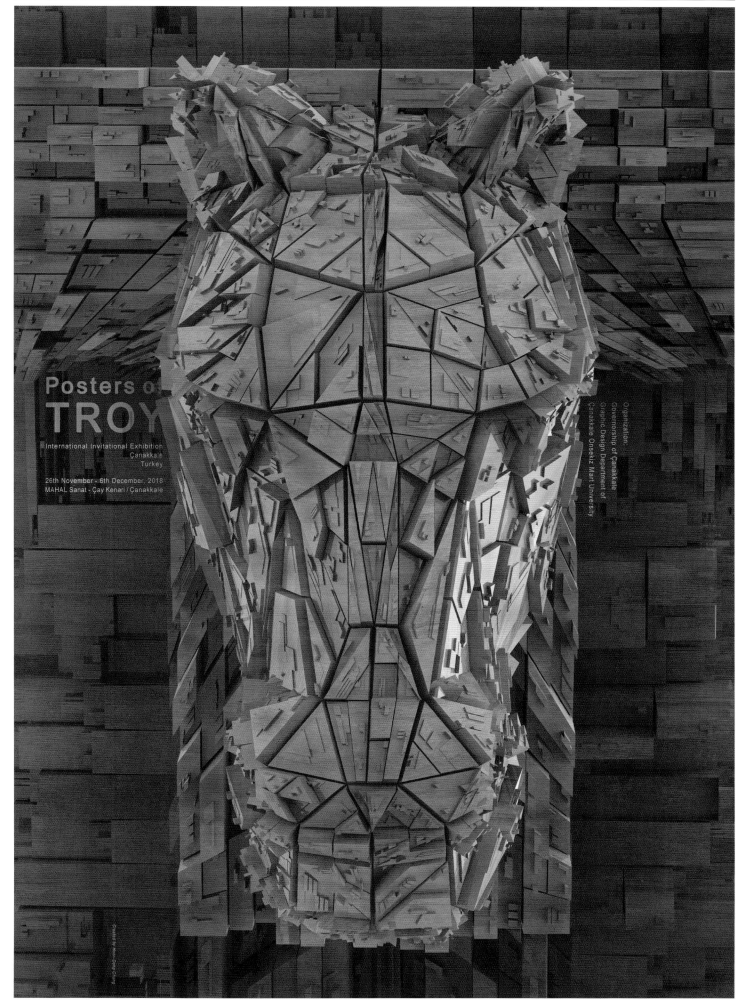

Posters of
TROY

International Invitational Exhibition
Çanakkale
Turkey

26th November - 6th December, 2018
MAHAL Sanat - Çay Kenarı / Çanakkale

Organization:
Governorship of Çanakkale
Graphic Design Department of
Çanakkale Onsekiz Mart University

Trojan Horse | Posters of Troy 2018 | **Dankook University**

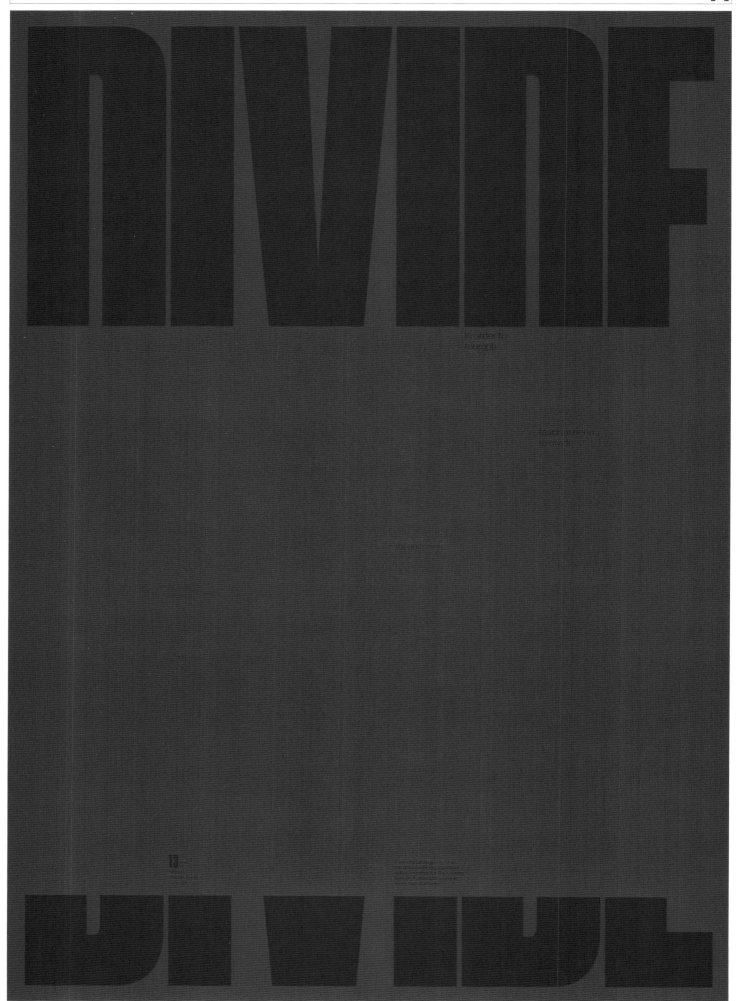

Stance: Design Against Fascism | **Sur Gallery** | **Underline Studio**

Visit website to view full series

City Face: Paris | **City Face Poster Design Exhibition** | **Creplus Design**

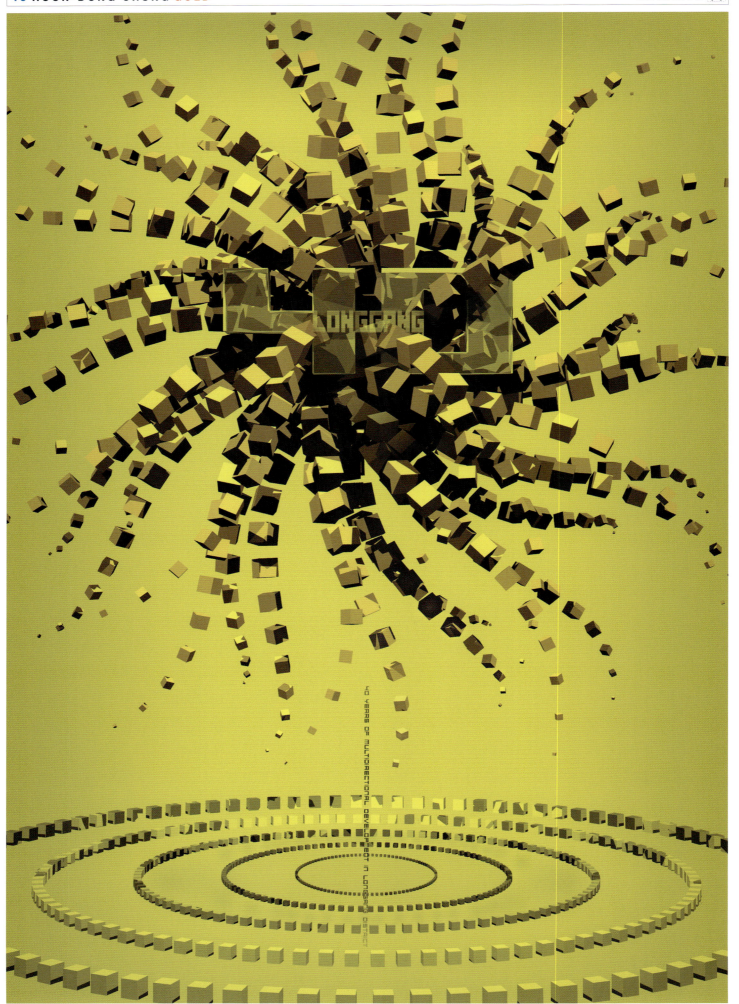

Longgang 40 | Hakka Impression International Poster Invitation Exhibition | **Dankook University**

Yossi Lemel

The Last Chassid of

האדמו"ר האחרון מראדומסק

Radomsko

Jan Koniarek Gallery
in Trnava, Slovakia
Synagogue - Center of
Contemporary Art,
Halenárska 2

Galéria Jána Koniarka
v Trnave, Synagóga -
Centrum súčasného umenia
Halenárska 2, Trnava

13.9.2018 - 25.11.2018

Trnavský samosprávny kraj
Self-governing Region of Trnava

fond
na podporu
umenia

Projekt z verejných zdrojov podporil Fond na podporu umenia
Supported using public funding by

Yossi Lemel The Last Chassid of Radomsko | Jan Koniarek Gallery, Trnava, Slovakia | **Yossi Lemel**

45TH TELLURIDE FILM FESTIVAL

TELLURIDE, CO. AUG. 31 – SEPT. 3, 2018

45th Telluride Film Festival | Telluride Film Festival | **Pirtle Design**

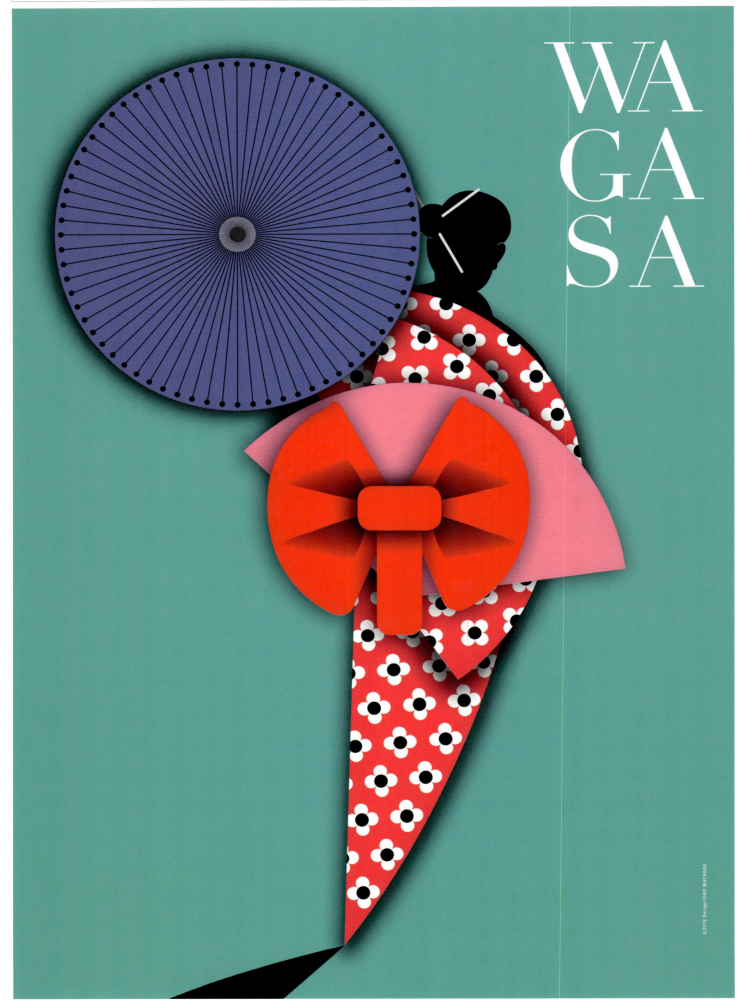

WA
GA
SA

©2018 Design/JOÃO MACHADO

29.07.2018
—

Batalla de Flors

#GranFiraVLC
granfiravalencia.com

Gran
Fira de
València

Juliol
2018

Your West Stole My East Away | Typomania Moscow | **Ariane Spanier Design**

KADIKÖY MURAL FESTİVALİ 2018

ARTEZ
[SIRBİSTAN]

LONAC
[HIRVATİSTAN]

JUNE
18
HAZİRAN
—
JULY
08
TEMMUZ

ARLIN
[BREZİLYA]

OMERIA
[TÜRKİYE]

Poster Design | Erman Yılmaz 2018

#muralistanbul

MURAL ISTANBUL FESTIVAL

www.
muralistanbul.
org

Kadıköy Mural Festivali süresince sanatçıların canlı performans tarihleri ve lokasyon bilgileri için web sitemizi ve sosyal medya hesaplarımızı takip etmeyi unutmayın.

mtn
montana colors

K KADIKÖY BELEDİYESİ

SKUPI

International
Theatre
Festival
2018

skupi**festival**
international theatre festival

24-30
October

MKC Skopje

skupifestival.org.mk

Beyond the barriers...

Министерство за култура
Ministria e kulturës

Koha

MPT

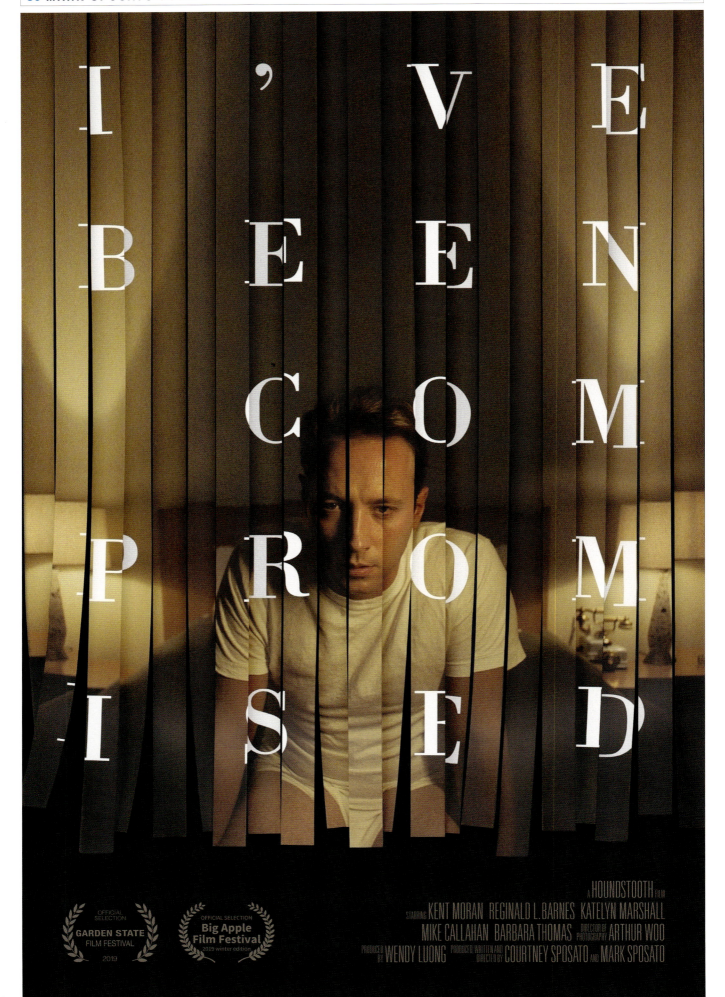

I've Been Compromised | **Houndstooth Studios** | **Mark Sposato Graphic Design**

NARRATOR **ADAM DRIVER** VOICE OF PULITZER **LIEV SCHREIBER**

AMERICAN MASTERS PICTURES PRESENTS A FILM BY **OREN RUDAVSKY**

JOSEPH PULITZER

voice of the people

"OUR REPUBLIC AND ITS PRESS WILL RISE AND FALL TOGETHER"

FOLIUM FILMS AND OREN RUDAVSKY PRODUCTIONS FOR AMERICAN MASTERS PICTURES PRESENTS JOSEPH PULITZER: VOICE OF THE PEOPLE NARRATOR ADAM DRIVER VOICE OF PULITZER LIEV SCHREIBER FEATURED VOICES LAUREN AMBROSE, RACHEL BROSNAHAN, HUGH DANCY, RYAN JAMES HATANAKA, BILLY MAGNUSSEN, TIM BLAKE NELSON, SEBASTIAN STAN ASSOCIATE PRODUCER CLARE REDDEN GRAPHICS ANDREW ROBERTS COMPOSERS OLIVIER & CLARE MANCHON EDITOR RAMON RIVERA MORET DIRECTOR OF PHOTOGRAPHY WOLFGANG HELD WRITERS ROBERT SEIDMAN & OREN RUDAVSKY PRODUCERS ANDREA MILLER, OREN RUDAVSKY & ROBERT SEIDMAN DIRECTOR OREN RUDAVSKY CASTING ADRIENNE STERN CASTING FOR AMERICAN MASTERS SUPERVISING PRODUCER JUNKO TSUNASHIMA SERIES PRODUCER JULIE SACKS EXECUTIVE PRODUCER MICHAEL KANTOR

FUNDERS NATIONAL ENDOWMENT FOR THE HUMANITIES, ROXANNE & SCOTT BOK, CARNEGIE CORPORATION OF NEW YORK, NORMAN PEARLSTINE & JANE BOON, DAVID & HOPE JEFFREY, JAMES SYKES

Joseph Pulitzer, Voice of the People | Oren Rudavsky Productions, American Masters Pictures | **IF Studio**

Bill-E's — Pigtails Campaign | Bill-E's | Lewis Communications

Visit website to view full series

nipponbebidas.com.br

Nippon
Japanese beverages
and food.

Mi Campo Tequila "Papel Picado" Poster (18x24 inches) | Mi Campo/Constellation Brands | **Sandstrom Partners**

Ager Palmensis | Fonti di Palme | Andrea Castelletti

Universität
Zürich[UZH]

9.11.2018 — 31.3.2019

»Exekias
hat mich gemalt
und getöpfert«

Archäologische Sammlung
der Universität Zürich

Dienstag bis Freitag 13 – 18 Uhr
Samstag und Sonntag 11 – 17 Uhr
Montag und allgemeine Feiertage geschlossen
Rämistrasse 73
8006 Zürich

SO
OO

OCT The Senses: Design Beyond Vision
THU 26 Cooper Hewitt Smithsonian Design Museum
2 East 91st

Studio Out of Office | **Self-initiated** | **Superunion**

Tribute to Art Blakey · 1919-1990

31ST AARHUS JAZZ FESTIVAL 13-20 JULY 2019 JAZZFEST.DK

Jazz 2019 Art Blakey | Aarhus International Jazz festival | Finn Nygaard

Akademie Konzerte

Nationaltheater-
Orchester
Mannheim

Soddy

Brahms

01./02.10.

Mo, 01. & Di, 02.
Oktober 2018
20 Uhr, Rosengarten

Alexander Soddy Dirigent
Augustin Hadelich Violine

Anton Webern Passacaglia
Felix Mendelssohn Bartholdy Violinkonzert
Johannes Brahms Symphonie Nr. 1

Infos und Karten:
0621 26044
musikalische-akademie.de

Academy Concerts 1-7 Season 2018/19 I Orchestra of the National Theatre Mannheim I Ariane Spanier Design

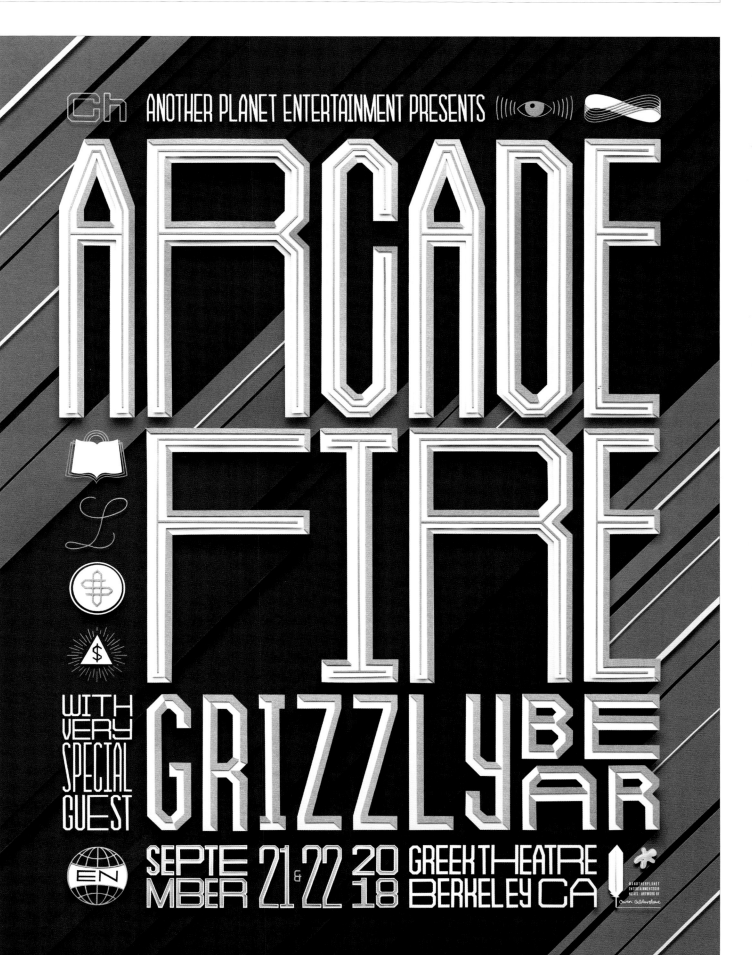

Arcade Fire Poster | Another Planet Entertainment | Owen Gildersleeve

19.09
18:00

ХУДОЖНІЙ КЕРІВНИК ТА
ГОЛОВНИЙ ДИРИГЕНТ
НАРОДНИЙ АРТИСТ УКРАЇНИ
ЮРІЙ КУРАЧ

УКРАЇНСЬКИЙ
КУЛЬТУРНИЙ
ФОНД

МІНІСТЕРСТВО
КУЛЬТУРИ УКРАЇНИ

ДО 100-РІЧЧЯ ЗАСНУВАННЯ –
НАЦІОНАЛЬНА ЗАСЛУЖЕНА
КАПЕЛА БАНДУРИСТІВ УКРАЇНИ
ІМЕНІ ГЕОРГІЯ МАЙБОРОДИ

ДНІПРО-
ПЕТРОВСЬКА
ФІЛАРМОНІЯ

ВУЛ. ВОСКРЕСЕНСЬКА 6, М. ДНІПРО

is

woman

14th international Festival
Jazz in the Ruins
3–19th August 2018
jazzwruinach.pl

Jazz is woman | Jazz in the Ruins | Wheels & Waves

Love. Honour. Obey.
Forced into marriage,
is madness Lucia's
only escape?

Lucia di Lammermoor

Donizetti's unforgettable story, in English
25 October – 5 December at London Coliseum
Tickets from £12 plus booking fee* at eno.org

English National Opera

ENO

ARTS COUNCIL
ENGLAND

*£1.50 fee per ticket up to a maximum of £6 per transaction applies to online and telephone bookings
Words by Andy Rigden Photography by Phil Fisk Art direction and design by Rose

Vincenzo Bellini

I puritani

Rambow 2018

PREMIERE: SONNTAG, 2. DEZEMBER 2018
WEITERE VORSTELLUNGEN:
6., 8., 14., 16., 21., 26., 28. DEZEMBER 2018
4., 12., 18. JANUAR 2019
TICKETS 069 212 49 49 4

Oper Frankfurt

Der fliegende Holländer (The Flying Dutchman) | Sommeroper Selzach | **Stephan Bundi**

Krol Roger | Oper Frankfurt | Gunter Rambow

JUGULAR

MODEL MELANIE GAYDOS

PHOTOGRAPHER NINA HAWKINS

STYLING ORETTA CORBELLI

MAKEUP ELENA BRACKS

FIRST ISSUE COMING SOON

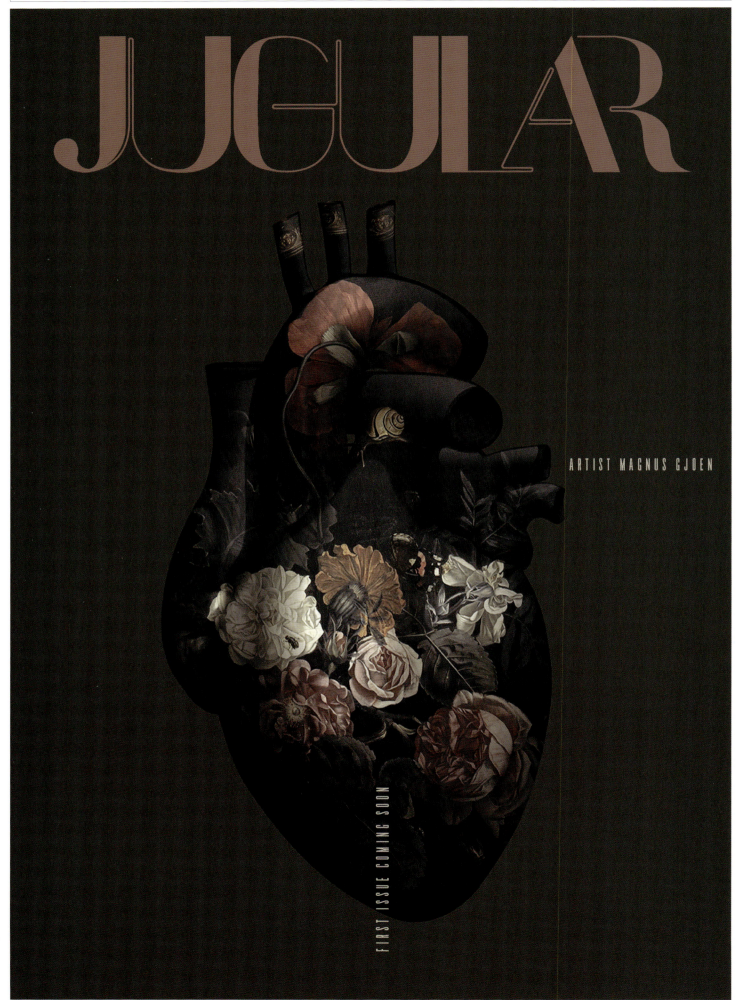

JUGULAR

ARTIST MAGNUS GJOEN

FIRST ISSUE COMING SOON

MODEL YANA DOBROLIUBOVA

PHOTOGRAPHY MAX ZAMBELLI

FIRST ISSUE COMING SOON

ARTIST RUBY RUMIÉ

FIRST ISSUE COMING SOON

JUGULAR

AN ANTIDOTE TO BOREDOM

SCALE OF BOREDOM

J
1
2
3
4
5
6
7
8
9
10
11
12
13
14
15
16
17
18
19
20
21
22
23
24
25
26
27
28
29
30
31
32
33
34
35
36
37
38
39
40
41
42
43
44
45
46
47
48
49
50
51
52
53
54
55
56
57
58
59
60
61
62
63
64
65
66
67
68
69
70
71
72
73
74
75
76
77
78
79
80
81
82
83
84
85
86
87
88
89
90
91
92
93
94
95
96
97
98
99

BOREDOM

NETWORKING
CONTOURING
PET GROOMING
STREAMING
TAXES
ZIKA
TROLLS
HIGH FIBER DIET
FARM-TO-TABLE
NO SUGAR
JUICING
NO DAIRY
BAILOUTS
WALL
KLEPTOCRACY
IRRELEVANT
DEPRESSION
REPETITIVE

SUCCULENTS
COLD-PRESSED
TELEVISION
FLOSSING
CRITICISM
KARDASHIAN
NEPOTISM
SCRAPBOOKING
FLOWER WREATHS
BREXIT
KALE
ART FAIRS
STREAMING
MAKE AMERICA GREAT AGAIN
HAIR EXTENSIONS

ISSUE N°1

DELIVER ACCEPTANCE SPEECH.

DELIVER WINNING IDEA.

DELIVER GREAT WORK.

DELIVER PIZZAS.

WIN PENCIL
DRAW RESPECT
ENTER NOW

Win Pencil, Draw Respect Campaign | One Show | Zulu Alpha Kilo Visit website to view full series

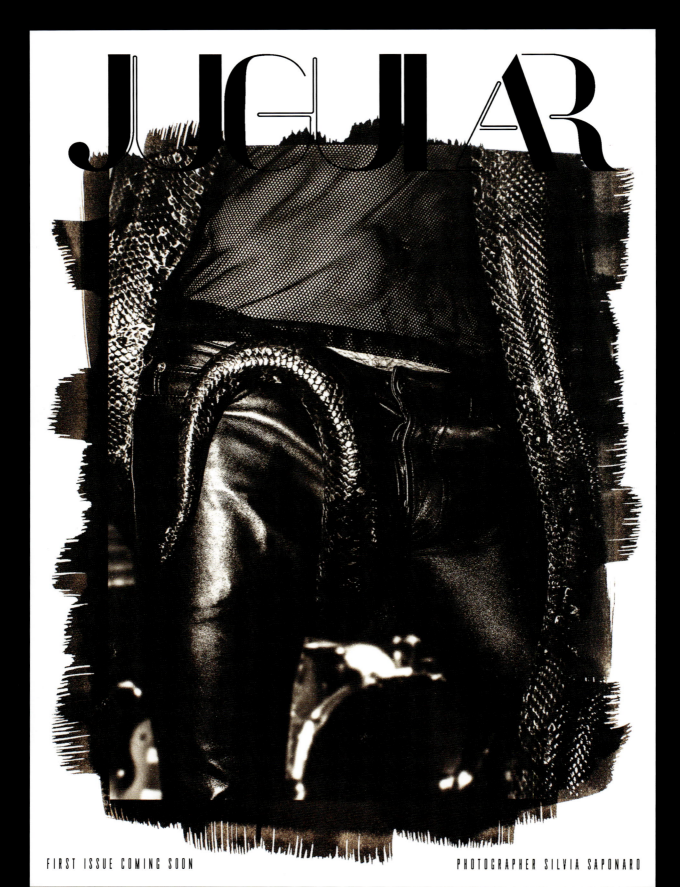

JUGULAR

"For some time past, though at intervals only, the unaccompanied, secluded White Whale had haunted those uncivilized seas mostly frequented by the Sperm Whale fishermen."

www.belafisterra.com

"MOBY DICK" HERMAN MELVILLE

Bela Fisterra Posters | Pepe Formoso, Bela Fisterra | **xosé teiga, studio.**

Visit website to view full series

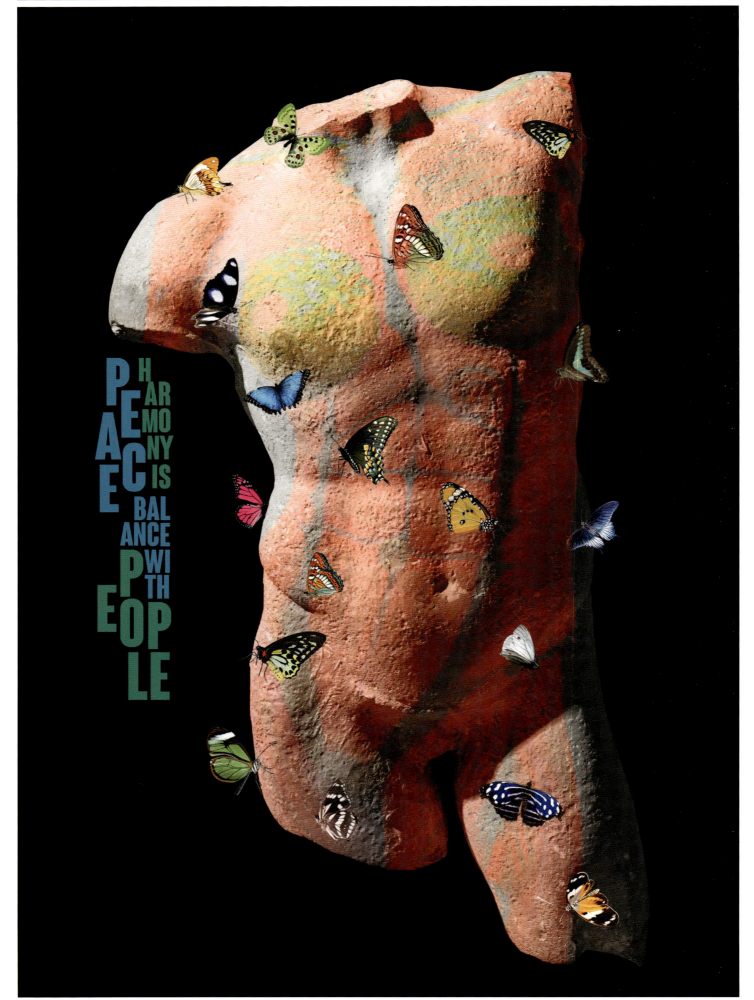

PEACE

HARMONY IS BALANCE WITH PEOPLE

Harmony is peace. Balance with people. | Peace Museum in Tehran | Namseoul University

Gerechtigkeit liegt im Auge der Entfremdeten (Equity Is in the Eye of the Disenfranchised) | Creative Reaction Lab | **The Chris Aguirre**

THE RACE
FOR ANYONE WHO LOVES
MIRACLE
ENDINGS

3RD ANNUAL
KENTUCKY DERBY PARTY
TO BENEFIT **ALS ASSOCIATION WISCONSIN CHAPTER**
AND **THE MS SOCIETY WISCONSIN CHAPTER**

MAY 5, 2018 · 3:30–9:00PM
PAUL DAVIS RESTORATION BOAT HOUSE
2000 SOUTH 4TH ST · MILWAUKEE
TICKETS: $**50** IN ADVANCE
$60 AT THE DOOR

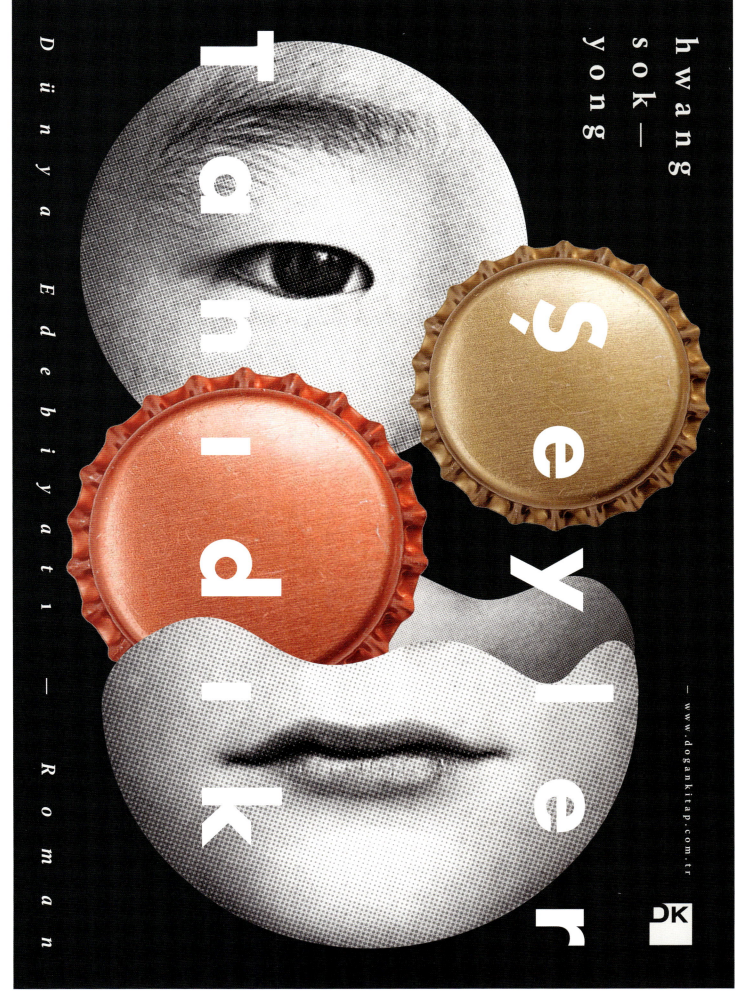

hwang
sok—
yong

Tanıdık Şeyler

Dünya Edebiyatı — Roman

— www.dogankitap.com.tr

DK

Crucifixion | Self-initiated | Steiner Graphics

Europawahl 2019

Rambow 2018

Wählt die Schatten weg!

European Election 2019 - Vote against shadows | Edition Galerie Rambow | Gunter Rambow

PEKKA LOIRI 2018

50 years since the book The Gulag Archipelago ★ 100 years anniversary of Aleksander Solzhenitsyn

Toleranssia.

DESIGN. KARI PIIPPO 2010

The Great Wave | Self-initiated | **Andrew Sloan**

INDIFFERENCE

Difference | UnknownDesign | **João Machado Design**

SOUTH AFRICAN

CHINESE

ISRAELI

IRANIAN

AMERICAN

VIETNAMESE

NIGERIAN

GERMAN

SERBIAN

KENYAN

RUSSIAN

JAPANESE

YEMENITE

SWEDE

CONGOLESE

FRENCH

LIBERIAN

ENGLISH

NORTH KOREAN

KIT HINRICHS, UNITED STATES OF AMERICA

TOLERANCE

Tolerance | Mirko Ilic | Studio Hinrichs

BE AWARE OF TROJAN HORSE IN THE MIDDLE EAST

Trojan Horse | **Çanakkale University** | **Dogan Arslan Studio**

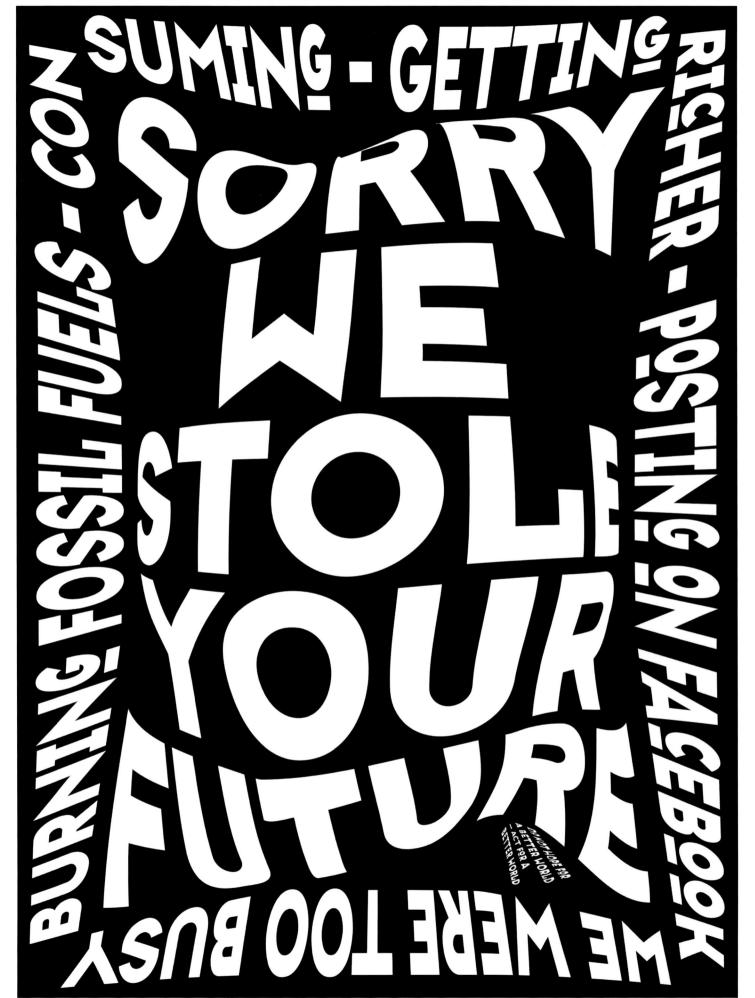

Sorry We stole your Future | The 5th Annual Alborz Graphic Design Exhibition | **Wheels & Waves**

PEKKA LOIRI 2018

DISCUSSIONS ABOUT DISCUSSIONS

Peace lives forever

Peace lives forever | The International Poster Contest Dedicated to the Victory Day in World War | **ZhaoChao Design**

その先に見えるもの。

DESTINATION

DESTINATION | Chubu Creators Club | **Toyotsugu Itoh Design Office**

Ovidiu Hrin // Romania

National Endurance Barefoot Water Ski Championships • August 25-26, 2018 • Crandon, WI

St. Louis Polo Club Poster | St. Louis Polo Club | **Ted Wright Illustration & Design**

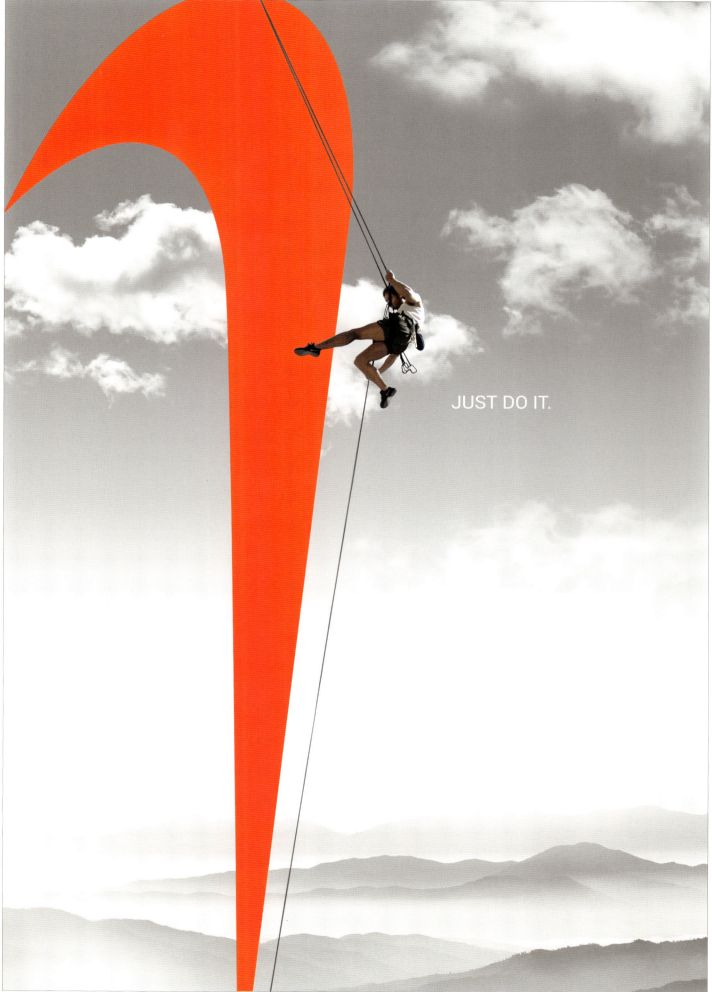

JUST DO IT.

Nike Poster | **Nike** | **Creplus Design**

Visit website to view full series

THE ROOMMATE

JEN SILVERMAN DEUTSCHSPRACHIGE ERSTAUFFÜHRUNG

THEATERRE

SOLOTHURN AB 19|09|2018
BIEL BIENNE AB 29|09|2018

LE BAL

NACH EINER IDEE DES THÉÂTRE CAMPAGNOL
D'APRES UNE IDÉE DU THÉÂTRE CAMPAGNOL
SCHWEIZER ERSTAUFFÜHRUNG/CRÉATION SUISSE

THEAT**ER RE**
SOLOTHURN AB 15|12|2018
BIEL BIENNE AB/DES LE 05|01|2019

Design: Stephan Bundi

Le Bal (Dancing Hall) | TOBS Theater Orchester Biel Solothurn | Stephan Bundi

Nho Oharagoko | DANCE WEST | OGAWAYOUHEI DESIGN

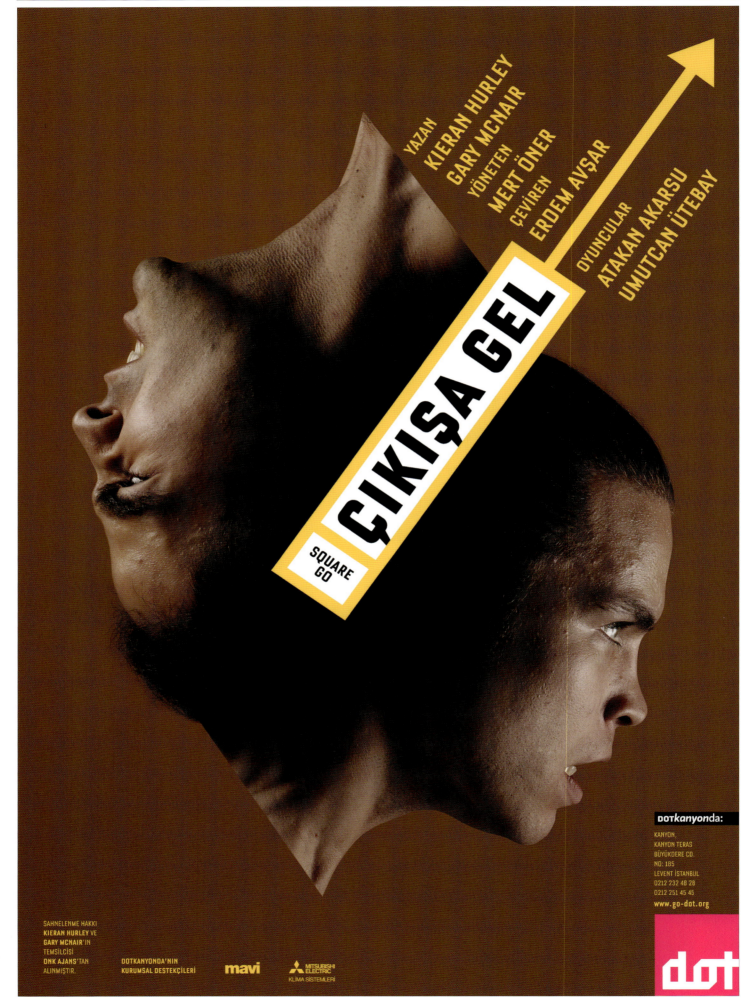

YAZAN
KIERAN HURLEY
GARY MCNAIR
YÖNETEN
MERT ÖNER
ÇEVİREN
ERDEM AVŞAR
OYUNCULAR
ATAKAN AKARSU
UMUTCAN ÜTEBAY

SQUARE GO
ÇIKIŞA GEL

DOTkanyonda:
KANYON,
KANYON TERAS
BÜYÜKDERE CD.
NO: 185
LEVENT İSTANBUL
0212 232 48 28
0212 251 45 45
www.go-dot.org

SAHNELENME HAKKI
KIERAN HURLEY VE
GARY MCNAIR'İN
TEMSİLCİSİ
ONK AJANS'TAN
ALINMIŞTIR.

DOTKANYONDA'NIN
KURUMSAL DESTEKÇİLERİ

mavi

MITSUBISHI
ELECTRIC
KLİMA SİSTEMLERİ

dot

Square go | DOT Theatre | H.Tuncay Design

DUET PËR NJË

NGA TOM KEMPINSKI

REGJISOR: **KUSHTRIM BEKTESHI**
SKENOGRAF: **BETIM ZEQIRI**
KOSTUMOGRAFE: **SAMKA FERRI**
E PËRKTHEU: **AGON MYFTARI**

ДУЕТ за ЕДЕН / DUET for ONE

TEATRI SHQIPTAR SHKUP
АЛБАНСКИ ТЕАТАР СКОПЈЕ

LUAJNË: **VEBI QERIMI** DHE **VJOLLCA BEKTESHI-HAMITI**

Министерство за култура
Ministria e kulturës

Eggra © NGADHNJIM MEHMETI 2024

✝THE CRUCIBLE

PLAY BY **ARTHUR MILLER**

DIRECTED BY **KARL KIPPOLA** THE CRUCIBLE IS PRESENTED BY SPECIAL ARRANGEMENT WITH DRAMATISTS PLAY SERVICE, INC., NEW YORK.

STUDIO THEATRE | KATZEN ARTS CENTER

OCTOBER 4 & 5 AT 8PM
OCTOBER 6 AT 2PM & 8PM

TICKETS | $15 REGULAR ADMISSION | $10 AU COMMUNITY AND SENIORS

202-885-ARTS AMERICAN.EDU/AUARTS

AU COLLEGE *of* ARTS & SCIENCES

Family Evolution | Worldwide Graphic Designers (WGD) | **Troxler Scott**

Love — Take 5 | Self-initiated | **Steiner Graphics**

MICHAEL SCHWAB

Premier Properties | Premier Properties | **Michael Schwab Studio**

RIKKE HANSEN

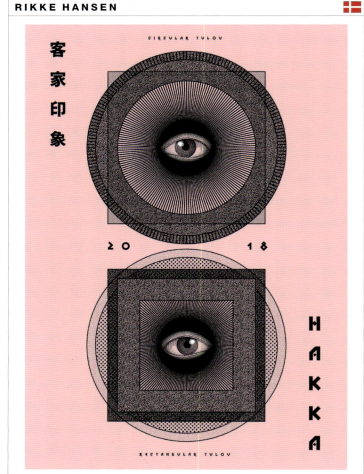

Hakka Impression | Shenzhen Int'l Poster Festival, China | **Wheels & Waves**

VIJAY MATHEWS

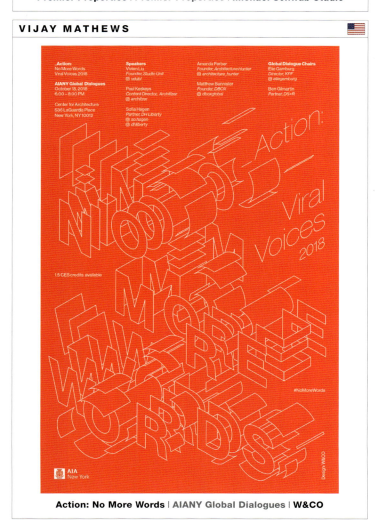

Action: No More Words | AIANY Global Dialogues | **W&CO**

MICHAEL SCHWAB

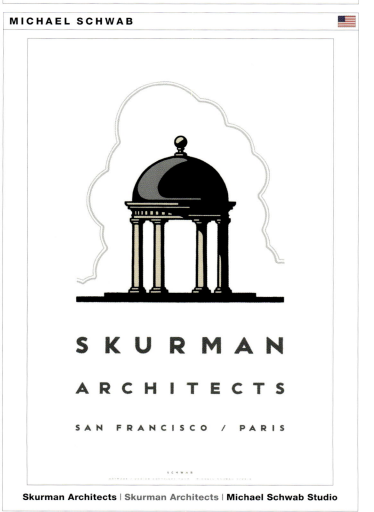

Skurman Architects | Skurman Architects | **Michael Schwab Studio**

SEAN FADEN

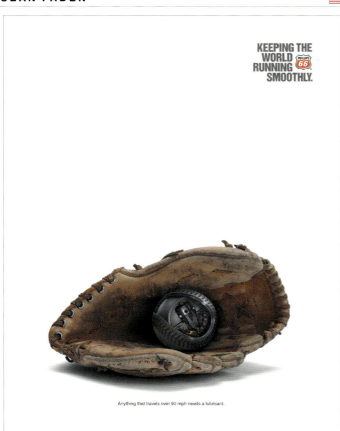

Phillips 66 International Stadium Poster
Phillips 66 | **Bailey Lauerman**

SPENCER TILL

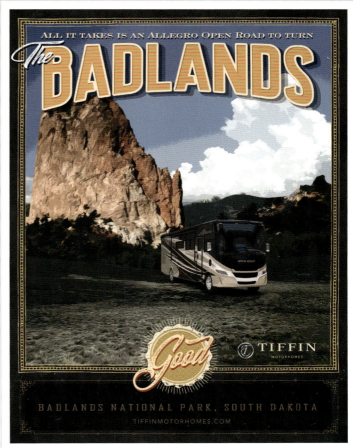

Tiffin Motorhomes — Dealer Show Poster Campaign
Tiffin Motorhomes | **Lewis Communications**

CARTER WEITZ

Bosch International Aerotwin UK Poster
Bosch International | **Bailey Lauerman**

TOPPAN PRINTING CO., LTD.

2019 BRIDGESTONE POSTER CALENDAR "AGS"
BRIDGESTONE CORPORATION | **Toppan Printing Co., Ltd.**

MARKHAM CRONIN

70 Years of Porsche - Latin America Country Posters
Porsche Latin America | **Markham & Stein**

PETER DIAMOND

Die Nibelungen
Black Dragon Press | **Peter Diamond Illustration**

JOHN GRAVDAHL

Year of the Pig | Self-initiated | **John Gravdahl Design**

JOÃO MACHADO

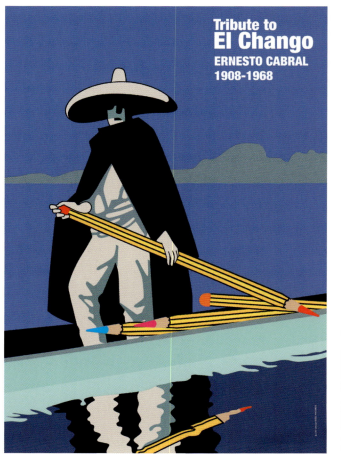

El Chango | Bienal Int'l Del Cartel En México (BICM) | **João Machado Design**

WIESLAW GRZEGORCZYK

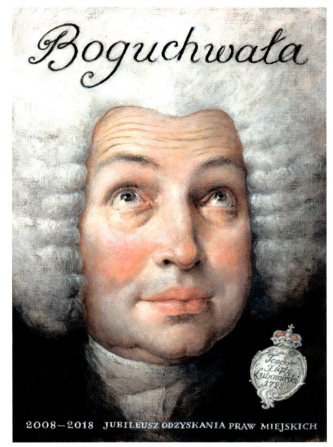

Boguchwala, 2008–2018, The Anniv. of the Reestablishment of the Town
Municipal Public Library in Boguchwala | **Wieslaw Grzegorczyk**

CHASPER WÜRMLI

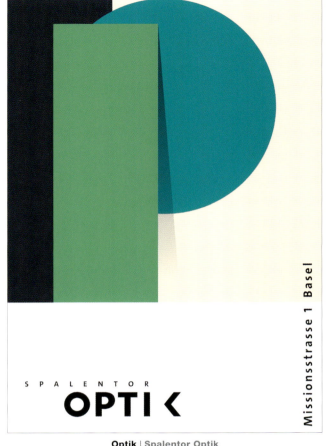

Optik | Spalentor Optik
Atelier Chasper Würmli

ORSAT FRANKOVIC

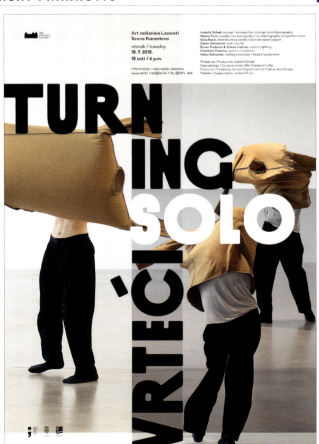

TURNING SOLO | Art Workshop Lazareti
Flomaster

J DAVID DEAL

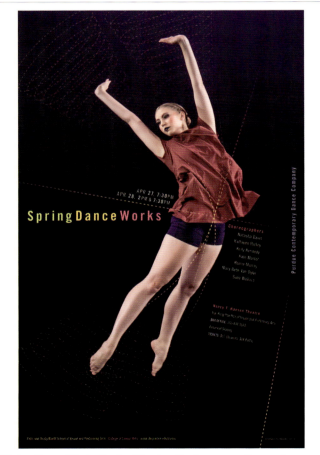

Winter Dance Works Poster | Purdue Contemporary Dance Company
J David Deal Graphic Design

J DAVID DEAL

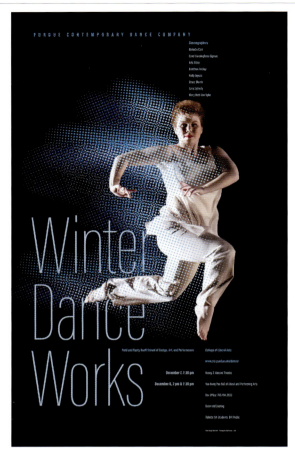

Winter Dance Works Poster | Purdue Contemporary Dance Company
J David Deal Graphic Design

YVONNE CAO

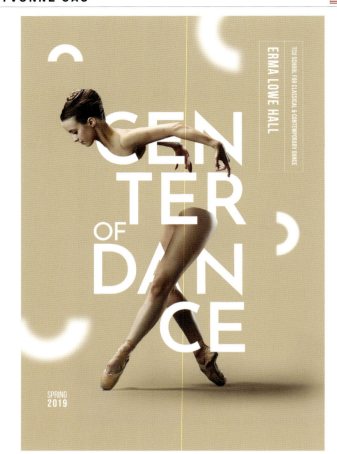

Center of Dance | Texas Christian University
CAO Design

TAKASHI AKIYAMA

Student Conference 2018 "Deformer"(Fire)
Tama Art University Illustration Studies | Takashi Akiyama Studio

TAKASHI AKIYAMA

Tama Art Univ. Postgraduate Illustration Studies, Graduate Exhibition 2018
Tama Art Univ. Postgraduate Illustration Studies | Takashi Akiyama Studio

ANNIE KOZAK, JEE-EUN LEE 🇺🇸

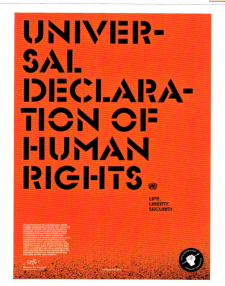

Universal Declaration of Human Rights Poster
Arte | ThoughtMatter

TAKASHI AKIYAMA 🇯🇵

Student Conference 2018 "Deformer" (Dogs)
Tama Art Univ. Illus. Studies | Takashi Akiyama Stu.

ART COLLART 🇳🇱

De Moestuin (The Vegetable Garden)
Villa Zebra | Art Collart Office

RANDY CLARK 🇺🇸

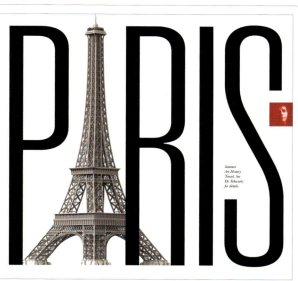

**Paris | MGC School of Design, Wenzhou Kean University
Randy Clark**

SEUNG MIN HAN 🇰🇷

**Thinking Real | Self-initiated
Hansung University Design & Arts Institute**

D. MACCORMACK, P. MCELROY 🇺🇸

Tyler School of Art - Japan Workshop
Tyler School of Art | 21XDESIGN

TIVADAR BOTE 🇨🇦

Year of the Dog Grad Poster
Alberta Coll. of Art & Design | Tivadar Bote Illus.

SARAH EDMANDS MARTIN 🇺🇸

Open Studios Promotional Poster
Indiana Univ. | Sarah Edmands Martin Designs

TAKASHI AKIYAMA ●

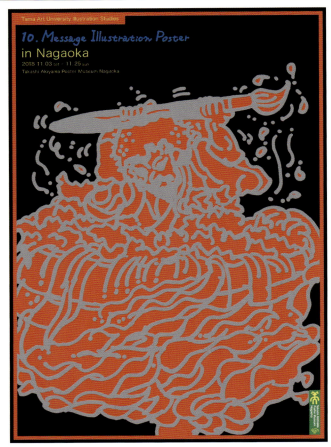

10. Message Illustration Poster in Nagaoka
Tama Art University Illustration Studies | **Takashi Akiyama Studio**

TAKASHI AKIYAMA ●

16. Message Illustration Poster 2018
Tama Art University Illustration Studies | **Takashi Akiyama Studio**

ARSONAL 🇺🇸

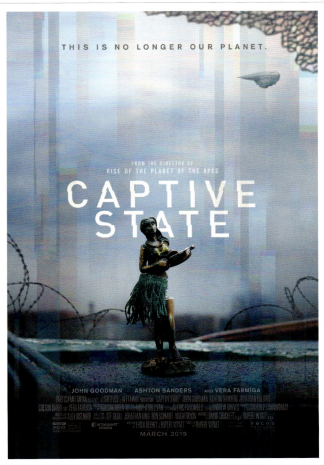

Captive State | Focus Features | **ARSONAL**

COLD OPEN 🇺🇸

Get Shorty - Season 2 | Epix | **Cold Open**

ARSONAL

Tully | Focus Features | **ARSONAL**

ARSONAL

Bobcat Goldthwait's Misfits & Monsters | truTV | **ARSONAL**

FX NETWORKS/ARSONAL

Pose - Elektra | FX Networks | **ARSONAL**

COLD OPEN

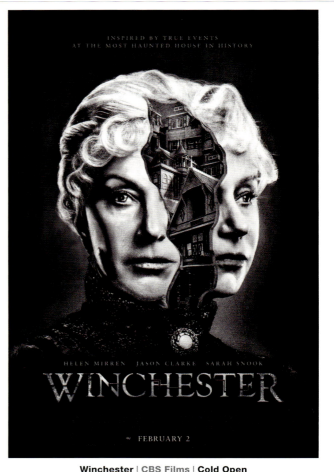

Winchester | CBS Films | **Cold Open**

COLD OPEN

The Nutcracker and the Four Realms | Walt Disney Co. | Cold Open

TOMMY GARGOTTA, TOM MORRISSEY

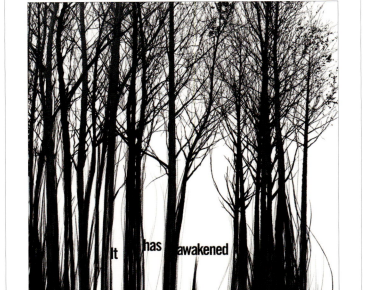

Season 2 Key Art for The Exorcist on Fox | Fox Broadcast Network | Fox

ARSONAL

Captive State | Focus Features | ARSONAL

COLD OPEN

Troy: Fall of a City | Netflix | Cold Open

ARSONAL

COLD OPEN

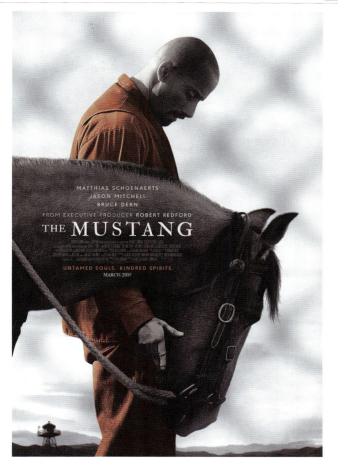

The Mustang | Focus Features | ARSONAL

Maniac | Netflix | Cold Open

TED WRIGHT

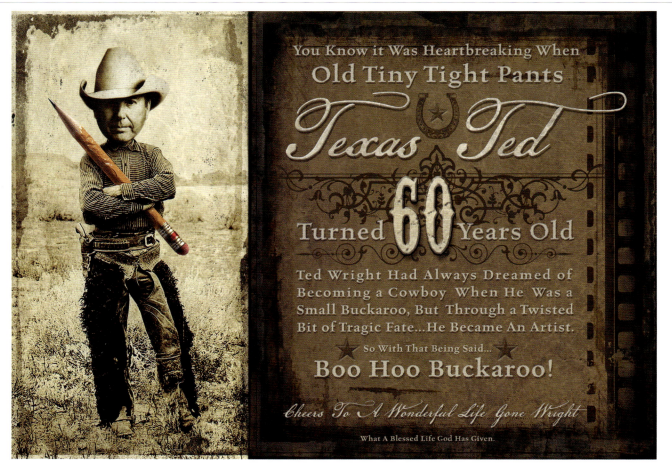

Tiny Tight Pants Texas Ted Birthday Announcement | Self-initiated | Ted Wright Illustration & Design

COLD OPEN

The After Party
Netflix | Cold Open

COLD OPEN

This Giant Beast That Is The Global Economy
Amazon Studios | Cold Open

COLD OPEN

The Curse of La Llorona
Warner Bros. Pictures | Cold Open

COLD OPEN

Hell Fest | CBS Films
Cold Open

COLD OPEN

Boy Erased - GLAAD | Focus Features
Cold Open

FX NETWORKS/OSCAR MAGALLANES

Mayans M.C. - Oscar Magallanes
Self-initiated | FX Networks

ARSONAL

Homecoming | Amazon Prime Video
ARSONAL

COLD OPEN

Cobra Kai | YouTube Originals
Cold Open

TED WRIGHT

Hillsboro Rodeo | Hillsboro Rodeo Association
Ted Wright Illustration & Design

ARSONAL

True Detective S3 | HBO PROGRAM MARKETING | **ARSONAL**

ARSONAL

Everybody Knows | Focus Features | **ARSONAL**

FX NETWORKS/EL MAC

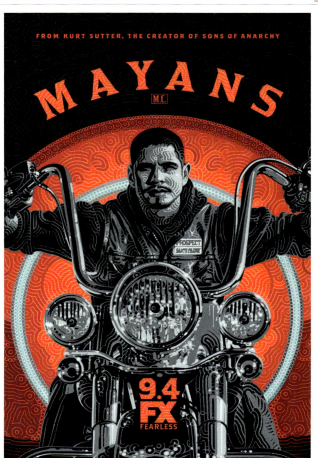

Mayans M.C. - El Mac | Self-initiated | **FX Networks**

COLD OPEN

The Darkest Minds - Int'l Key Art | 20th Century Fox | **Cold Open**

KELLY SALCHOW MACARTHUR

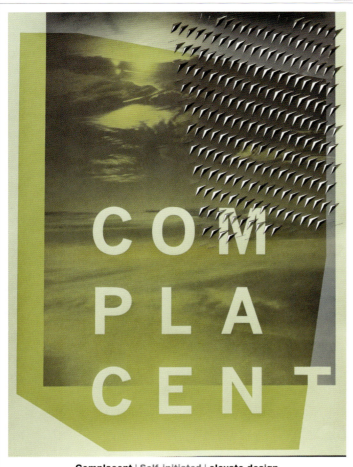

Complacent | Self-initiated | elevate design

SCOTT LAMBERT

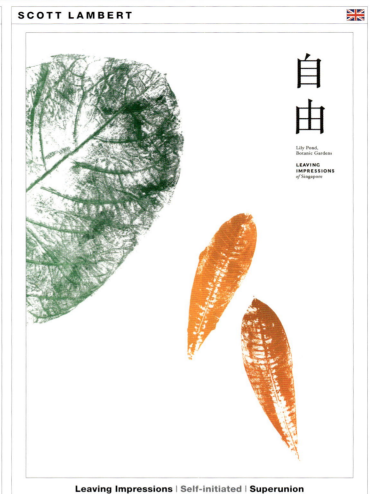

Leaving Impressions | Self-initiated | Superunion

JIE-FEI YANG

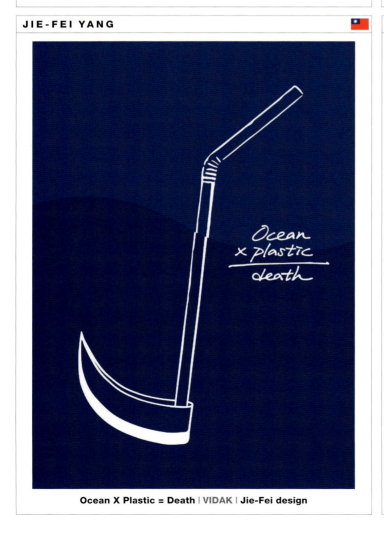

Ocean X Plastic = Death | VIDAK | Jie-Fei design

ONUR AŞKIN

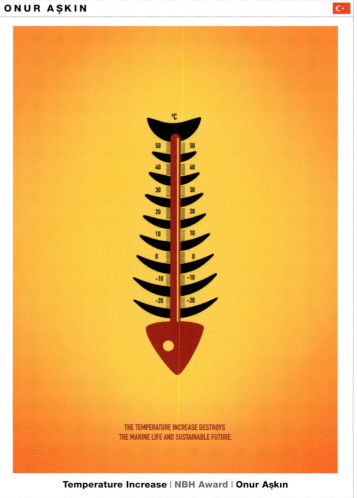

Temperature Increase | NBH Award | Onur Aşkın

DOUGLAS. D. MAY

Build Green | VIDAK - Visual Info. Design Assn. of Korea | **May & Co.**

HAJIME TSUSHIMA

Future Energy | World Expo Museum | **Tsushima Design**

MARLENA BUCZEK SMITH

THERE IS NO SUCH THING AS GLOBAL WARMING

There is no such thing as Global Warming | Self-initiated
Marlena Buczek Smith

JAN ŠABACH

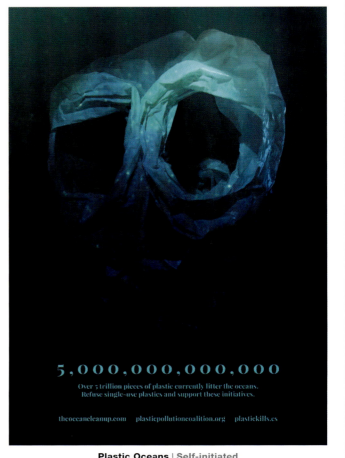

5,000,000,000,000

Over 5 trillion pieces of plastic currently litter the oceans.
Refuse single-use plastics and support these initiatives.

theoceancleanup.com plasticpollutioncoalition.org plastickills.es

Plastic Oceans | Self-initiated
Code Switch

DAISUKE KASHIWA

The Emperor's New Clothes
Japan Book Design Award 2018 | **Daisuke Kashiwa**

LORENA SAYAVERA, MARÍA PRADERA

Fallas from Valencia
Valencia City Council, Generalitat Valenciana and Metro Valencia | **Yinsen**

DAEKI SHIM

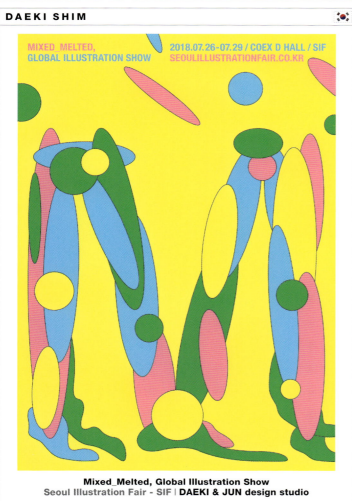

Mixed_Melted, Global Illustration Show
Seoul Illustration Fair - SIF | **DAEKI & JUN design studio**

DAVID WILGUS

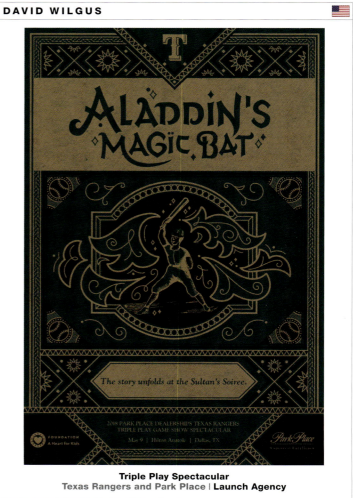

Triple Play Spectacular
Texas Rangers and Park Place | **Launch Agency**

DAISUKE KASHIWA

BICeBé 2009–2019: 10 years Biennial of Poster Bolivia
The Biennial of the Poster Bolivia BICeBé | **Daisuke Kashiwa**

IBÁN RAMÓN

Arròs amb Jazz
Grupo La Sucursal | **Ibán Ramón**

TED WRIGHT

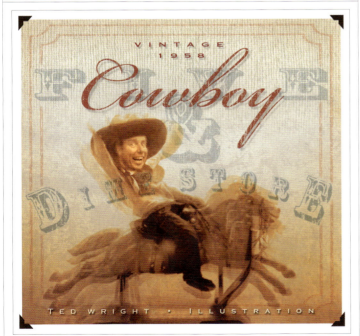

Vintage Dimestore Cowboy Ted Wright
Self-initiated | **Ted Wright Illustration & Design**

RANDY CLARK

Snackmix Apocalypse
MGC School of Design, Wenzhou Kean University | **Randy Clark**

ANA ALVES DA SILVA

Simultaneous Openings
Porto Lazer / CMP | anacmyk

PETER FISHEL

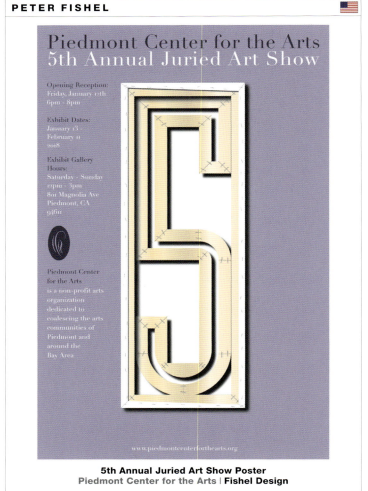

5th Annual Juried Art Show Poster
Piedmont Center for the Arts | Fishel Design

RICHARD PULLEY, DAVID H GWALTNEY

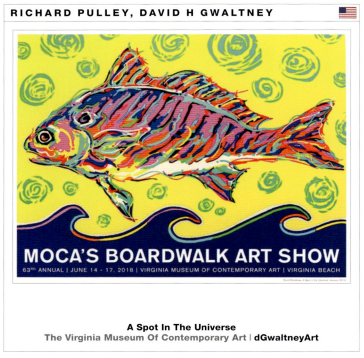

A Spot In The Universe
The Virginia Museum Of Contemporary Art | dGwaltneyArt

RANDY CLARK

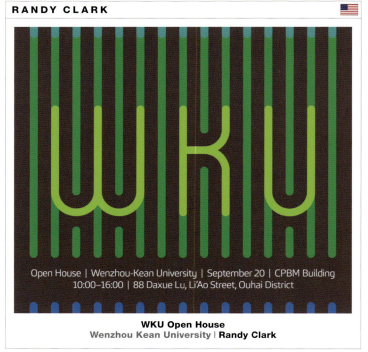

WKU Open House
Wenzhou Kean University | Randy Clark

NICK MENDOZA 🇺🇸

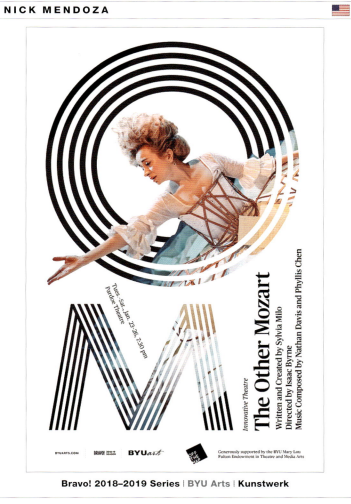

Bravo! 2018–2019 Series | BYU Arts | Kunstwerk

XOSÉ TEIGA 🇪🇸

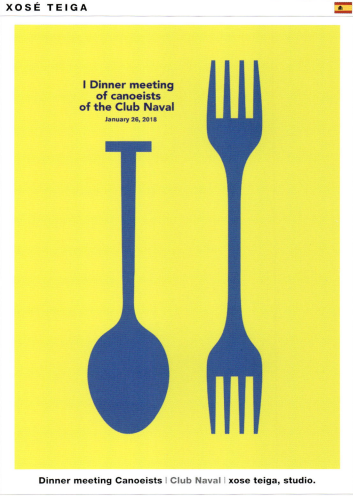

Dinner meeting Canoeists | Club Naval | xose teiga, studio.

ZAK MROUEH 🇨🇦

Why does Helvetica just feel so good?

Speak the truth. DesignThinkers Toronto 2018 | RGD | October 24 & 25 designthinkers.com

DesignThinkers - Speak the Truth
Association of Registered Graphic Designers (RGD) | Zulu Alpha Kilo

LINDA RITOH ●

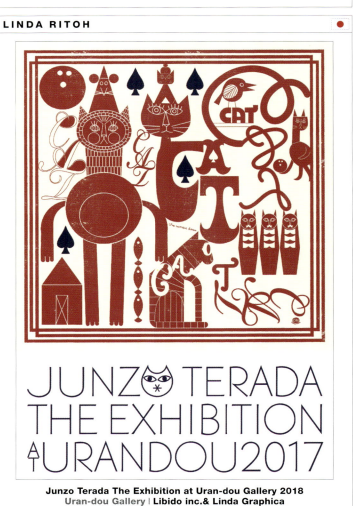

Junzo Terada The Exhibition at Uran-dou Gallery 2018
Uran-dou Gallery | Libido inc.& Linda Graphica

CARLO FIORE

Warhol. The art of being famous
Fondazione Sant'Elia - Rosini Gutman Gallery | **Venti caratteruzzi**

RANDY CLARK

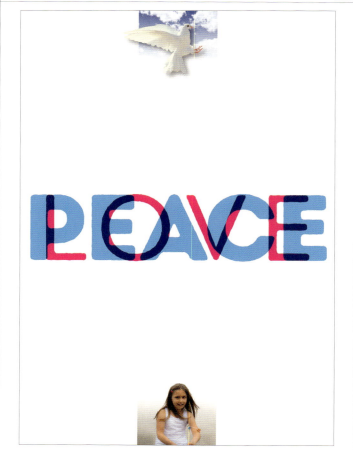

Peace Love
Taiwan Poster Design Association | **Randy Clark**

MELCHIOR IMBODEN

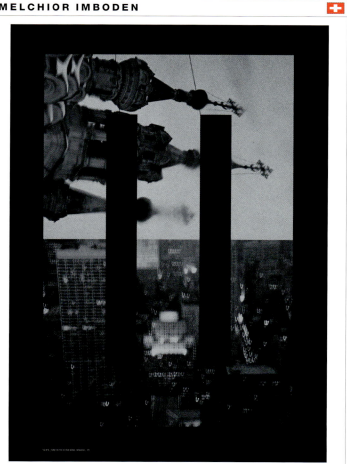

East/West
Int'l Invited Poster Exhibition in Moscow | **Melchior Imboden**

DAISUKE KASHIWA

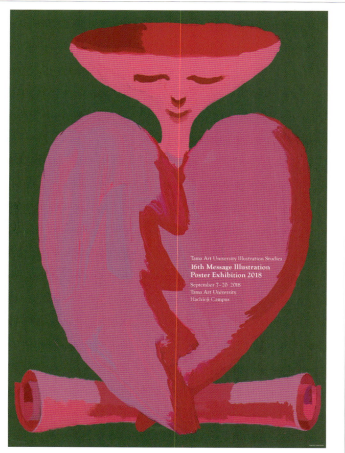

16th Message Illustration Poster Exhibition 2018
Illustration Studies, Tama Art University | **Daisuke Kashiwa**

TAKAHIRO ETO

The Study of Symbols | **Self-initiated** | **STUDY LLC.**

BYOUNG-IL SUN

Byoung-il Sun Poland Exhibition | **Poland PJAIT Univ.** | **Namseoul Univ.**

RYAN RUSSELL

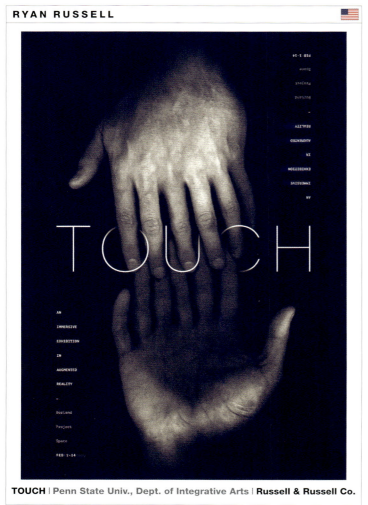

TOUCH | **Penn State Univ., Dept. of Integrative Arts** | **Russell & Russell Co.**

DAISUKE KASHIWA

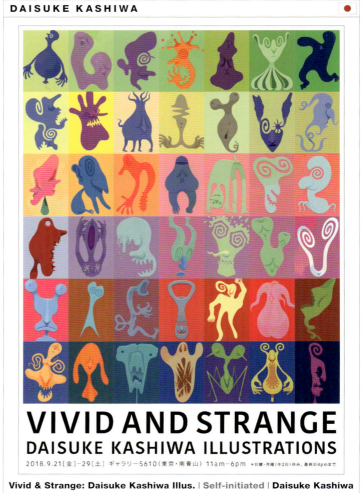

Vivid & Strange: Daisuke Kashiwa Illus. | **Self-initiated** | **Daisuke Kashiwa**

SVEN LINDHORST-EMME

Das Kapital ist weg – Wir sind das Kapital
Zwischenraum Schaffhausen (Switzerland) | **studio lindhorst-emme**

FINN NYGAARD

Tribute to Ernesto "El Chango" Cabral (1908-1968)
Bienal Internacional del Cartel en México

Tribute to Ernesto Cabral
Bienal Internacional del Cartel en Mexico | **Finn Nygaard**

CHOONG HO LEE

UOU X KSU 20th Anniversary Invitational Exhibition

2018.10.30-11.11 Ulsan Metropolitan Library Exhibition Hall

Poster for UOU X KSU 20th Anniversary Invitational Exhibition
University of Ulsan | **Choong Ho Lee**

CHOONG HO LEE

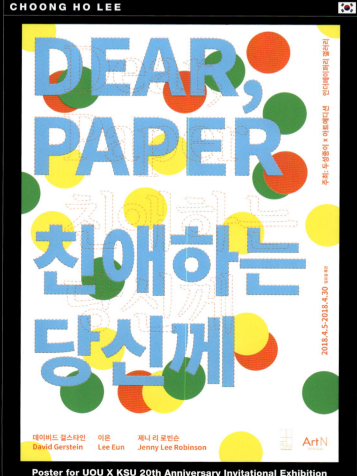

데이비드 걸스타인 이은 제니 리 로빈슨
David Gerstein Lee Eun Jenny Lee Robinson

Poster for UOU X KSU 20th Anniversary Invitational Exhibition
University of Ulsan | **Choong Ho Lee**

RANDY CLARK 🇺🇸

Love | Taiwan Poster Design Association
Randy Clark

LINDA RITOH ●

LIFE—Linda Ritoh, The Exhib. with Photographers
Uran-dou Gallery | Libido inc. & Linda Graphica

MELCHIOR IMBODEN 🇨🇭

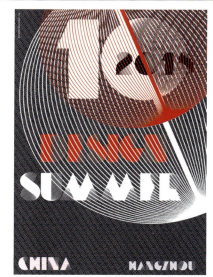

10 Years Design Summer Hangzhou, China
Design Summer Hangzhou | Melchior Imboden

WIESLAW GRZEGORCZYK 🇵🇱

Wieslaw Grzegorczyk – Painted & Printed Posters
Office of Art Exhibitions | Wieslaw Grzegorczyk

VIKTOR KOEN 🇺🇸

SNF Philanthropy Poster Project Exhib. @ SVA
SNF & SVA | Attic Child Press, Inc.

TAKAHIRO ETO ●

Between symbols and illustrations
Tokyo Polytechnic University | STUDY LLC.

PETER DIAMOND

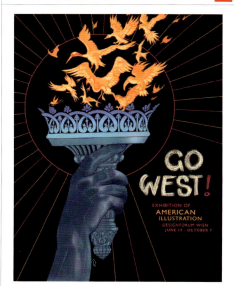

GO WEST! | designforum Wien
Peter Diamond Illustration

KUOKWAI CHEONG

Chapas Sínicas | Macao S.A.R. Government
Cultural Affairs Bureau of the Macao S.A.R. Govt.

YOHEI TAKAHASHI ●

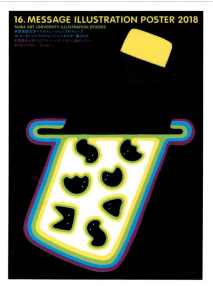

16. Message Illustration Poster 2018
Illus. Studies, Tama Art Univ. | Yohei Takahashi

JOÃO MACHADO

40 Anos Cinanima | Cooperativa Nascente | João Machado

JOHN BUTLER

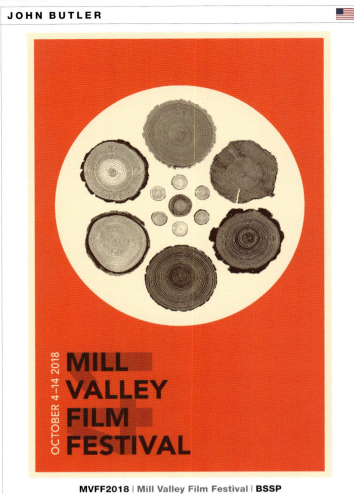

MVFF2018 | Mill Valley Film Festival | **BSSP**

JUREK WAJDOWICZ, LISA LAROCHELLE

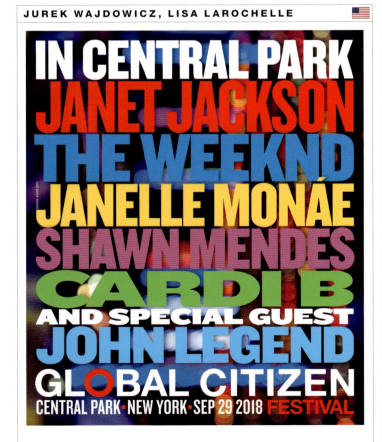

Global Citizen NYC Concert Poster | Global Citizen
Emerson, Wajdowicz Studios

JOÃO MACHADO

Cinanima 19 | Cooperativa Nascente
João Machado Design

ERMAN YILMAZ

Alex | Selman Nacar | **Erman Yılmaz**

XOSÉ TEIGA

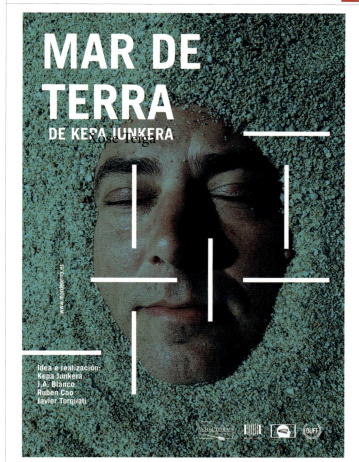

Mar de Terra | Kepa Junkera | **xose teiga, studio.**

STEVE SANDSTROM

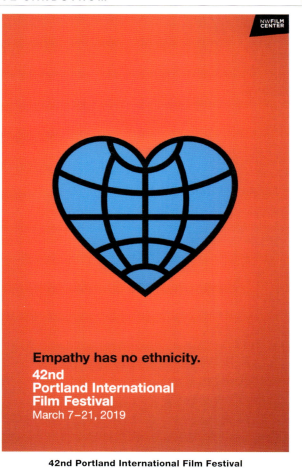

42nd Portland International Film Festival
Northwest Film Center/Portland Art Museum | Sandstrom Partners

STEVE SANDSTROM

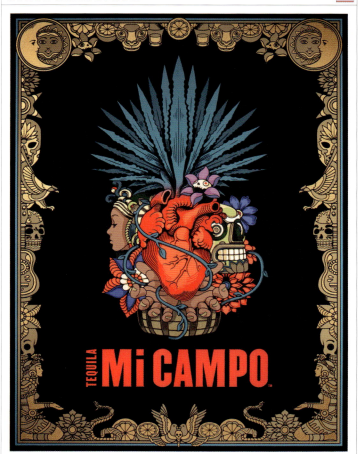

Mi Campo Tequila Screen-printed Poster (14 colors)
Mi Campo/Constellation Brands | Sandstrom Partners

AYA CODAMA

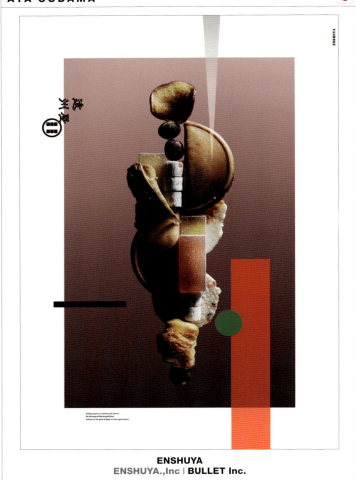

ENSHUYA
ENSHUYA.,Inc | BULLET Inc.

MARY LAINE

Cache Valley Gardeners Market Poster '18
Cache Valley Gardener's Market Association | Design SubTerra

TOM VENTRESS

Vestri IPA Poster | Asgard Brewing Company | **Ventress Design Works**

SASHA VIDAKOVIC

USA2018SASHA | Missouri State University | SVIDesign

NICOLE ELSENBACH, HELMUT ROTTKE 🇩🇪

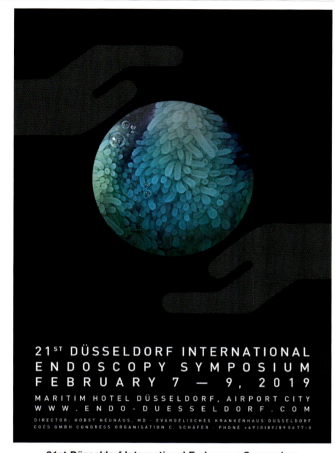

21st Düsseldorf International Endoscopy Symposium
COCS GmbH | Elsenbach Design

RYAN BENNETT 🇺🇸

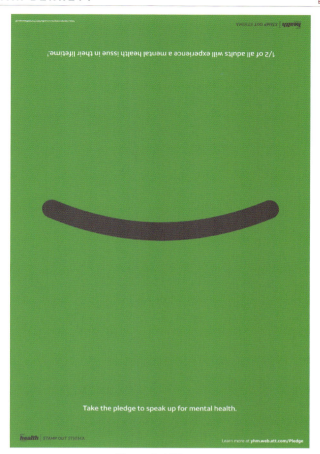

Stamp Out Stigma
AT&T with FleishmanHillard | FleishmanHillard

LARRY SMITH, R.P. BISSLAND 🇺🇸

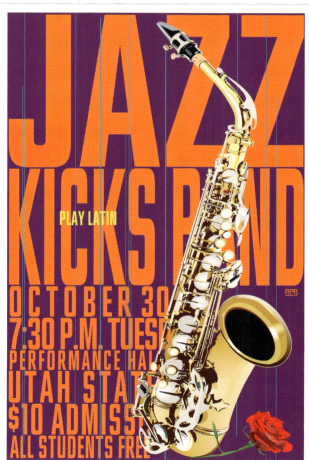

Jazz Kicks Band Play Latin | Jazz Kicks Band | Design SubTerra

OVIDIU HRIN 🇷🇴

The Cinamatic Orchestra | JazzTM Festival | Synopsis

CHEMI MONTES

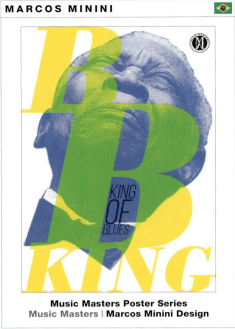

B-List Composers
AU Dept. of Performing Arts | Chemi Montes

MARCOS MININI

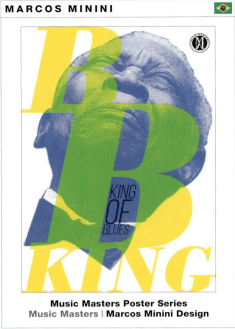

Music Masters Poster Series
Music Masters | Marcos Minini Design

MIKHAIL PUZAKOV

Flock of keys
Moscow Symphony Orchestra | 12 points

RON CLARK, TED WRIGHT

Lyle Lovette and His Big Band Bow Tie World Tour
Lyle Lovette | Ted Wright Illustration & Design

JOREL DRAY

Lost Lakes/Josh Harty Reversible Poster
Lost Lakes & Josh Harty | Jorel Dray

BOB DELEVANTE

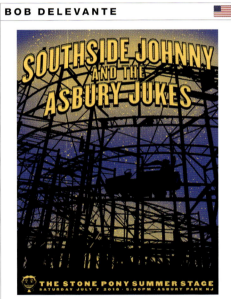

Southside Johnny & the Asbury Jukes at the Stone Pony | Southside Johnny | Bob Delevante Studios

KAVEH HAERIAN

First Thursday Concert Poster
WTMD Radio | Kaveh Haerian

OVIDIU HRIN

Gregory Porter
JazzTM Festival | Synopsis

MARCOS MININI

Music Masters Poster Series
Music Masters | Marcos Minini Design

CARMIT MAKLER HALLER

La Sonnambula | Self-initiated | Haller Metalwerks

GUNTER RAMBOW

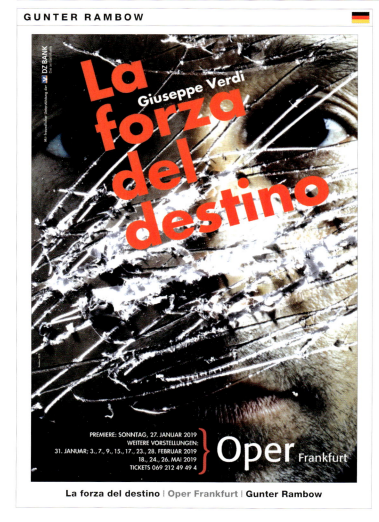

La forza del destino | Oper Frankfurt | Gunter Rambow

STEPHAN BUNDI

Pollicino (Opera for children) | TOBS Theater Biel Solothurn | Stephan Bundi

GUNTER RAMBOW

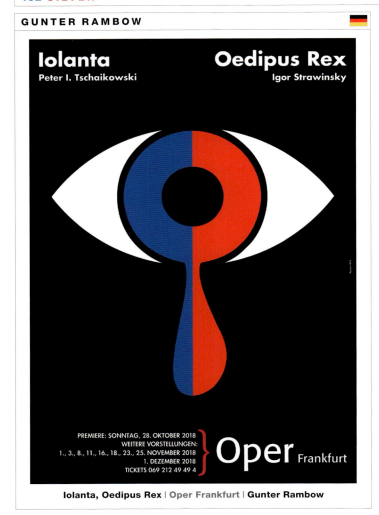

Iolanta, Oedipus Rex | Oper Frankfurt | Gunter Rambow

GUNTER RAMBOW

Dalibor | Oper Frankfurt | Gunter Rambow

GUNTER RAMBOW

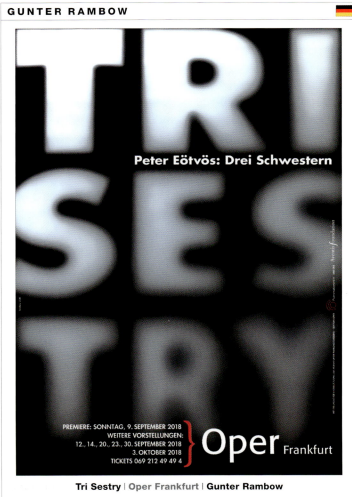

Tri Sestry | Oper Frankfurt | Gunter Rambow

CHAK KIN, JEFF POON

The Poster of Linshang Bank | Linshang Bank | UNISAGE

JOSHUA RITCHIE

The Bountiful Year | Post Ratio | Column Five

KEN-TSAI LEE

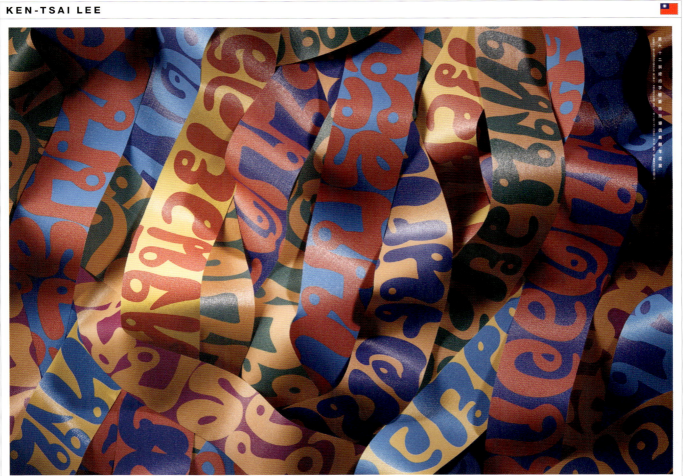

Type for wearing | TAIWAN TECH | National Taiwan University of Science and Technology

HYOJUN SHIM, DAEKI SHIM

안녕하세요 대기앤준 DAEKI SHIM 대기앤준
你好 심대기 +82.(0)10.8650.3465 심효준
おはようございます 沈昊基 DAEKI@DAEKIANDJUN.COM 沈孝俊
HALLO DAEKI & JUN DAEKI & JUN
HI WWW.DAEKIANDJUN.COM HYOJUN SHIM
BONJOUR +82.(0)10.3104.0831
ПРИВЕТ JUN@DAEKIANDJUN.COM
HEJ
HOLA HANNAM-DONG. SEOUL. SOUTH KOREA
BUONGIORNO

DAEKI & JUN design studio | **Self-initiated** | **DAEKI & JUN design studio**

SIDDHARTH KHANDELWAL

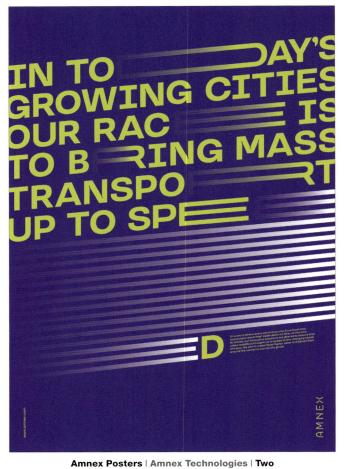

Amnex Posters | **Amnex Technologies** | **Two**

HIDETAKA SUGIYAMA

Get it? | **Japan Advertising Agencies Association** | **nikkeisha, inc.**

LEE SELSICK

Business of Design Week | **Self-initiated** | **Next**

LEO LIN

Impressions of Huizhou
An-Hui Graphic Design Assn. | **Leo Lin Design**

HISA IDE, TOSHIAKI IDE

Jugular Poster 6
J Squad | **IF Studio**

SASHA VIDAKOVIC

Dizajnerska Farsa
Self-initiated | **SVIDesign**

DERWYN GOODALL

Peace | Self-initiated
Goodall Integrated Design

DERWYN GOODALL

Wonder | Self-initiated
Goodall Integrated Design

DERWYN GOODALL

Beauty | Self-initiated
Goodall Integrated Design

HYOJUN SHIM, DAEKI SHIM

Afterimage | Gallery Show & Tell
DAEKI & JUN design studio

PEP CARRIÓ

Biblioteca Palermo "Libro-biblioteca"
Artes Gráficas Palermo | **Estudio Pep Carrió**

PEP CARRIÓ

Welcome 2019
Self-initiated | **Estudio Pep Carrió**

OWEN GILDERSLEEVE

Wonderful Print | Self-initiated | **Owen Gildersleeve**

JOHN SPOSATO

Summer/Winter 2018 | Self-initiated | **John Sposato Design & Illustration**

ZAK MROUEH

Everything Gets Better | ParticipACTION | **Zulu Alpha Kilo**

SARAH MOFFAT

Equal Justice Initiative - Bus Stop Poster | Equal Justice Initiative | **Turner Duckworth: London, San Francisco, New York**

SARAH MOFFAT

Equal Justice Initiative - Chain Poster | Equal Justice Initiative | **Turner Duckworth: London, San Francisco, New York**

CARTER WEITZ

Polar Plunge 2019 Poster | Special Olympics of Nebraska | Bailey Lauerman

DAVE ROBERTS

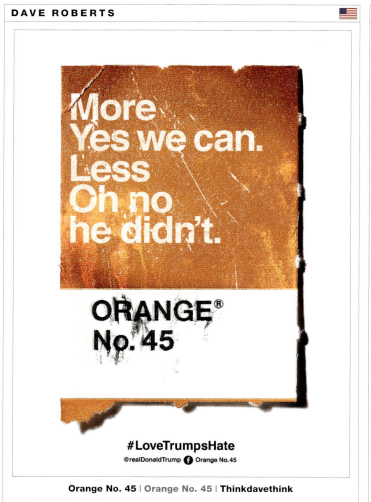

Orange No. 45 | Orange No. 45 | Thinkdavethink

SELCUK CEBECIOGLU

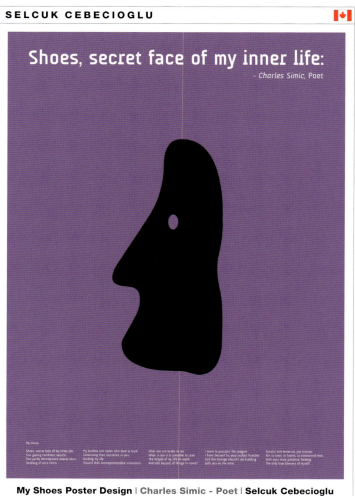

My Shoes Poster Design | Charles Simic - Poet | Selcuk Cebecioglu

NICHOLE TRIONFI

Kinely | Intrapac | **Hoyne**

CARRIE RETALLACK

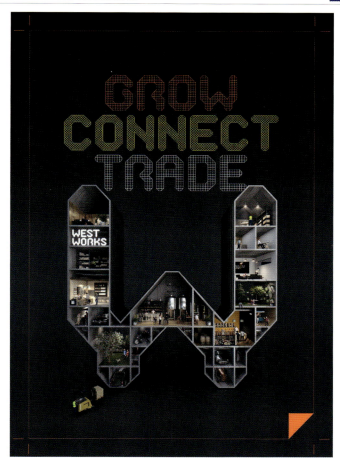

Westworks | JVMC | **Hoyne**

CARRIE RETALLACK

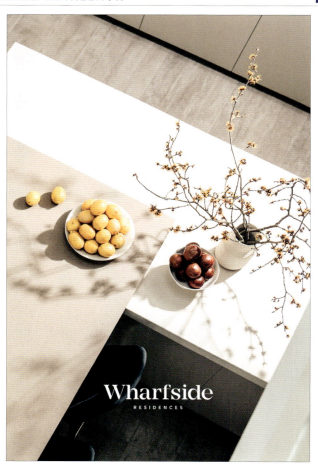

Wharfside | Mirvac | **Hoyne**

BROCK HALDEMAN

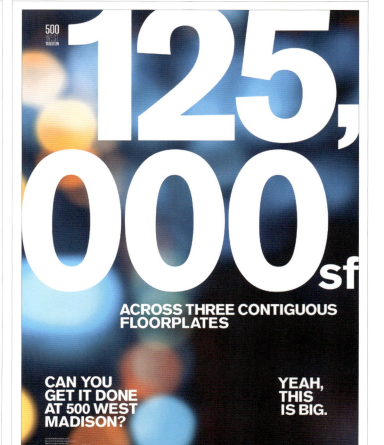

500 West Madison Direct Mail Poster | KBS | **Pivot Design**

ZIGGY HUANG, CARRIE RETALLACK

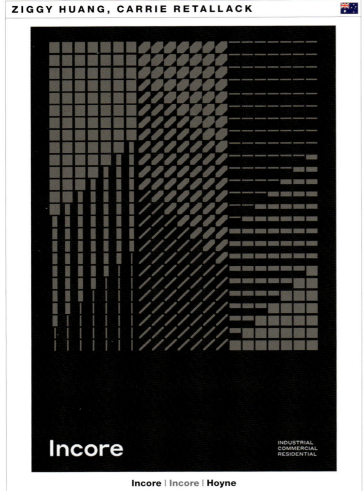

Incore | Incore | Hoyne

RENE V. STEINER

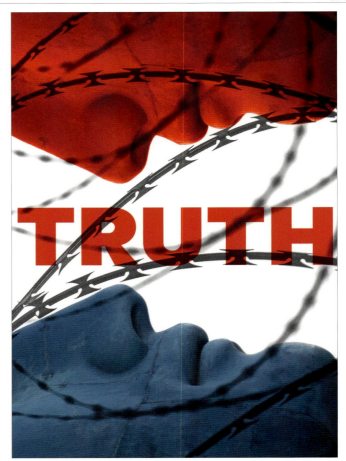

Truth Under Assault | Self-initiated | STEINER GRAPHICS

KEITH KITZ

Current | Self-Initiated | Keith Kitz Design

NICOLE ELSENBACH

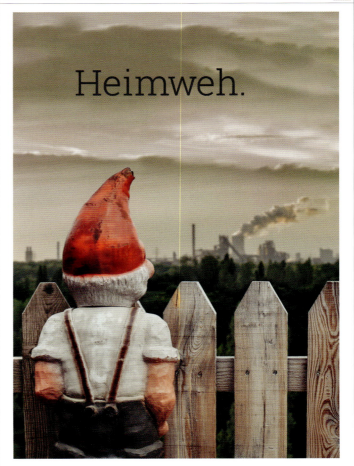

Homesick. | Self-Initiated | Elsenbach Design

FINN NYGAARD

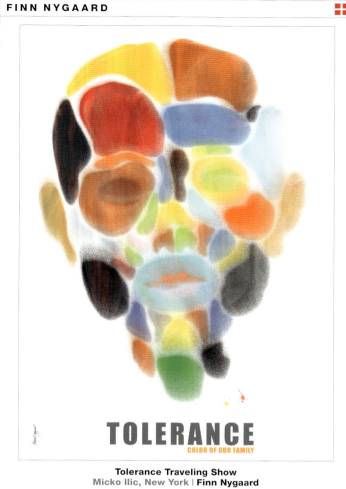

Tolerance Traveling Show
Micko Ilic, New York | **Finn Nygaard**

GUNTER RAMBOW

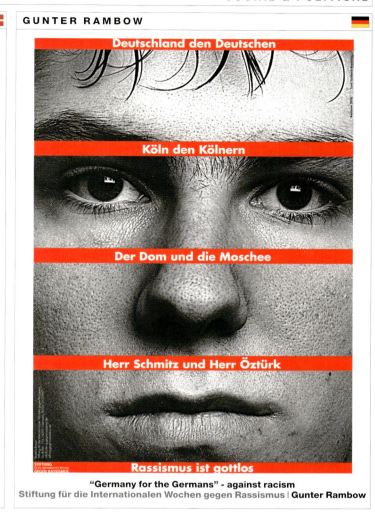

"Germany for the Germans" - against racism
Stiftung für die Internationalen Wochen gegen Rassismus | **Gunter Rambow**

RIKKE HANSEN

Year of Troy | Çanakkale Onsekiz Mart University | **Wheels & Waves**

JOÃO MACHADO

Human Rights | CTT - Correios de Portugal | **João Machado Design**

ARIANE SPANIER

Toleranz | Tolerance Traveling Poster Show by Mirko Ilić
Ariane Spanier Design

JASON KERNEVICH

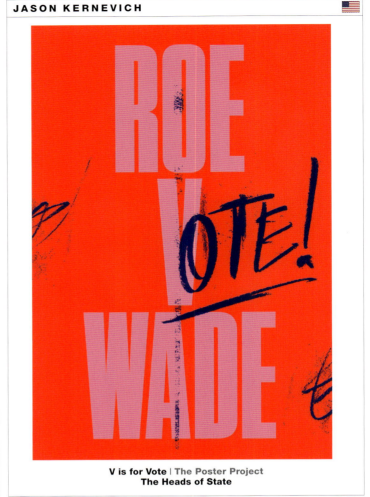

V is for Vote | The Poster Project
The Heads of State

CARMIT MAKLER HALLER

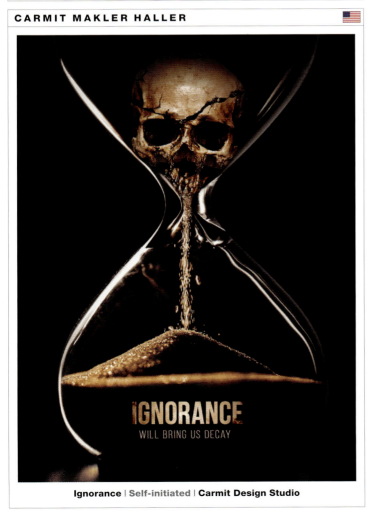

Ignorance | Self-initiated | **Carmit Design Studio**

YUNJI JUN

How to invent cliché | Calarts GD MFA | **Yunji Jun**

YOHEI TAKAHASHI ●

Earthquake and Chiyoda Ward, Tokyo
Junior Chamber Int'l Tokyo, Chiyoda Ward Committee | **Yohei Takahashi**

MARTIN FRENCH 🇺🇸

40 Million
Self-initiated | **Martin French Studio**

MARLENA BUCZEK SMITH 🇺🇸

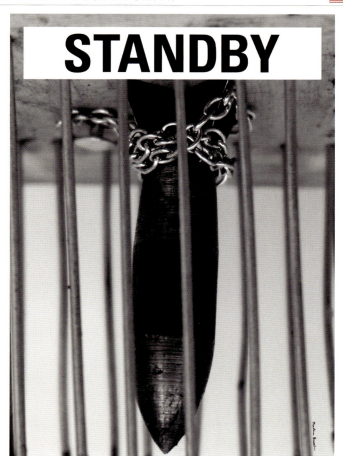

Standby | Self-initiated | **Marlena Buczek Smith**

HOON-DONG CHUNG 🇰🇷

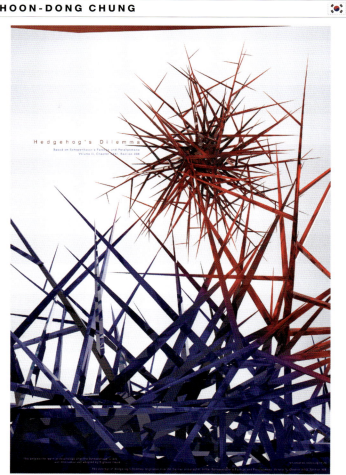

Hedgehogs Dilemma | Self-initiated | **Dankook University**

BRAD HOLLAND

Poor Bradford's Wise Sayings | Poor Bradford's Almanac | Brad Holland

ZAK MROUEH

This outdoor campaign made the national news by showing the before and after of Toronto's skyline being swallowed up in bullet casings.

Encased City | Coalition For Gun Control | Zulu Alpha Kilo

MEAGHAN A. DEE 🇺🇸

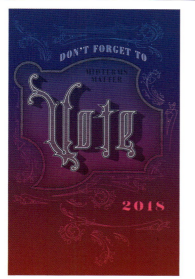

Vote: Midterms Matter
Design for Democracy | **Virginia Tech**

BEN GREENGRASS 🇺🇸

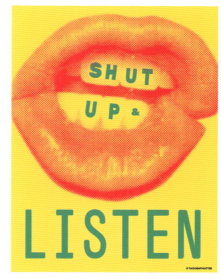

Women's March Posters
Self-Initiated | **ThoughtMatter**

ANDREW SLOAN 🇬🇧

Stranger
Self-Initiated | **Andrew Sloan**

YOSSI LEMEL 🇮🇱

Fake News | Self-Initiated
Yossi Lemel

YIN ZHONGJUN 🇩🇪

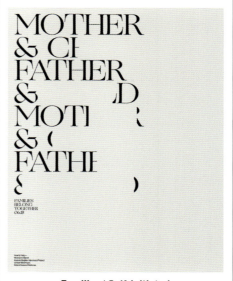

Game of Death | BICeBe
Dalian RYCX Advertising Co., Ltd.

FIDEL PEÑA, CLAIRE DAWSON 🇨🇦

Families | Self-Initiated
Underline Studio

JAN ŠABACH 🇺🇸

Guns Gone | Self-Initiated
Code Switch

TOYOTSUGU ITOH 🇯🇵

BEYOND | Japan Graphic Designers Assn. Inc.
Toyotsugu Itoh Design Office

CLAIRE DAWSON, FIDEL PEÑA 🇨🇦

Lines Breaking | Self-Initiated
Underline Studio

LUIS ANTONIO RIVERA RODRIGUEZ

YOHEI TAKAHASHI

DOCTRINES | VARIOUS | Luis Antonio Rivera Rodriguez

Earthquake Poster Support Project | Tama Art University | Yohei Takahashi

CARMIT MAKLER HALLER

We Believe | Self-initiated | Carmit Design Studio

ORSAT FRANKOVIC

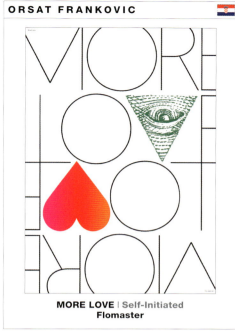

MORE LOVE | Self-Initiated
Flomaster

JAN ŠABACH

Vote for Women | Self-Initiated
Code Switch

CHRIS CORNEAL

Love Harmonizes Life | Self-Initiated
Symbiotic Solutions

GENARO SOLIS RIVERO

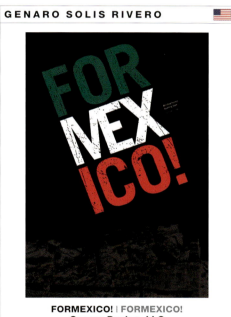

FORMEXICO! | FORMEXICO!
Genaro Design, LLC

MARLENA BUCZEK SMITH

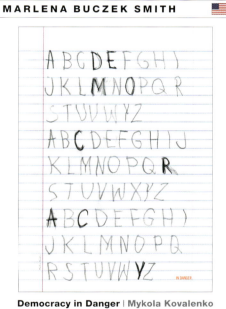

Democracy in Danger | Mykola Kovalenko
Marlena Buczek Smith

HOUDA BAKKALI

Too many fishes, too few loaves | Self-Initiated
Houda Bakkali

KARI PIIPPO

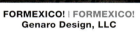

1917-2017, CCCP-Russia | Golden Bee in Moscow
Kari Piippo Oy

DALE ADDY

Nashville–A Cautionary Tale | TwangTownTattlers
DNA Creative Marketing

ZAK MROUEH

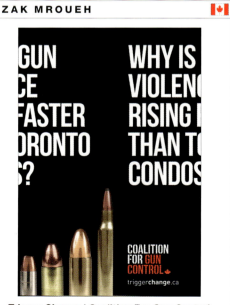

Trigger Change | Coalition For Gun Control
Zulu Alpha Kilo

GARY MUELLER

Saw | Footstock National Endurance Barefoot Water Ski Championships | BVK

MARCELLE KARP

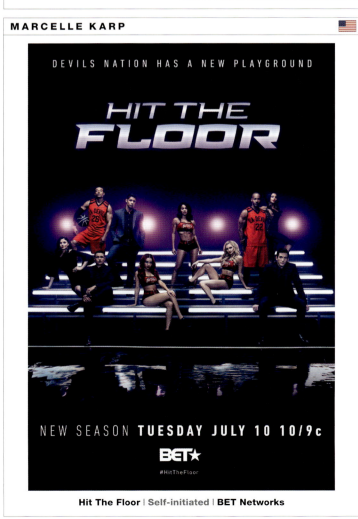

Hit The Floor | Self-initiated | BET Networks

ALLISON CAVINESS

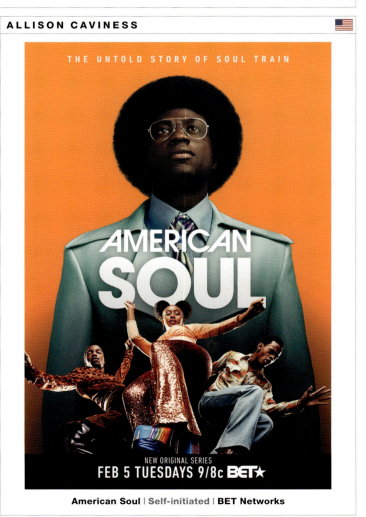

American Soul | Self-initiated | BET Networks

JEROME FORD

BET Awards | **BET Networks** | **Sibling Rivalry**

LEROY & ROSE

Preacher Season 3 | **AMC** | **Leroy & Rose**

JEROME FORD

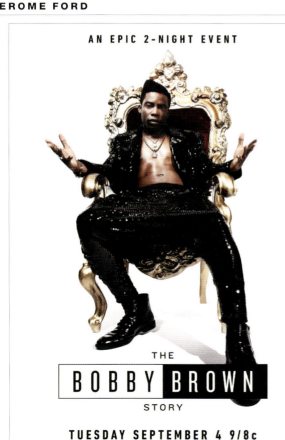

The Bobby Brown Story | Self-initiated | **BET Networks**

DAVID O'HANLON

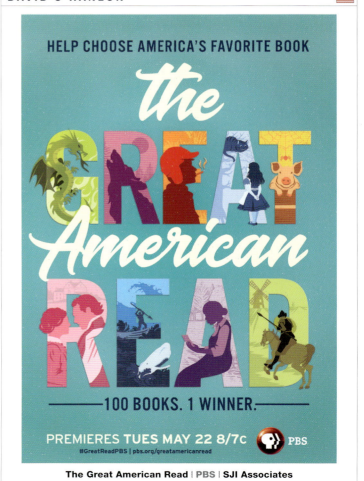

The Great American Read | **PBS** | **SJI Associates**

LEROY & ROSE

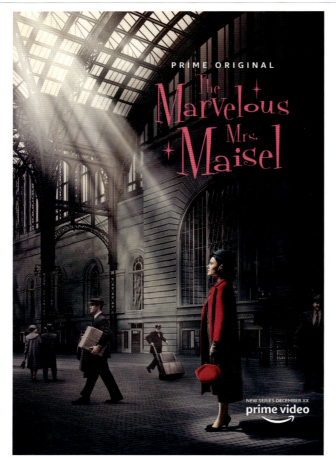

The Marvelous Mrs. Maisel Season 2 | Amazon | Leroy & Rose

DAVID O'HANLON

Country Music, A Film by Ken Burns | PBS | SJI Associates

LEROY & ROSE

Drew Michael | HBO | Leroy & Rose

MIRKO ILIC

Yugoslav Drama Theatre Posters | Yugoslav Drama Theatre | Mirko Ilic Corp.

CARMIT MAKLER HALLER 🇺🇸

The Visit | Haller Metalwerks
Carmit Design Studio

JAMES LACEY 🇺🇸

Revival Theatre Company - Oklahoma! | Revival Theatre Company
Dennard, Lacey & Associates

STEPHAN BUNDI 🇨🇭

Popoch – Die Arbeit des Lebens | Neuestheater | Stephan Bundi

NGADHNJIM MEHMETI 🇲🇰

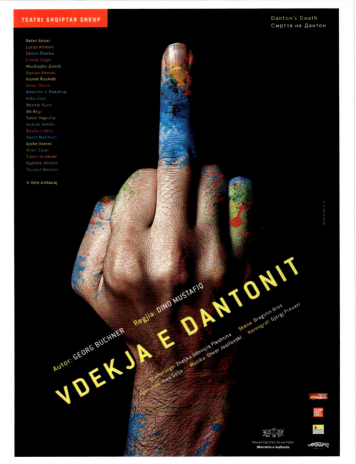

Danton's Death | The Albanian Theatre Skopje | EGGRA

CHEMI MONTES

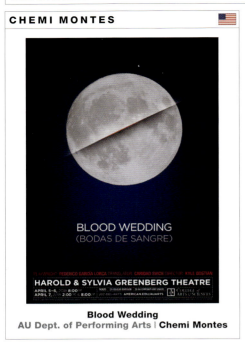

Blood Wedding
AU Dept. of Performing Arts | Chemi Montes

CHOE GON

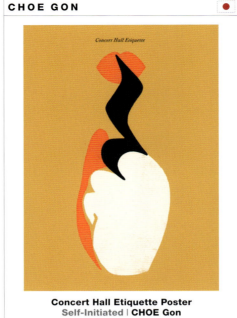

Concert Hall Etiquette Poster
Self-Initiated | CHOE Gon

LISA KREIENBERG

LIKAH!
Deep Arts | Jay Advertising

SPENCER STRICKLAND

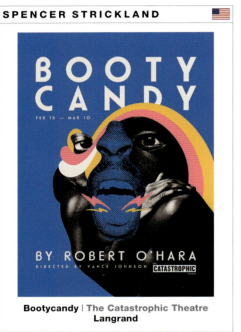

Bootycandy | The Catastrophic Theatre
Langrand

DESSEIN

Mimma | Orana Productions
Dessein

STEPHAN BUNDI

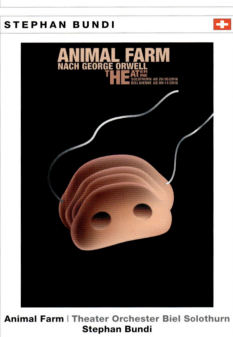

Animal Farm | Theater Orchester Biel Solothurn
Stephan Bundi

SPENCER STRICKLAND

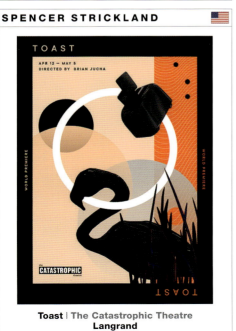

Toast | The Catastrophic Theatre
Langrand

KATE RESNICK

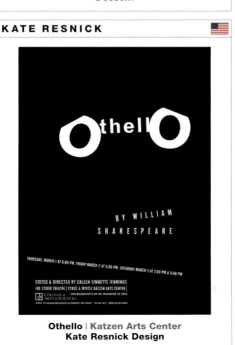

Othello | Katzen Arts Center
Kate Resnick Design

LEILA SINGLETON

Molière's "Tartuffe" | Univ. of California, Berkeley
L.S. Boldsmith

MARGARET KEENE 🇺🇸

Creativity Is In The Air | EVA Air | **MullenLowe Los Angeles**

MICHAEL SCHWAB 🇺🇸

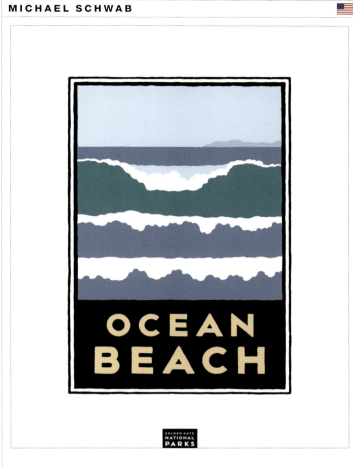

Ocean Beach | Golden Gate Ntl. Park Conservancy | **Michael Schwab Studio**

KEITH KITZ 🇺🇸

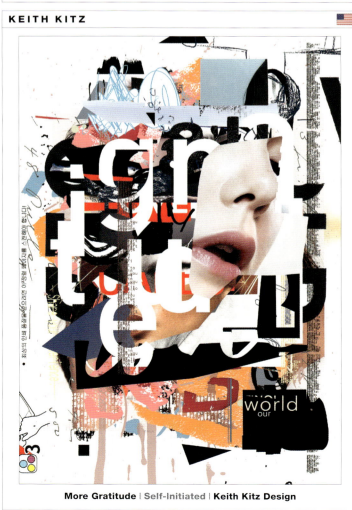

More Gratitude | Self-Initiated | **Keith Kitz Design**

PAULA AMARAL 🇬🇧

Are You Ready To Recover? | Business In the Community | **THERE IS**

THOMAS KÜHNEN

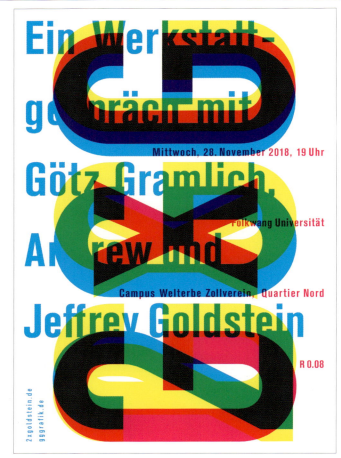

GGG2xG Workshop-Talk | **Folkwang UdK** | **Thomas Kühnen**

RIKKE HANSEN

My Emotions | The 2nd Exhib. & Conf. on "Awareness" | **Wheels & Waves**

CHIA-HUI LIEN

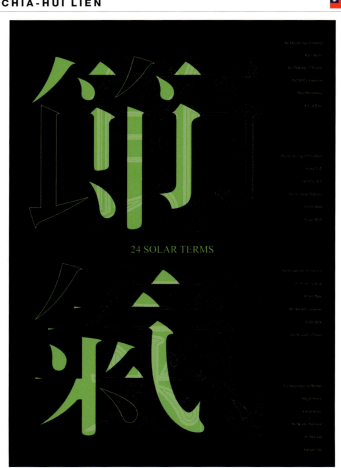

24 Solar Terms | Self-initiated | **Tungfang Design Uni.** | **Deisgn Dept.**

FRED MACHUCA

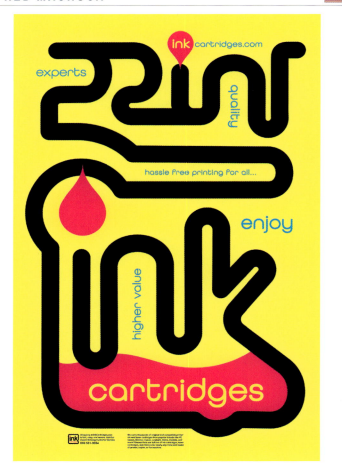

InkC | **LD Products** | **Studio LD**

Honorable Mentions

Automobile Assn. of Singapore

TFI Envision, Inc.

Houda Bakkali

Koji Miwa

Martin French Studio

Martin French Studio

Page/Dyal

Takashi Akiyama Studio

Komprehensive Design

Anagraphic

Jansword Design

Chase Body

Hansung Univ. Design & Art Inst.

Ostro Design

ARSONAL

ARSONAL

Cold Open

Cold Open

Cold Open

ARSONAL

Cold Open

Cold Open

Cold Open

Noise 13

Ostro Design

Paul Rogers Studio

Shangning Wang Graphic Design

Paul Rogers Studio

Bailey Lauerman

May & Co.

TAKI PRODUCTS

FleishmanHillard

Bailey Lauerman 🇺🇸

Buck Smith 🇺🇸

Bailey Lauerman 🇺🇸

Alfred University 🇺🇸

Attic Child Press, Inc. 🇺🇸

AABB 🇰🇷

Choong Ho Lee 🇰🇷

Eleven19 🇺🇸

camilart 🇺🇸

OUWN 🇯🇵

Stoltze Design 🇺🇸

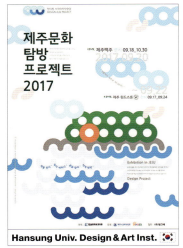

Hansung Univ. Design & Art Inst. 🇰🇷

Estudio Pep Carrió 🇪🇸

AABB 🇰🇷

cooltiger ltd. 🇯🇵

Daisuke Kashiwa 🇯🇵

Jillian Coorey 🇺🇸

Instacoin 🇰🇷

Behind the Amusement Park 🇸🇪

Markham & Stein 🇺🇸

EGGRA 🇲🇰

BRAND DIRECTORS 🇰🇷

Crowley Webb 🇺🇸

Sabri Akın 🇺🇸

Nick Mendoza 🇺🇸

Leroy & Rose 🇺🇸

Two 🇮🇳

Hoyne 🇦🇺

OUWN 🇯🇵

Zulu Alpha Kilo 🇨🇦

For Good Measure 🇺🇸

João Machado Design 🇵🇹

Zulu Alpha Kilo

Anagraphic

Flomaster

Bob Delevante Studios

Jorel Dray

Owen Gildersleeve

THERE IS

xose teiga, studio.

effiwerks

Anagraphic

Bob Delevante Studios

BVK

BRAND DIRECTORS

Gunter Rambow

Yewon Yoo

UNISAGE

Jay Advertising

Grafik Marketing Comm.

Design Studio

Aesthetic Apparatus (Mpls)

FleishmanHillard

Mermaid, Inc.

BVK

CHOE Gon

Mingliang Li Design Studio

UNISAGE

BVK

Cardwell Beach

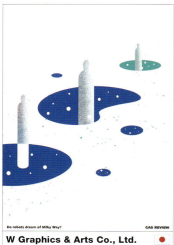

W Graphics & Arts Co., Ltd.

Hoyne

Hoyne

Hoyne

Hoyne

Hoyne

Hoyne

MullenLowe Los Angeles

Mytton Williams

Meaningful Works

Houda Bakkali

Chantal Fischzang

Keith Kitz Design

NW Media Group

Scott Pridgen Design Co

Onur Aşkın

Toyotsugu Itoh Design Office

Uhlein Design

Amanda Smith Designs

Keith Kitz Design

Bailey Lauerman 🇺🇸

Superunion 🇬🇧

Leroy & Rose 🇺🇸

BET Networks 🇺🇸

Leroy & Rose 🇺🇸

BET Networks 🇺🇸

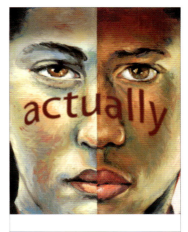

Elizabeth Lada Design & Illus. 🇺🇸

L.S. Boldsmith 🇨🇦

W Graphics & Arts Co., Ltd. 🇯🇵

Nick Mendoza 🇺🇸

Dennard, Lacey & Associates 🇺🇸

Dennard, Lacey & Associates 🇺🇸

Langrand 🇺🇸

Chemi Montes 🇺🇸

H.Tuncay Design 🇹🇷

Langrand 🇺🇸

Hoyne 🇦🇺

Thomas Kühnen 🇩🇪

hufax arts 🇹🇼

Graphic Comm. Laboratory 🇯🇵

Zulu Alpha Kilo 🇨🇦

Yunji Jun 🇺🇸

Thomas Kühnen 🇩🇪

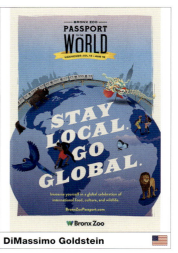

DiMassimo Goldstein 🇺🇸

Honorable Mentions & Silver winners receive the same presentation on our website as Platinum & Gold.

I think that the competition is very important because it offers the joy of exploring beautiful expression. It will be very meaningful for young designers.

Hajime Tsushima, *Designer, Tsushima Design*

Though the role of the poster may have changed, this publication shows that at the end of the day, thoughtful design will always shine through.

Dermot Mac Cormack, *Co-founder, 21xdesign*

Zulu Alpha Kilo 🇨🇦

Randy Clark 🇺🇸

design+envy 🇺🇸

Shine United 🇺🇸

Tom Dixon Creative 🇺🇸

Lorenzo Petrantoni (Milan) 🇺🇸

Soto Creative 🇺🇸

Turner Duckworth: LDN, SF, NY 🇺🇸

Lewis Communications 🇺🇸

Andrew Sloan 🇬🇧

SJI Associates 🇺🇸

SJI Associates 🇺🇸

Studio LD 🇺🇸

PLATINUM WINNERS:

26 AUTO & TRUCK SERVICES — THE ART OF REPAIR POSTER
Design Firm: Lewis Communications | Designer: Spencer Till | Client: Auto & Truck Services
Photographer: Jeffrey Williams | Chief Creative Officer: Spencer Till | Art Director: Spencer Till

Assignment: For five years, Auto and Truck Services has been running a combination of installations, social campaigns, posters and other guerilla tactics to distinguish themselves as "The Art of repair."
Approach: For their 2019 poster campaign, Auto & Truck wanted to feature their actual mechanics as the real difference between Auto & Truck and just any repair shop. To accomplish this, we enlisted part photography and part master's paintings to bring the artists (mechanics) to life.
Results: Service on cars is up 76% over last year, against their new target audience of women motorists. Because the campaigns have established an approachable personality, they see more and more women drivers not too intimidated to drive into the service bay.

27 GENIUS: PICASSO | Design Firm: ARSONAL | Designer: ARSONAL / National Geographic
Client: National Geographic | Photographer: Kurt Iswarienko
Director of Project Management: Leah Wojda (National Geographic)
Creative Director: ARSONAL, Chris Spencer, EVP Creative (National Geographic), Brian Everett, VP Design (National Geographic) | Copywriter: Linda Castillo | Art Director: ARSONAL

Assignment: Following on the heels of the season one Genius art that featured the iconic hair of Einstein, our challenge was to find an equally arresting image to capture the essence of season two's subject, Pablo Picasso, without using any of his art or iconic signature. Tonally, our goal was to present Picasso as modern rebel with a punk rock personality.
Approach: The final direction utilized paint swatches and strokes applied to Picasso himself, making the artist the art. This storytelling thread was then carried through to the extended character campaign
Results: The client was extremely happy with the creative.

28 SAVE THE LIFE | Design Firm: João Machado Design
Designer: João Machado | Client: UnknownDesign

Assignment: Over the years I've been working on the environmental subject for the brand UNKNOWNdesign. The purpose was to call attention to all the problems related to promoting better forest management and conservation as well as protection of the animal life habitat.
Approach: The human negligence and lack of forestry policy has been a real threat to the preservation of our forests. Their preservation is essential to the balance and survival of life species on the planet.

29 LES FÉES DU RHIN | Designer: Stephan Bundi | Client: Theater Orchester Biel Solothurn

Assignment: A pacifist opera in which the Rhine mermaids intervene in the action, silence the struggles and make love triumph over violence.
Approach: The dangerous depth of the Rhine.
Results: Used for advertising material and an animation on the website.

30 SALOME | Design Firm: Carmit Design Studio | Designer: Carmit Makler Haller
Client: Haller Metalwerks | Photo Illustrator: Eyal Orlee Studio | Photographer: Stock_colors

Assignment: Oscar Wilde's play tells in one act the Biblical story of Salome, who, to her stepfather's dismay but to the delight of her mother Herodias, requests the head of Jokanaan on a silver platter, so she can kiss it, as a reward for dancing the dance of the seven veils.
Approach: Salome is the virgin princess of Judah: royal, powerful, beautiful, seductive, naive, mesmerizing—yet unaware of her consequences. Her contradicting characteristics are displayed in this scene, depicting the climax of the play.

31 TOLERANZ | Design Firm: Gunter Rambow | Designer: Gunter Rambow | Client: Tolerance Travelling Show by Mirko Ilic, New York | Creative Team: Angelika Eschbach-Rambow

Assignment: Part of "Tolerance Traveling Show by Mirko Ilic, New York," invited artists to create an image with their own language.

32 8TH AMENDMENT OF THE CONSTITUTION POSTER | Design Firm: Studio Hinrichs
Designer: Kit Hinrichs | Client: We The People | Illustrator/Designer: Dang Nguyen

Assignment: In celebration of the 230th anniversary of the US Constitution, 10 designers were asked to create a visualization of the Bill of Rights. Studio Hinrichs' assignment was to visualize the 8th Amendment as a poster for We The People.
Approach: The 8th amendment, which prohibits cruel and unusual punishment, was visualized as a human being peering out from behind a mask made of hard metal pieces.
Results: An exhibition was presented in New York City, on the anniversary date, with wild postings of the group of 10 posters all over the city.

33 TOCSIN | Design Firm: Studio Pekka Loiri | Designer: Pekka Loiri | Client: The mankind
Assignment: Almost the last chance to influence our future.
This poster is my personal statement, made for future generations.
Approach: I am concerned about the global climate and for all the children of the world. After designing this poster, the young, 16-year-old Swedish climate activist Greta Thunberg rose to headlines. I observed that these protests and actions go mostly unnoticed and have been branded to only attract attention.
Results: That remains to be seen, but the hurry has begun!

34 AHS: CULT – BEE EYES | Design Firm: FX Networks/Iconisus
Designer: FX Networks/Iconisus | Client: FX Networks | Production: Lisa Lejeune (FX Networks)
Photographer: Frank Ockenfels | Design Manager: Laura Handy (FX Networks)
Creative Directors: Todd Heughens (Senior Vice President, Print Design, FX Networks), Iconisus, Stephanie Gibbons (President, Creative, Strategy & Digital, Multi-Platform Marketing, FX Networks) | Art Director: Rob Wilson (Director, Print Design, FX Networks)

Assignment: A cult culture relinquishes individuality for a single leader.
Approach: This series explored the hive mind and bees, hexagons, patterns, immersion and control.
Results: The "hive" mentality creates the illusion of power as part of a larger purpose for the trapped individual and absolute power for the leader.

35 JOKER | Design Firm: Marcos Minini Design | Designer: Marcos Minini
Client: Guilherme Fernandes | Photographer: Marcos Minini

Assignment: It's a monologue about the villain at Arkham asylum. The text mixes pop culture with existentialism, citations from Sartre, Nietzsche, Shakespeare and a non stop provocation of the audience.
Approach: The image shows the joker with two faces, in anticipation of the multiple personalities and his ability to confuse with words.
Results: The season had a full audience most nights.

36 CONTEMPORARY NOH ONMYOJI-ABENO SEIMEI
Design Firm: OGAWAYOUHEI DESIGN | Designer: Youhei Ogawa | Client: DANCE WEST
Assignment: Contemporary Noh plays.
Approach: Expressing the strength of Abe Seikei by typography wrapped in flames of Abe Hideaki.
Results: Packed full, tickets sold out.

37 2018 SVA SUBWAY POSTER | Design Firms: Visual Arts Press, Ltd., Delcan & Company
Designer: Pablo Delcan | Client: School of Visual Arts | Illustrator: Justin Metz
Executive Creative Director: Anthony P. Rhodes | Creative Director: Gail Anderson

Assignment: Since the mid-1950s, SVA has been commissioning contemporary designers and illustrators to create NYC subway platform posters.
Approach: Starting in 2018, the college began asking the artists it commissioned to use the prompt "Art Is!" to create their poster.
Results: Delcan's solution was the first in this series. Delcan, an alumni and current faculty member of SVA's BFA Graphic Design department, displayed the message abstractly using computer-generated lettering.

GOLD WINNERS:

40 ARCHITEKTUR, ABSEITS (ARCHITECTURE, OFFSIDE) | Designer: Stephan Bundi
Client: Architekturforum Bern
Assignment: Interesting construction projects in the periphery.
Approach: Lecture series on unusual architecture.
Results: The poster was used for all advertising material.

41 LEANING OUT V: WOMEN IN ACADEMIC LEADERSHIP NOW | Design Firm: W&CO
Designer: Vijay Mathews | Client: AIANY Global Dialogues

Assignment: Design a poster for an annual event that conveys the spirit of the topic in an engaging manner.
Approach: To build off on the idea that the academic landscape is changing, with more women in the field taking on new roles and responsibilities. This notion was visualized by stretching and skewing letterforms.
Results: The poster creatively captured the event's intent, and was appreciated and shared socially by the participants of the event.

42 AUTO & TRUCK SERVICES — WE SPEAK AUTO CAMPAIGN | Design Firm: Lewis Communications | Designer: Spencer Till | Client: Auto & Truck Services | Illustrator: Spencer Till
Copywriter: Spencer Till | Chief Creative Officer: Spencer Till | Art Director: Spencer Till

Assignment: Continuing a series of images to be used in new print ads and posters for Auto & Truck Services, a specialty independent automotive service center in Birmingham, Alabama.
Approach: Auto & Truck's master mechanics understand cars and truck like no one else. They speak the language. Using imaginative, eye-catching typographic illustrations that physically render the speech of cars felt like a surprising way to convey this notion.
Results: By expanding on what Auto & Truck Services considers an art form, we've helped them stand out in an overcrowded, generically, and unimaginatively advertised category.

43 2019 BRIDGESTONE POSTER CALENDAR "APR" | Design Firm: Toppan Printing Co., Ltd. | Designers: Masahiro Aoyagi, Fuyuki Hashizume [TOR DESIGN] | Client: BRIDGESTONE CORPORATION | Print Designer: Akihiro Takamoto [TOPPAN IDEA CENTER]
Photographer: Tomohiro Ichikawa [TOPPAN IDEA CENTER] | Creative Director: Kohei Sakamoto [BRIDGESTONE CORPORATION]

44 THE NEW 20S | Design Firm: João Machado Design
Designer: João Machado | Client: UnknownDesign

Assignment: Self-initiated. An experimental poster about the meaning of the new 20's. The 1920s represented a revolutionary decade of world history. The "crazy twenties" were a time of huge changes in the mentality and behaviors of the population. The woman changed her attitude towards life. The hat models fit the latest cut of hair "à la garçonne"
Approach: Inspired by the fashionable lines of the 1920s. The message I wanted to pass on was to draw attention to current new trends on concepts of gender identity and sexual orientation in today's world. Human behavior is becoming less and less homogenized, free from concepts and prejudices. The masculine and feminine merge themselves.

45 ALABAMA PASTPORT POSTER SERIES | Design Firm: Tatum Design
Designers: Marion Powers, Joey Nees | Client: Alabama Bicentennial Commission | Illustrator:
David Webb | Creative Director: Travis Tatum | Copywriters: Wendy Tatum, Catherine Farlow

Assignment: The Alabama Bicentennial Commission engaged our team to create an original series of posters honoring the people, places and events that uniquely shaped Alabama counties. The county posters are a part of the larger Alabama Bicentennial PastPort Initiative, which encourages explorers to go on adventures to the state-shaping and world-changing places of Alabama history. Promoting tourism, educating young people and stirring local pride were a few of the strategic goals of the poster series.
Approach: We developed a series of posters to cleverly capture the true historical essence of local counties for the Alabama Bicentennial. To gather inspiration, we explored every corner of the state, spoke with archaeologists and historians, visited archives and immersed ourselves in history. The posters are as unique as the counties themselves. We didn't use a template or replicate a solution — each poster was inspired by the authentic character of the place it represented.
Results: The Alabama Bicentennial PastPort Initiative has been wildly successful. The Alabama Bicentennial Poster Series is now a central element of the state's curriculum for 4th grade Alabama history.

46 MAKING ALABAMA POSTER SERIES | Design Firm: Tatum Design | Designers:
Marion Powers, Joey Nees | Client: Alabama Humanities Foundation | Illustrator: David
Webb | Creative Director: Travis Tatum | Copywriters: Wendy Tatum, Catherine Farlow

Assignment: In honor of Alabama's 200th anniversary of statehood, we partnered with the Alabama Humanities Foundation to create the Making Alabama Traveling Exhibit and the Making Alabama Poster Series. The exhibit traces the entirety of Alabama history. The objective was to immerse explorers of all ages in Alabama history like never before with interactive touchpoints and larger-than-life-artwork.
Approach: We organized centuries of Alabama history into distinctive eras, named the time periods and created custom collage illustrations for each one, reflecting the predominant themes of the era. Each collage would serve as a panel of the exhibit and a poster in the series.
Results: The thought-provoking, challenging and whimsical designs have reshaped the modern understanding of our state's complex history. The Alabama Humanities Foundation touts the posters for representing the broad sweep of human experience rather than fixating on the legendary characters who often dominate our history.

**47 CAPE AIR: CONNECTING THE CARIBBEAN, HURRICANE RELIEF, MARIA & IRMA
2017** | Design Firm: Photon Snow LLC | Designer: Natasha Rethke | Client: Cape Air, Hyannis Air
Service, Inc. | Chief Creative Director: David Harris | Artist: Natasha Rethke

Assignment: Create a poster displaying Cape Air's long-standing commitment to servicing the Caribbean. The natural disasters inflicted by Hurricanes María and Irma onto the islands made this airline indispensable to the Caribbean community. Cape Air's dedication to connect the Caribbean community was honored.
Approach: A traditional poster design style, evocative of the nostalgic age of passenger aircraft travel is created. Heroic and dynamic imagery are essential elements to convey this intense story of destruction, relief and rebuilding. Dense with information, all graphic elements are carefully selected. The image of the sun and hurricane motif create the sense of a dynamic climate. The dominant image of the indigenous, feral, Paso Fino horse exemplifies strength and survival throughout history. The drawing if the aircraft is specifically the model of the Cessna 402C flown, positioned with the Cape Air headquarters in Puerto Rico and represented by the flag, with the regional route map.
Results: A reminder the ongoing effort to connect, aid and rebuild the much loved Caribbean community, the promise made by Cape Air.

48 THE LEGEND OF SLEEPY HOLLOW | Design Firm: Peter Diamond Illustration
Designer: Peter Diamond | Client: Black Dragon Press | Main Contributor: Peter Diamond

Assignment: The assignment was to create a collector's poster commemorating Washington Irving's classic 1820 short story 'The Legend Of Sleepy Hollow' in a fresh way, easily distinguished from existing interpretations of the story in film and television.
Approach: In order to make this poster stand out among other 'Sleepy Hollow' material, I chose not to portray the Headless Horseman, instead depicting the climax when Ichabod Crane is struck with the Horseman's pumpkin, thus setting the Horseman outside the frame. That this scene is reminiscent of the Headless Horseman's own demise by decapitation helps to suggest more of the back-story, and the simultaneously morbid and humorous tone is intended to capture the story's spirit.
Results: Due perhaps to the impact of the unusual composition, the design found good traction on social media, getting more traffic than any of the client's previous publications. The posters sold out quickly.

49 COPPELIA | Design Firm: Carmit Design Studio | Designer: Carmit Makler Haller
Client: Haller Metalwerks | Photographer: Klubovy | Photo Editor: Carmit Haller

Assignment: Delibes' ballet is about a doll named Coppelia, who sits on her balcony all day reading and never speaking to anyone. A boy named Franz falls deeply in love with her and wants to marry her, even though he is already engaged to another woman. His fiancée decides to take action by pretending she's the doll, in order to gain back his love.
Approach: Coppélia was based on German writer E.T.A. Hoffmann's story "Der Sandmann"(1816; "The Sandman"), a dark psychological fantasy concerning a man's destructive infatuation for a lifelike mechanical doll. The approach here explores that dark and eerie side of the story, instead of Delibes' musing and sweet-tempered version.

50 WE CREATE BEAUTY | Design Firm: Woosuk University
Designer: Mi-Jung Lee | Client: Self-initiated

Assignment: Poster for Beauty Design Major at Woosuk University.
Approach: Beauty design classes teach makeup and scientific skin care and theory research. The image symbolizes beauty by expressing the figure in touch, texture and color.
Results: It was used as a poster for promoting the beauty design major.

51 DESIGN RESEARCH AND WRITING | Design Firm: Monash University
Designer: Gene Bawden | Client: Self-initiated

Assignment: Draw attention to research events held at the university, especially for design academics.
Approach: Imagery was sourced from various archives and repositories to reflect the provenance of research within an established Australian University. The images would also reference in direct or subtle ways particular themes being discussed.
Results: A series of posters made cohesive through recurring but adaptive typography, and a thematic imagery style.

52 DESIGN SUMMER 10 | Design Firm: Kari Piippo
Designer: Kari Piippo | Client: Hesign International/Hangzhou

Assignment: 10 years of Design Summer is a workshop in Hangzhou, China, focused on poster design.
Approach: Some 80 students, mainly Chinese, attend each year. Tutors are internationally renowned poster designers and were invited to design an Anniversary poster for this event.
Results: The cat reflects a young designer who is ready to show his nails.

53 DESIGN IS LANGUAGE | Design Firm: hufax arts | Designers: Fa-Hsiang Hu,
JingYan Zhong, Cing-Fang Lin, Woody Hu | Client: China University of Technology
Executive Creative Director: Fa-Hsiang Hu | Art Director: Alain Hu

Assignment: The poster for China University of Technology Graduate Institute of Visual Communication Design to enroll new students in 2019.
Approach: How does visual communication design affect students and the general public? We believe that contemporary designers need to understand visual language and excel at communication.
Results: We attract more students interested in visual communication. And establish a better professional image of China University of Technology Graduate Institute of Visual Communication Design.

54, 55 KOREAN TRADITIONAL DANCE GRAPHIC SEMINAR
Design Firm: Hansung University Design & Arts Institute | Designer: Seung Min Han

Client: **Self-initiated**

Assignment: It is a poster for "Korean Traditional Dance Graphic Seminar." It expresses the spirit of Dosalpuri Dance. a traditional Korean dance.
Approach: The aesthetic core concept of Korean traditional dance 'Dosalpuri Dance' is "Joy." Dosalpuri Dance is a dancing with the purpose of purifying sorrow. I visualized the lines of transformation that are positive in Korean traditional dance.

56 21ST CENTURY KOREAN CULTURE FORUM | Design Firm: Woosuk University
Designer: Mi-Jung Lee | Client: Korea Foundation for Cultures and Ethics

Assignment: This poster aims at Korean Culture Forum in the 21st century.
Approach: It symbolizes traditional and cultural values communicating with citizens with redesigned traditional Korean patterns to form images.
Results: This poster is for promoting the beauty design major in 2019.

57 AMERICAN HORROR STORY: APOCALYPSE | Design Firm: ARSONAL
Designer: ARSONAL / FX Networks | Client: FX Networks | Production Manager: Lisa Lejeune
(FX Networks) | Photographer: Frank Ockenfels | Design Manager: Laura Handy (FX Networks)
Creative Director: ARSONAL, Stephanie Gibbons, President (FX Networks), Todd Heughens,
SVP (FX Networks) | Art Director: ARSONAL, Michael Brittain, VP (FX Networks)

Assignment: Play with the theme of the Antichrist and his potential connections to past seasons of American Horror Story.
Approach: We landed on art that represented the birth of this season's central figure, the Antichrist, hinting at the evil to come.
Results: This campaign mirrored the same bold palette of the iconic Season 1 American Horror Story poster and was equally provocative.

58 GREAT SAGE EQUALLING HEAVEN | Design Firm: Dalian RYCX Advertising Co., Ltd.
Designer: Yin Zhongjun | Client: Heiwa Court | Creative Director: Yin Zhongjun

Assignment: Monkey King is a world-famous classical mythological figure in China's four famous works. In China, it is a household name.
Approach: The symbolic face of Chinese Peking Opera combines the of dyeing Paper-cut Art, which sets off the aloof charm of the protagonist. The fit of the font enriches the diversity of the dramatic faces.
Results: The work received good reviews.

59 FILLMORE JAZZ DRUMMER | Design Firm: Michael Schwab Studio
Designer: Michael Schwab | Client: Steven Restivo Event Service, LLC

Assignment: To create the fourth in a series of street banners and posters portraying and celebrating the romantic past of this historic Fillmore Street neighborhood and its unique, cool jazz culture.

Approach: Michael wanted to create a timeless jazz musician portrait for The Jazz Festival - one that could have been designed back in the 1940's or 50's. His graphic style portrays a drummer deeply in a solo performance.

Results: Michael's Fillmore Jazz Festival posters have been collected by festival visitors for many years - and this year is no exception.

60 ANIMAL KINGDOM S3 | Design Firm: ARSONAL | Designer: ARSONAL
Client: TNT | Creative Director: ARSONAL | Art Director: ARSONAL

Assignment: TNT was looking for a compelling, iconic image that would continue the visual theme from seasons 1 and 2 of using fire to convey the literal and figurative combustible nature of the show, and tie it into the show's surf culture setting.

Approach: Looked for visual cues captured the intense energy and danger of the show and could incorporate the previous seasons' visual themes. We landed on an underwater shot that is ambiguous as to identity but clear in it's volatility. The colors imply fire without actually showing it.

Results: Show premiered in May with fans anxiously awaiting its return.

61 POSE - BLANCA | Design Firm: Icon Arts | Designer: FX Networks / Icon Arts
Client: FX Networks | Production: Lisa Lejeune (FX Networks) | Photographer: Pari Dukovic
Design Manager: Laura Handy (FX Networks) | Creative Directors: Todd Heughens (Senior Vice President, Print Design, FX Networks), Stephanie Gibbons (President, Creative, Strategy & Digital, Multi-Platform Marketing, FX Networks), Icon Arts
Art Director: Michael Brittain (Vice President, Print Design, FX Networks)

Assignment: Pose revolves around the Harlem ball culture of the mid 1980's, which was both a celebration and send-up of super models from the pages of magazines, like Vogue. The people who "walk" the balls are gay and transgender people of color. They do not feel seen, accepted or beautiful in their everyday lives, but when they "walk" they feel like their most authentic and most glamorous, beautiful selves.

Approach: Capture and even heighten that feeling of authenticity and glamor in our marketing campaign. Pose features the largest transgender cast ever assembled for a scripted series. In this photo, photographer Pari Dukovic was able to capture a feeling of movement in-camera by actually moving the camera just slightly while shooting. Blanca is one of the main transgender female characters in the show and is featured here looking and feeling her most glamorous.

Results: The key art campaign was extremely well-received and the show was far more successful than anticipated.

62 THE MAN IN THE HIGH CASTLE S3 | Design Firm: ARSONAL | Designer: ARSONAL
Clients: Amazon Prime Video, Mike Chen, Sr. Brand Manager, Andrew Meengern, Brand Manager, Jean Ly, Campaign Manager | Photographer: Frank Ockenfels
Creative Director: ARSONAL, Sarah Hamilton, Group Creative Director (Amazon Prime Video), Patrick Raske (Amazon Prime Video) | Art Director: ARSONAL, Aaron Goodman, Sr. Art Director (Amazon Prime Video)

Assignment: As the campaigns for S1 and S2 did the heavy lifting to setup the dark and oppressive world of Man in the High Castle, the campaign for S3 provided an opportunity to evolve the tone to be more hopeful and positive. A key focus of the campaign was to be the rebirth of the Resistance, thereby providing viewers with something to root for.

Approach: To counter the complex nature of the show, we looked to create a simple message focused on the key themes of hope and rebellion.

Results: A lot of positive feedback from the client and on social media.

63 NO DEFORESTING AND PROTECT ANIMALS | Design Firm: ZhaoChao Design
Designer: Chao Zhao | Client: The 12th international poster triennial in Toyama

Assignment: For the sake of its own interests, human beings have been felling the trees of nature, causing harm to all kinds of animals living in the forest and destroying their homes on which they live. The goal of the poster is reminding people to say no to deforesting, to protect animals and to protect their homes.

Approach: The wood grain forms the shapes of all kinds of animals and the work combines the wood grain with the English title of writing. It reminds people to protect animals and to protect their homes.

Results: The posters vividly expresses the phenomenon of deforestation and the gradual demise of animals, leaving a deep impression on people and inspiring their environmental awareness.

64 LIFE&PEACE | Design Firm: Tsushima Design | Designer: Hajime Tsushima
Client: Japan Graphic Designers Association Hiroshima

Assignment: A peace poster for the Peace Poster Exhibition to be held annually in Hiroshima.

Approach: By facing environmental problems, I believe that many lives will be saved and reach peace. I designed LIFE and PEACE typography with images cracked into glaciers and deteriorating the environment.

Results: A lot of people attended and it conveyed a message of peace.

65 GOLF TOURNAMENT | Design Firm: FleishmanHillard
Designer: Buck Smith | Client: Self-initiated

Assignment: FleishmanHillard holds a corporate golf tournament every year with proceeds benefiting a local charity. They needed a poster to advertise the event and recruit golfers.

Approach: The goal was to portray golf in a unique way, to gain the attention of everyone, from golfers to people who typically weren't interested in playing in the tournament. Inspired by Bauhaus poster design the sun, flag, the golf ball and its shadow are represented by simple shapes. All type and elements align along two intersecting angles.

Results: A large number of employees registered to play, many who were not passionate golfers. A significant donation was made to a local charity.

66 THE TRUE STORY OF AH Q | Design Firm: Daisuke Kashiwa | Designer: Daisuke Kashiwa
Client: Japan Book Design Award 2018 | Illustrator: Daisuke Kashiwa

Assignment: This is a poster for participating in the competition "Japan Book Design Award 2018".

Approach: I designed Lu Xun's "The True Story of Ah Q" themed poster. I submitted this work to category of literature poster design.

Results: This work won the award of Silver Book given to excellent works at the category. The exhibition of winning works was held at Takashi Akiyama Poster Museum Nagaoka, Niigata, October 2018.

67 SAN FRANCISCO ANTIQUARIAN BOOK FAIR 2019 POSTER
Design Firm: Studio Hinrichs | Designer: Kit Hinrichs
Client: Nancy Johnson Events Management | Illustrator: Zoey Li

Assignment: Created a poster for San Francisco Antiquarian Book, Print & Paper Fair 2019.

Approach: Poster is the 5th in series of interpretations of the letter "A". This time, the Antiquarian "A" is a collage of book-covers, ephemera and historic antiquarian imagery.

Results: Now an integral part of an antiquarian collector series.

68 IMPROVÁVEIS (UNLIKELY) | Design Firm: Marcos Minini Design
Designer: Marcos Minini | Client: Rodolpho Pajuaba

Assignment: Unlikely is a series of talks between two people who do not know each other about art, culture, life and all between it.

Approach: Inspiration comes from chaos theory, where flapping wings of a butterfly in one place— in the world can trigger unexpected reactions elsewhere on the planet. It suggests the driving of these conversations, which always have a planned starting point, but never an end point.

69 HIGH SCHOOL TO ART SCHOOL (HS2AS) ALUMNI EXHIBITION POSTER | Design Firm: For Good Measure | Designers: Kevin Chao, Sean Danz | Client: Queens Council on the Arts

Assignment: Exhibition poster for the alumni of Queens Council on the Arts' social program, High School to Art School (HS2AS), that provides free portfolio building programs for low income High School students in NYC to prepare them to get into the top art schools in the country. The exhibition is meant to highlight the "next steps" that HS2AS students took with their careers after the program.

Approach: Our creative director is an alumni himself and developed custom display typography with staggered "steps" in the letter-forms to represent graduating from the program to supplement the "next steps" theme.

Results: What started out as a poster quickly became reformatted into the exhibition branding itself including variations on the custom letterforms to create takeaways, stickers, postcards, and more.

70 TDC PHENOTYPES EXHIBITION POSTER | Design Firm: Attic Child Press, Inc.
Designer: Viktor Koen | Client: Type Directors Club | Illustrator: Viktor Koen

Assignment: Phenotypes, showcases Viktor Koen's obsession with composing images, symbols, and concepts into typography for the last twenty years. This Type Directors Club exhibition is a trilogy composed by Artphabet, Sciphabet and Steam Punkphabet as works in progress.

71 KEEP MOVING | Design Firm: Moniker
Designer: Nate Luetkehans | Client: Design Museum of Chicago

Assignment: This poster was for the Chicago Design Museum's upcoming exhibition Keep Moving: Designing Chicago's Bicycle Culture.

Approach: Create a poster that combines cycling with a local approach that will resonate with a Chicago audience.

Results: It set out to represent the clutter of using a bicycle in a city with a nod to Chicago's iconic Cloud Gate by artist Sir Anish Kapoor.

72 BEYOND | Design Firm: Melchior Imboden
Designer: Melchior Imboden | Client: Toyama Invited Poster Exhibition

73 TROJAN HORSE | Design Firm: Dankook University | Designer: Hoon-Dong Chung
Client: Posters of Troy 2018 | Art Director: Hoon-Dong Chung

Assignment: This work is for "Posters of Troy 2018" Exhibition, with the 20th anniversary of Troy's inclusion in UNESCO world heritage list.

Approach: 'The Head' on 'T' as the initial letter of the Troy conveys symbolic imagery of the Trojan War.

Results: This work got good reviews on the design field.

74 STANCE: DESIGN AGAINST FASCISM | Design Firm: Underline Studio
Designer: Fidel Peña | Client: Sur Gallery | Creative Directors: Fidel Peña, Claire Dawson

Assignment: We were one of nine Toronto-based artists and designers— working with themes relevant to marginalized and under-represented communities in Canada— asked to reinterpret two of the posters in the 1973 Chilean poster art exhibition Por la Vida...Siempre! (For Life... Always!). Stance: Design Against Fascism, brought current societal challenges such as polarization, radicalization, the rise of white nation-

alism and fascist tactics to the foreground. It creates a space for an audience to question how far we have truly advanced from the ideological dogmas of the past and how they continue to shape our current political, social and economic realities.

Approach: Our solution was to reinterpret the original posters in a clean and direct manner to encourage an urgent response from the audience.

Results: The exhibition was a success in terms of visitors and attention received in the media. Canadian Art Magazine listed it in its must see shows at the time in Canada, and it greatly helped increase the conversations designers are having about our role in our current political times.

75 CITY FACE: PARIS | Design Firm: Creplus Design | Designer: Hao SHAN
Client: City Face Poster Design Exhibition | School: ECUST School of Art Design&Media
Creative Director: Hao SHAN | Art Director: Wei YU

Assignment: With your unique vision, design a poster themed "CITY FACE" for the city you know well.

Approach: A city's trash can represents a city's face to some extent. The photo in the poster was taken at the Paris metro station. Paris is a city full of contradiction, although Parisians exclaim loudly that they don't like or even resist American culture, just as Mickey Mouse balloon and Coca-Cola thrown into the trash, they cannot help going to Disneyland, drinking Coca Cola, eating McDonald's, smoking Marlboro and watching American movies It's ironic that they claim they don't like American culture. This is exactly Paris, full of French style.

Results: This Poster show a different Paris, reflecting an inconsistent mentality incisively and vividly with visual language.

76 LONGGANG 40 | Design Firm: Dankook University | Designer: Hoon-Dong Chung | Client:
Hakka Impression International Poster Invitation Exhibition | Art Director: Hoon-Dong Chung

Assignment: This work is for Hakka Impression International Poster Invitation Exhibition. The goal was to convey the achievements of urban development in Longgang District of Shenzhen city for 40 years.

Approach: Symbolizing the multi-directional development.

77 YOSSI LEMEL THE LAST CHASSID OF RADOMSKO | Design Firm: Yossi Lemel
Designer: Yossi Lemel | Client: Jan Koniarek Gallery, Trnava, Slovakia

Assignment: I designed a poster for my solo exhibition in Jan Koniarek Gallery in Trnava, Slovakia

Approach: The exhibition describes the journey I made in the footsteps of my Grandfather that was an important Rabbi in the Chassidic court in the city Radomsko in Poland. All 50,000 members of this court including my Grandfather were murdered during the Holocaust. In the exhibition I dressed up like an orthodox Rabbi and recreate the life of the Chassidic court and the Grand Rabbi that no longer exist. In the poster there is a self portrait of me as a Grand Rabbi from behind

78 PAIN | Design Firm: Randy Clark
Designer: Randy Clark | Client: Taiwan Poster Design Association

Assignment: I received an invitation to design a poster for an exhibition in Taiwan. I was given creative control over what I wished to express.

Approach: To explore the different facets of Love and Peace, including negative emotions, such as hate. Since I have been teaching in China for a number of years, I am always fascinated by their beautiful and express typography. As such, I incorporate more of their type into my work.

Results: I understand the exhibition was well received and attended.

79 45TH TELLURIDE FILM FESTIVAL | Design Firm: Pirtle Design
Designer: Woody & Lucas Pirtle | Client: Telluride Film Festival

Assignment: Create a poster for the 45th Telluride Film Festival that focuses on an ionic building on the main street in this beautiful Colorado mountain town.

Approach: We chose to use the tower of the courthouse to link film and the location of the festival.

Results: By using a gorgeous photograph of the surrounding environment and linking film to the tower on main street, we created an interesting and unexpected juxtaposition of location, iconography and the festival.

80 WAGASA | Design Firm: João Machado Design
Designer: João Machado | Client: UnknownDesign

Assignment: Self-initiated

Approach: Wagasa means the Japanese old style umbrella. Other than its utility, oil-paper umbrellas appear quite often in Japanese culture, and are often associated with geisha, traditional dance, tea ceremony, and daily utility including wedding ceremony.

81, 82 GRAN FIRA DE VALÈNCIA 2018 | Design Firm: Ibán Ramón
Designer: Ibán Ramón | Client: Ajuntament de València

Assignment: Although the origin of La Gran Fira is a traditional festival, it is currently a summer festival of diverse and heterogeneous content. The proposal was a contemporary response, coherent with current reality.

Approach: Four variations of the main poster in four colors introduce the series in which the Grand Fira is the main visual argument.

Results: The update of an image that focuses on the effective communication of its contents and the projection of a current identity.

83 YOUR WEST STOLE MY EAST AWAY | Design Firm: Ariane Spanier Design
Designer: Ariane Spanier | Client: Typomania Moscow

Assignment: Invitational poster contribution on the subject "EAST WEST" for the typography festival Typomania in Moscow, in 2018, silkscreen on metallic paper, 70cm x 100 cm.

Approach: East and West are, while geographical terms, highly political and often part of the narrative of people's identities. In the simple yet accusing phrase "Your West Stole My East Away" are many of these issues expressed. This poster reflects on that but also questions the terms as such by using "My" and "Your," because speaking of directions, "East" and "West" are always depending on the way you turn your head or the map.

Results: The posters from the contributors were exhibited at the festival venue and used in promotional items for the event.

84 KADIKÖY MURAL FESTIVAL 2018 | Design Firm: Erman Yılmaz
Designer: Erman Yılmaz | Client: Kadıköy Municipality

Assignment: Mural Istanbul is Turkey's first mural festival and every year there are various artists from around the world. Organized through the support of the Kadıköy Municipality, Mural Istanbul is one of the city's most prominent street art festivals.

Approach: It's about the street art and street culture festival

85 SKUPI THEATER FESTIVAL | Design Firm: EGGRA | Designer: Ngadhnjim Mehmeti
Client: Skupi Theater Festival | Illustrator: Igor Nastevski

Assignment: Skupi Theater Festival takes place every year during the first week of November in different venues in the city of Skopje. The main program each year presents a selection of eight to ten performances, offering a diverse range of professional theatre productions, where the institutional and the non-institutional theatres are equally present.

Approach: Skupi festival is opening the doors of theater with love...Even if there are obstacles.

86 I'VE BEEN COMPROMISED | Design Firm: Mark Sposato Graphic Design
Designer: Mark Sposato | Client: Houndstooth Studios

Assignment: Design a unique, attention-grabbing poster for the short psychological thriller, "I've Been Compromised," which had its world premiere at the Big Apple Film Festival and is also an Official Selection at the Garden State Film Festival.

Approach: I co-wrote and co-directed the film with my wife Courtney, so I'm very close to the material. As a designer, it was important to me that our poster be thematically relevant and conceptually clever. Since our film is a psychological thriller that deals with a fractured psyche, I chose to cut up an image of our protagonist in a way that's reminiscent of a document sent through a paper shredder.

Results: We've received a lot of positive feedback. It was featured on SVA's Instagram account for Type Tuesday. It kicked off a social promotion campaign using the same key art with an extension of the title treatment that employed redaction in addition to shredding as a method of "compromising" the letterforms. We had a great turnout at our premiere. It will be featured in a book on poster design, published by Bloomsbury.

87 JOSEPH PULITZER, VOICE OF THE PEOPLE
Design Firm: IF Studio | Designers: Toshiaki Ide, Hisa Ide | Client: Oren Rudavsky Productions,
American Masters Pictures | Project Manager: Athena Azevedo
Design Directors: Toshiaki Ide, Hisa Ide | Creative Directors: Toshiaki Ide, Hisa Ide

88 BILL-E'S — PIGTAILS CAMPAIGN | Design Firm: Lewis Communications
Designer: Ryan Gernenz | Client: Bill-E's | Retoucher: Anthony Morrow, PXL. HOUSE
Project Manager: Miranda Coifed | Photographer: Steve Belkowitz | Other: Beth Beverly,
Diamond Tooth Taxidermy | Copywriters: Jason Corbin, Patton Smith | Chief Creative Officer:
Spencer Till | Brand Strategy: Jennifer Dira | Art Director: Ryan Gernenz | Agency Producer:
Christina Terrell | Executive Creative Director: Stephen Curry

Assignment: William "Bill E" Stitt has given his bacon focused, laid back, show up as you are and let-it-all-hang-out restaurant a new name, his — BILL-E's —and needed a campaign to promote it.

Approach: As Bill-E's long-time ad agency we were up for the challenge. We wanted something that was bold, loud, gluttonous and like his bacon sizzled. So the team of Jason Corbin, ACD/Copy; Ryan Gernenz, ACD/Art; and Patton Smith, Sr. Copywriter went to work developing several concepts before ultimately landing on the oddly humorous yet highly effective "pigtails" work featured here.

Results: Recently launched, the campaign has already generated significant buzz in the local community, both online and in-restaurant.

89 BOTTLE CAP AND HASHI FLAG | Design Firm: Angry Dog
Designer: Rafael Fernandes Client: Nippon Bebidas | Creative Director: Rafael Fernandes
Copywriter: Rafael Fernandes | Art Director: Rafael Fernandes

Assignment: Months after its launch, Nippon Bebidas, Brazilian importer of Japanese beverages, also began to import Japanese food.

Approach: Due to the success of the launch campaign, we decided to take the same approach by adding a hashi to the composition.

90 MI CAMPO TEQUILA "PAPEL PICADO" POSTER (18X24 INCHES)
Design Firm: Sandstrom Partners | Designer: Steve Sandstrom
Client: Mi Campo/Constellation Brands | Project Manager: Robin Olson | Illustrator: Raul Urias

Assignment: Mi Campo means My Field or My Country. It also means My Area of Expertise.

Approach: The illustration by Mexican artist Raul Urias, is a visual interpretation of the name and the pride within its meanings.

Results: The elements that make up the illustration refer to the makers and their passion, the processes involved in creating the tequila, the distillery and its natural setting, and the mythology and culture of Mexico.

91 AGER PALMENSIS | Design Firm: Andrea Castelletti | Designer: Andrea Castelletti
Client: Fonti di Palme | Photo Retouching: Studio Cirasa | Photographer: Studio Cirasa
Copywriter: Andrea Castelletti | Art Director: Andrea Castelletti

Assignment: Present and drive attention to the new identity.

Approach: The precious labeling, with the distinctive and iconic design of the Fonte di Palme Premium Mineral Water, evokes the history of the very ancient city of Palma. The campaign was inspired by a poetry wrote in 1950 by the founder of the company.

Results: Remarkable increase of the brand awareness and sales

92 EXEKIAS | Design Firm: Gottschalk+Ash Int'l AG
Designer: Sascha Lötscher, Jacqueline John | Client: Archeological Collection

Assignment: Exekias is a potter and painter who signed his work. He lived 550 bc in Athens. Worldwide there are forty pieces around, twenty of them are shown at the first monographic exhibition, at the Archeological Collection in Zurich. G+A was asked to design all visual communication for this exhibition on Exekias.

Approach: Exekias signed his work with the words "Exekias painted and made me". We proposed it as name for the exhibition.

Results: As they are very antique, old, these vases are pached together from single pieces. This and the duality – painter and potter – is what the poster expresses. We split up the subject in different pieces. There are pieces focusing on the form of the vase and others on the painting aspects of this great artist: Exekias painted and made me.

93, 94 STUDIO OUT OF OFFICE | Design Firm: Superunion | Designer: Ben Ross
Client: Self-initiated | Executive Creative Director: Ross Clugston

Assignment: This series, part of an ongoing internal engagement initiative, Studio Out of Office, was produced to promote a studio visit to "The Senses: Design Beyond Vision" at the Cooper Hewitt Design Museum.

Approach: The posters embody the abstract phenomenon of sensory perception in fun, ironic, self-referential ways. Surreal typographic compositions evoke unique aspects of each sense. The densely layered stylistic approach results in a whimsical and uncanny take on the five senses.

95 ROOTS AND ORIGINS | Design Firm: Superunion | Designer: Sam Ratcliffe
Client: London Symphony Orchestra | Senior Designer: Marc Spicer
Executive Creative Director: Stuart Radford | Account Management: Miki Nathan

Assignment: Create a campaign to promote the London Symphony Orchestra's 2019/20 season. The encompassing theme of the season is Roots and Origins, an exploration of the origins of classical music,. Fundamental to the campaign is the new visual identity launched two years ago, which reinterprets motion capture data in collaboration with a different artist every year, communicating the emotion and experience of an LSO performance in new and unexpected ways.

Approach: We developed a simple 'Back to our Roots' idea to convey the theme – a simple "reverse bloom" narrative for the new season's film, sees an abstract interpretation of a full bloom scene trace it's growth all the way back to its source, the seed. The foliage tracks it's way to the seed following the movement of the conductor and his baton, and, moments of bloom echo the details of the orchestra's performance. ■ The set of five posters appear sequentially, with the first, a fully boomed scene. This scene then gradually reduces across the series, ending in seed form.

Results: The season program was announced in January 2019, with a campaign across print, film, and online. It was well received upon launch.

96 JAZZ 2019 ART BLAKEY | Design Firm: Finn Nygaard
Designer: Finn Nygaard | Client: Aarhus International Jazz festival

97, 98 ACADEMY CONCERTS 1-7 SEASON 2018/19 | Design Firm: Ariane Spanier Design
Designers: Ariane Spanier, Stephie Becker, Romain Fontaine |
Client: Orchestra of the National Theatre Mannheim | Creative Director: Ariane Spanier

Assignment: Graphic identity for the 2018/19 season for the classical concert series of the orchestra of the National Theatre Mannheim. We created 3-D visuals resembling musical instruments. The black numbers are part of the visual identity of the orchestra which we designed using elements of musical notes, they mark the number of each concert in a season.

Results: The client and audience reaction and feedback was very positive to this unusual visual approach for a classical concert series.

99 ARCADE FIRE POSTER | Design Firm: Owen Gildersleeve | Designer: Owen Gildersleeve
Client: Another Planet Entertainment | Art Director: Jessica Rogers | Agency: Levine/Leavitt

Assignment: Owen was asked by US promoters Another Planet Entertainment to create a limited edition poster for Canadian Indie rock band Arcade Fire and special guest, Grizzly Bear.

Approach: The design was inspired by the band's latest album Everything Now, with Owen creating a bespoke typeface for all the text with a fittingly retro-future feel, as well as reinterpreting a selection of the logos from the record. The design was drawn up digitally and then handcrafted

out of paper, using a range of layers to add an interesting visual depth.

Results: The final poster was a huge hit both with Another Planet Entertainment and with the bands, who were given copies of the poster by the promoters as a thank you for playing the show.

100 AU JAZZ ORCHESTRA | Design Firm: Chemi Montes
Designer: Chemi Montes | Client: AU Department of Performing Arts

101 BANDURIST CAPELLA OF UKRAINE - 100 YEARS ANNIVERSARY
Design Firm: Gutsulyak.Studio | Designer: Yurko Gutsulyak
Client: The National Honoured Bandurist Capella of Ukraine

Assignment: In 2018 The National Honoured Bandurist Capella of Ukraine celebrated its 100 years anniversary. It is the biggest and oldest music band of the country. The poster was created to announce a special concert tour dedicated to this occasion.

Approach: Poster idea inspired by Ukrainian Avant-Garde art that was born in the same period of time - about 100 years ago. Folk art influence that is typical of this style helps to reflect repertoire of the band - traditional and patriotic songs of Ukraine. The main element of the design is bandura (musical instrument) with a sound hole in the shape of "play" button as an allusion to an integration of folk and contemporary music.

Results: Visual communication of the anniversary tour was created.

102 JAZZ IS WOMAN | Design Firm: Wheels & Waves
Designer: Rikke Hansen | Client: Jazz in the Ruins

Assignment: Poster for the 14th edition of the Festival Jazz in the Ruins, Poland. ■ The Jazz in the Ruins is a festival of young, rising stars of jazz music and improvised music. Combining the most interesting music and graphic projects from all over the world.

Approach: Jazz can be calm, temper, sensual, seductive, tempting like women. How do you show a woman without showing a woman – and still have a erotic approach showing the feeling of affection for both women and jazz with an visual edge.

Results: Exhibited during the 14th edition of the Festival Jazz in the Ruins festival in Poland.

103, 104 ENO AUTUMN 2018 | Design Firm: Rose | Designer: Rose | Client: English National
Opera | Project Manager: Joanna Waclawski | Photographers: Matt Davis, Mark Laita,
Mads Perch, Louisa Parry, Tal Silverman, Phil Flsk, Rachell Smith | Junior Designer: Abbie Edis
Creative Director: Simon Elliott | Copywriter: Andy Rigden | Art Director: Ali Boschen

Assignment: Our brief from ENO was simple: 'make opera more accessible'. But further to research, one of the key challenges was the perception and assumption that opera is elitist, expensive and sung in a foreign language. So ENO asked us to help them break down barriers and connect them with new culturally literate audiences they should be attracting.

Approach: Our approach to marketing takes inspiration from the publishing world, where a strong, graphic approach to a cover engages buyers visually, but it's the synopsis on the back that clinches a purchase. Consequently, all campaigns now lead with the stories, and clarify that each production is either sung, or translated, into English, with tickets available for every production from only £12, to appeal to new and younger audiences.

Results: The Autumn 2018 season saw an increase of 40.5% in ticket sales year on year compared to the Autumn 2017 season. Porgy and Bess was particularly successful, exceeding box office targets by 51%. 42.7% of audiences for the season were first-time bookers. 19% of audiences were aged under 44, which represented a 13% year-on-year increase.

105 I PURITANI | Design Firm: Gunter Rambow | Designer: Gunter Rambow
Client: Oper Frankfurt | Creative Team: Angelika Eschbach-Rambow

Assignment: Opera by Vincenzo Bellini

106 DER FLIEGENDE HOLLÄNDER (THE FLYING DUTCHMAN)
Designer: Stephan Bundi | Client: Sommeroper Selzach

Assignment: Opera by Richard Wagner

Approach: The silhouette of a galleon corresponds to an inverted skull.

Results: Used for advertising material and an animation for the website.

107 KROL ROGER | Design Firm: Gunter Rambow | Designer: Gunter Rambow
Client: Oper Frankfurt | Creative Team: Angelika Eschbach-Rambow

Assignment: Opera by Karol Szymanowski

108 25 JAHRE DEXTRO.ORG | Design Firm: Dextro.org
Designer: Walter Gorgosilits (Dextro) | Client: Self-initiated

Assignment: For the 25th anniversary of Dextro.org, find an image representing the nature of the project (algorithmic, organic, non-linear) but whose simple, geometric shape appeals to a wider audience .

Approach: From the center outwards, a large number of lines grow. They attract each other, yet avoid touching one another, thereby filling the (2D-) space evenly, but not regularly.

Results: Indeed this image appeals to people, who usually don't subscribe to Dextro.org's sophisticated balances and semi-intentional compositions.

109 JUGULAR POSTER 2 | Design Firm: IF Studio | Designers: Hisa Ide, Toshiaki Ide
Client: J Squad | Creative Directors: Hisa Ide, Toshiaki Ide
Art Directors: Athena Azevedo, Kumiko Ide | Photographer: Nina Hawkins
Editors-In-Chief: Maurizio Marchiori, Max Zambelli | Managing Editor: Francesca Maltauro
Logo Designer: Zoe Pu | Executive Producers: Lucia Braggion, Amy Frankel

110 JUGULAR POSTER 3 | Design Firm: IF Studio | Designers: Hisa Ide, Toshiaki Ide
Client: J Squad | Creative Directors: Hisa Ide, Toshiaki Ide | Design Director: Hisa Ide
Art Directors: Athena Azevedo, Kumiko Ide | Artist: Magnus Gjoen
Editors-In-Chief: Maurizio Marchiori, Max Zambelli | Managing Editor: Francesca Maltauro
Logo Designer: Zoe Pu | Executive Producers: Lucia Braggion, Amy Franke

111 JUGULAR POSTER 1 | Design Firm: IF Studio | Designers: Hisa Ide, Toshiaki Ide
Client: J Squad | Creative Directors: Hisa Ide, Toshiaki Ide | Design Director: Hisa Ide
Art Directors: Athena Azevedo, Kumiko Ide | Photographer: Max Zambelli
Editors-In-Chief: Maurizio Marchiori, Max Zambelli | Managing Editor: Francesca Maltauro
Logo Designer: Zoe Pu | Executive Producers: Lucia Braggion, Amy Frankel

112 OTHER | Design Firm: Keith Kitz Design | Designer: Keith Kitz | Client: Self-initiated
Assignment: Generated as a response to the topic of identity.
Approach: A selection from an on-going project in which I make one poster a day. Each entry is a study in making and experimentation.

113 PARKER / JOTTER LONDON | Design Firm: Splash Worldwide
Designer: John Fairley | Client: Parker / Newell Brands
Assignment: Parker Jotter caters for the everyday demand of a young, lively, and quality mindful consumer, looking to take their first steps into the fine writing category. The task was to amplify the reach of Parker Jotter through new creative that increased impact, drove awareness and trial for 18-30 years olds. The creative needed to display that the new Jotter line was the ideal choice as a first fine writing pen.
Approach: Each Jotter pen is named after a different London address. The resulting creative displayed a Union Jack made up from the pens themselves. The "Jotter London" headline linked to the idea and "Just A Click Away" became a sign-off that alluded to the Jotter pen click.
Results: The creative posters appeared internationally and were transformational for the business, resulting in Parker changing all of their Jotter packaging to reflect the new creative. The posters appeared internationally.

114 JUGULAR POSTER 4 | Design Firm: IF Studio | Designers: Hisa Ide, Toshiaki Ide
Client: J Squad | Creative Directors: Hisa Ide, Toshiaki Ide
Art Directors: Athena Azevedo, Kumiko Ide | Artist: Ruby Rumié |
Editors-In-Chief: Maurizio Marchiori, Max Zambelli | Managing Editor: Francesca Maltauro
Logo Designer: Zoe Pu | Executive Producers: Lucia Braggion, Amy Frankel

115 JUGULAR COVER | Design Firm: IF Studio, Caselli Strategic Design
Designers: Fabio Caselli, Hisa Ide, Toshiaki Ide | Client: J Squad | Creative Directors: Hisa Ide, Toshiaki Ide | Design Directors: Fabio Caselli, Hisa Ide | Art Directors: Athena Azevedo, Kumiko Ide | Photographer: Max Zambelli | Editors-In-Chief: Maurizio Marchiori, Max Zambelli
Logo Designer: Zoe Pu | Executive Producers: Lucia Braggion, Amy Frankel

116 TRANSFORMATION | Design Firm: Graphic Communication Laboratory
Designer: Noriyuki Kasai | Client: Nihon University College of Art
Assignment: These posters are promotion for the art university which has various departments, fine arts, theater, broadcast, music, and design.
Approach: When students graduate, they are changed from when they entered. Because a lot of friends and professor take a chance to change when they study at this university. This poster express to change, a lot of students are transforming.
Results: Lots of people understand how to study and what to character in this art university. We think to approach, "transformation" is easy to understand. This campaigns are successful just now.

117 WIN PENCIL, DRAW RESPECT CAMPAIGN | Design Firm: Zulu Alpha Kilo | Designer: Ryan Booth | Client: One Show | Creative Director: Zak Mroueh | Art Director: Andrea Por
Copywriters: Christina Roche, Patrick Godin | Photographer: Shereen Mroueh
Retouchers: Nabil Elsaadi, Brandon Dyson | Digital Artists: Greg Heptinstall, Andrew Martin
Agency Producer: Laura Dubcovsky | Account Services: Terri Mattucci, Matt Sinuita
Assignment: To promote the One Show, we were asked to develop a campaign that targeted our toughest critics – ad creatives. Through this campaign our goal was to remind everyone why it was important to enter their work into the One Show Awards.
Approach: For today's young advertisers, they didn't fully grasp the prestige of winning a One Show pencil. To them, cultural currency was achieved when your work was featured in Buzzfeed, Fast Company or the New York Times. Not in an awards show that only spoke to industry people. ■ To help create a connection between young creative talent and the One Show Awards, we needed to remind them how important it was for their careers to win a One Show pencil.

118 JUGULAR POSTER 5 | Design Firm: IF Studio | Designers: Hisa Ide, Toshiaki Ide | Client: J Squad | Creative Directors: Hisa Ide, Toshiaki Ide | Design Director: Hisa Ide | Art Directors: Athena Azevedo, Kumiko Ide | Photographer: Silvia Saponaro | Editors-In-Chief: Maurizio Marchiori, Max Zambelli | Managing Editor: Francesca Maltauro | Logo Designer: Zoe Pu

119 BELA FISTERRA POSTERS | Design Firm: xosé teiga, studio.
Designer: Xosé Teiga | Clients: Pepe Formoso, Bela Fisterra | Creative Director: Xosé Teiga
Art Director: Xosé Teiga | Graphic Designers: Maria Toucedo, Xosé Teiga
Illustrators: Xosé Teiga, Maria Toucedo | Writer & Content Developer: Tania Pagola
Content Coordinators: Anton Castro, Modesto Fraga, Anton Pombo
Assignment: Taking the philosophy of the literary hotel Bela Fisterra, we created an element that was part of the user experience of the guests.
Approach: Based on a type of content that is composed of a text and an illustration, some writers of universal works related to the sea have been selected (Hemingway, Conrad, Melville …).Some posters were designed by mixing illustration and text.

120 HARMONY IS PEACE. BALANCE WITH PEOPLE. | Design Firm: Namseoul University
Designer: Byoung-il Sun | Client: Peace Museum in Tehran

Assignment: An exhibition at the Peace Museum in Tehran.
Approach: Harmony is peace. Balance with people.

121 GERECHTIGKEIT LIEGT IM AUGE DER ENTFREMDETEN (EQUITY IS IN THE EYE OF THE DISENFRANCHISED) | Design Firm: The Chris Aguirre
Designer: Chris Aguirre | Client: Creative Reaction Lab
Assignment: Every year, the United Nations' International Day for the Elimination of Racial Discrimination is observed on March 21. In 1960, this was the date when police opened fire at a peaceful anti-Apartheid demonstration in Sharpeville, South Africa—killing 69 people. In recognition of this day and in support of its own work for racial equity, Creative Reaction Lab is launching the second year of the Artwork for Equity Advocacy Campaign with an Exhibit and Auction.
Approach: Gerechtigkeit liegt im Auge der Entfremdeten (Equity Is in the Eye of the Disenfranchised), takes much of its inspiration from some for the most effective poster design in history—Nazi propaganda—and co-opts, reinterprets and subverts it to challenge the viewer to engage with the piece despite whatever confusion or unease they might experience. The real challenge was figuring out how to convey the disparate groups of marginalized communities seeking equity across the spectrum of venues from which they have been systemically excluded. After much research and exploration, the human eye presented itself as a concise and iconic way in which to represent all of humanity.
Results: An accessible piece informed by challenging notions.

122 MIRACLE ENDINGS | Design Firm: Traction Factory | Designer: David Brown
Client: ALS Association Wisconsin Chapter | Executive Creative Director: Peter Bell
Design Director: David Brown | Copywriter: Tom Dixon | Account Directors: David Brown, Shannon Egan | Account Executive: Whitney Marshall | Production: Christopher Dick
Assignment: Create a poster inviting the community and potential donors to a Kentucky Derby Viewing Party to raise awareness and funds for the ALS Assoc. Wisconsin Chapter and local Multiple Sclerosis chapter.
Approach: Design a moving poster that invites the viewer into the world of the Kentucky Derby and a great social cause through the use of engaging typography and imagery.
Results: The event raised $17,000 and drew 300 attendees. Both attendance and funds raised exceeded the prior year event.

123 FAMILIAR THINGS | Design Firm: Studio Geray Gencer
Designer: Geray Gencer | Client: Dogan Egmont Publishing
Assignment: Poster for the book "Familiar Things" by Hwang Sok-yong.
Approach: This poster aim to reveal the darker side of modernization through the trash picker boy living in micro-society of a rubbish dump.

124 CRUCIFIXION | Design Firm: Steiner Graphics
Designer: Rene V. Steiner | Client: Self-initiated
Assignment: The American people are being crucified in order to protect the interests of a morally bankrupt gun lobby. Meanwhile those who have the power to change this status quo of horror talk and pray, talk and pray. After each mass shooting the media goes through its now knee-jerk post-mortem of maudlin reflections which lead nowhere.
Approach: Using a cross to represent the United States, bullet holes graphically reference the price that America is paying to placate its love affair with the gun. The crucifix is also symbolic of America's peculiar brand of religiosity.
Results: The poster was designed to not only make a comment about the American gun problem but to stimulate dialogue on the issue in online forums. It proved to be a useful tool in this regard.

125 EUROPEAN ELECTION 2019 - VOTE AGAINST SHADOWS
Design Firm: Gunter Rambow | Designer: Gunter Rambow
Client: Edition Galerie Rambow | Creative Team: Angelika Eschbach-Rambow
Assignment: Political Poster
Approach: A swastika is shown as a shadow behind the European Flag.
Results: Many replies and many people ordered the print data. We hope that we encourage some people to take the European Election serious and will vote in May 2019.

126 50 YEARS SINCE THE BOOK THE GULAG ARCHIPELAGO, 100 YEARS OF ALEKSANDER SOLZHENITSYN | Design Firm: Studio Pekka Loiri
Designer: Pekka Loiri | Client: Golden Bee Moscow
Assignment: A tribute to an important series and a remarkable author.
Approach: Attempt to portray the face and reality of Soviet communism.
Results: On display at the Golden Bee show and in a few publications.

127 TOLERANCE. | Design Firm: Kari Piippo | Designer: Kari Piippo | Client: Mirko Ilic Corp.
Assignment: We need tolerance! An international poster show.
Approach: The poster depicts an atmosphere dominated by intolerance.
Results: The Tolerance Traveling Poster Show circulates around the world in many universities and galleries.

128 THE GREAT WAVE | Design Firm: Andrew Sloan
Designer: Andrew Sloan | Client: Self-initiated
Assignment: The amount of plastic, especially plastic bottles in the sea is of a great concern for all of us and for which we're all responsible.
Approach: I wanted to make an image on this particular form of pollu-

tion and environmental damage that might help keep the issue in people's minds. Hence Hokusai's print The Great Wave off Kanagawa, which is one of the world's most famous images, provides a way to achieve this.
Results: The Japanese prints of Horoshige, Utamaro and Hokusai were an inspiration to me when I was at school and developing my interest in art so it's not with great pleasure that I've reworked one of Japan's most iconic images to highlight pollution. However I'd like to think that Hokusai's passion for the sea is echoed in the sentiment of this piece of work.

129 DIFFERENCE | Design Firm: João Machado Design
Designer: João Machado | Client: UnknownDesign
Assignment: In 2011 for the Association of Graphic Designers I designed "4th Block" a poster entitled The Faces of Racism Revealed. Racism was reflected in the two F's of the word.
Approach: I decided to retake the same work, omitting two letters that make all the difference. Let's just read DIFFERENCE, placing the F's face to face, holding each other. There's no place for Indifference!

130 TOLERANCE | Design Firm: Studio Hinrichs | Designer: Kit Hinrichs
Client: Mirko Ilic | Illustrator/Designer: Dang Nguyen
Assignment: This is one in a traveling series of posters, created by hundreds of international designers, to promote global tolerance.
Approach: In order to demonstrate a divergent portrait of global mankind, a selection of ethnic and photographic elements were combined into one unified version of tolerance.
Results: Mirko has had dozens of exhibitions at universities, colleges, public parks and city centers around the world displaying the hundreds of uniquely designed posters.

131 #NEVERAGAIN | Design Firm: 21XDESIGN
Designers: Patricia McElroy, Dermot MacCormack | Client: Self-initiated
Art Directors: Patricia McElroy, Dermot MacCormack | Illustrator: Julie Lam
Assignment: This poster joins a series of social awareness posters on the subject of gun-control that we have developed over the years. As part of this exploration, we want to bring attention to the issue of gun control and the need for more effective legislation in the US.
Approach: Each poster in this series begins as a visual play on the American flag to emphasize that this is an American problem. In this iteration, we wanted to get the idea across that 14,717 lives lost, by at least that many bullets and very likely many more, is staggering.
Results: This poster and the others in the series are used to promote awareness and push for improved gun legislation. We make our posters available to non-profit organizations that promote this cause.

123 TROJAN HORSE | Design Firm: Dogan Arslan Studio
Designer: Dogan Arslan | Client: Çanakkale University
Assignment: This work was prepared for the year of Troy which was declared in 2018 by Ministry of Culture and Tourism in Turkey.
Approach: Re-imagine the meaning of the Troy war in modern times. And the poster reflects this meaning where Trojan Horse became the peaceful American soldiers in some Asian and Middle East Countries.
Results: Strong reflections regarding the poster's controversial claim.

133 SORRY WE STOLE YOUR FUTURE | Design Firm: Wheels & Waves
Designer: Rikke Hansen | Client: The 5th Annual Alborz Graphic Design Exhibition
Assignment: Poster for The 5th Annual Alborz Graphic Design exhibition. Theme: Children are the owners of the future world.
Approach: Poster title: Sorry We stole your future - We were too busy burning fossil fuels - consuming- getting richer - posting on Facebook. The poster has been quite important for me to do, especially after the the latest COP24 climate summit in Poland.
Results: Exhibited at The 5th Annual Alborz Graphic Design exhibition.

134 DISCUSSIONS ABOUT DISCUSSIONS | Design Firm: Studio Pekka Loiri
Designer: Pekka Loiri | Client: Seminario de justicia
Assignment: Poster for a Seminar. Speaking anonymously causes angry or at least vague statements.
Approach: Intention is to reach the right audience.
Results: The customer felt that the poster had aroused discussion.

135 PEACE LIVES FOREVER | Design Firm: ZhaoChao Design | Designer: Chao Zhao
Client: The International Poster Contest Dedicated to the Victory Day in World War
Assignment: The goal of the poster is to express the opposition to the war and the Cherish for peace.
Approach: The work uses the bonsai of the family beautifying the environment to express people's longing for long-term peace. It symbolizes the environment where all families can live and work without wars.
Results: Through the combination of the helmet and the bonsai in life, the poster expresses the opposition to the war and the Cherish for peace.

136 DESTINATION | Design Firm: Toyotsugu Itoh Design Office
Designer: Toyotsugu Itoh | Client: Chubu Creators Club
Assignment: Exhibit work to the poster exhibition; Theme: Destination. There are 2 phrases in this poster. One is "DESTINATION" in English, another one is "What we can see over there" in Japanese.

Approach: I drew a person's body like a hill or a mountain and one line like as a road carved on it.

137 TOLERANCE | Design Firm: Synopsis | Designer: Ovidiu Hrin
Client: The Traveling Tolerance Poster Show
Assignment: Invited to submit to the Int'l. Traveling Tolerance Poster Show produced/organized by Mirko Ilic corp. & Denise Benmosche.
Approach: "Tolerance cannot seduce the young." –Emil Cioran

138 DOMINATE/SUBMIT | Design Firm: BVK | Designer: Matt Herrmann
Client: Footstock National Endurance Barefoot Water Ski Championships
Executive Creative Director: Gary Mueller | Creative Director: Mike Holicek
Group Creative Director: Matt Herrmann | Art Director: Matt Herrmann
Copywriter: Mike Holicek | Photographer: Lucian McAfee | Retoucher: Anthony Giacomino
Assignment: Footstock is the national championship of endurance barefoot water skiing. Posters are designed to create awareness and increase attendance at the event.
Approach: Barefoot water skiing is an endurance event that borders on physical torture. Highlighting the punishment a skier's foot endures, we pursued a lighthearted "master and servant" concept in which the winner gains dominance over all the rest. Designed to feel gothic and raw.
Results: The 2018 championship boasted one of its biggest fields of bare-footers in over a decade.

139 SAINTS & STARS |Design Firm: VBAT | Designer: Graham Sturt (Creative Director) / Renata Szlachta (Creative) | Client: Health City | Art Director: Celia Rosa | Account Director: Robbert Dickmann | Copywriter: John Weich, Monumantalpropaganda | Photographer: Leon Hendrickx | Producer: Rachel Franke | Production: Luminous CI | Strategy: Andre Soff
Assignment: Create a name, brand identity, tone of voice and launch campaign for this upmarket gym. The real challenge was that they wanted to unveil the gym in their home country, the Netherlands, arguably one of the most difficult markets for luxury 'anything' on the planet.
Approach: Strategy: The Dutch are naturally averse to open displays of luxury and privilege. So while the name and concept needed to promise more than just another gym experience, it needed to do it in a way the egalitarian and collaborative Dutch could accept. Our strategy was to promote people, not equipment. ■ Creativity: Saints & Stars is an irreverent wink towards the (near) religious devotion many urban professionals have for fitness, and the star status of contemporary trainers. Motivation through numbers, individual improvement through collaboration.
Results: Saints & Stars aspires to slowly take over Amsterdam before following in its budget sister's footsteps across the rest of the Netherlands and Europe. "The agency brought our wildest dreams to life...The end result was even better than expected." —Tom Moos, CEO Saints & Stars

140 ST. LOUIS POLO CLUB POSTER | Design Firm: Ted Wright Illustration & Design
Designer: Ted Wright | Client: St. Louis Polo Club | Art Director: Suzanne Ebel
Assignment: Design a poster in honor of Steve Orthwein who passed away last year. In his honor, I was to create a piece of art showing Steve riding his faithful polo pony. Steve is a member of the POLO Hall of Fame in Wellington, Florida.
Approach: To create a graphic poster that would be used on promo posters and consumer t-shirt sales to raise money for the St. Louis Polo Club.
Results: The poster was presented to Steve's wife Ginny Orthwein at the St. Louis POLO Club dinner and prints were given to all of the members of the club as a remembrance of their dear friend.

141 NIKE POSTER | Design Firm: Creplus Design | Designer: Hao SHAN
Client: Nike | Creative Director: Hao SHAN | Design Director: Weimiao DU
School: ECUST School of Art Design&Media
Assignment: Make a visual image that is fresh and focuses on the brand features of Nike to propagandize the sports brand image of Nike.
Approach: Integrate the logo of Nike into all kinds of sports, transforming the symbols of Nike into the stairs of the athletes with good results, ribbons of gymnasts, diving platforms of divers and the peak of rock climbing. The poster is made simply with explicit features and extraordinary visual effects, clear information transfer, and shows the features of the sports and risk-taking of Nike.
Results: The visual of sports brands in the market is more and more similar. How to get a fresh and creative visual experience is the key point of the brand propaganda. The poster launch was very successful.

142 BOOMERANG | Design Firm: BET Networks | Designers: Dana Kinlaw, Alfredo Palermo
Client: Self-initiated | Creative Director: Michael Williams | Art Director: Dana Kinlaw
Senior Vice President: Kendrick Reid | Vice Presidents Brand Creative: Adrian Hilton, Josh Pelzek | Directors of Project Management: Rebecca Heineman, Seida Saidi
Project Manager: Martha Tobar | Photographer: Kareem Black | Retoucher: Mandy Strong
Assignment: Introduce our audience to the children of the characters of fan favorite film, Boomerang, and attract a new audience of millennials.
Approach: Our cast stands out from the norm, whether it's at work, life or play. But the heart has its role. Our goal was to showcase the friendships while hinting at, but not giving away, the love story.
Results: The final layout has our cast relaxing together, with past and present couples subtly reaching out to or looking at one another.

143 THE ROOMMATE | Designer: Stephan Bundi | Client: Theater Orchester Biel Solothurn
Assignment: Two women, in their late fifties, attempt to live together.
Approach: The conflict is presented in one detail.
Results: The poster was used for all advertising material.

144 LE BAL (DANCING HALL) | Designer: Stephan Bundi
Client: TOBS Theater Orchester Biel Solothurn
Assignment: Dancing over several decades.
Approach: It's about the Dancing Hall, not the dancers.
Results: Design for the Poster and Program.

145 NHO OHARAGOKO | Design Firm: OGAWAYOUHEI DESIGN
Designer: Youhei Ogawa | Client: DANCE WEST
Assignment: Announcement poster for Noh.
Approach: It is the main part of Noh. I express a scene walking six paths.
Results: Great praise.

146 SQUARE GO | Design Firm: H.Tuncay Design | Designer: Haluk Tuncay | Client: DOT Theatre
Digital Directors: The Hubvs, Tayfun Alaylıoğlu | Director of Photography: Serdar Tanyeli
Assignment: A play on friendship of two young people with different characters within process of their conflict and compromise.

147 DUET FOR ONE | Design Firm: EGGRA | Designer: Ngadhnjim Mehmeti
Client: The Albanian Theatre Skopje | Photo Editor: Igor Nastevski
Assignment: Stephanie Anderson, a world-famous violinist, becomes unable to play because of multiple sclerosis. A depressed psychiatrist she sees is unable to help with her rage and frustration. Her star pupil, realizing he will learn nothing more, leaves her. Her husband departs with his young secretary, and her accompanist dies. Her fierce desire to be alone in her pain alienates everybody except her faithful maid.
Approach: Psychiatrist is repairing a relationship like a broken violin.

148 THE CRUCIBLE | Design Firm: Chemi Montes
Designer: Chemi Montes | Client: AU Department of Performing Arts

149 FUTURE PERFECT TENSE | Design Firm: Chase Body
Designer: Chase Body | Client: Maryland Institute College of Art
Assignment: Future Perfect Tense attempts to question our attitudes and relationships towards an artificially intelligent future. (Future Perfect Tense: Indicates that an action will have been completed, finished or perfected at some point in the future.)
Approach: Completed in 2018 as a component of MFA thesis work concerning artificially intelligent technology, this poster series explores the shared characteristics of human condition and AI in an effort to spark conversation around humanizing and discussing its implications more responsibly. ■ Formal cues are taken from what has historically been popular archetypes of future-forward design—utilizing languages of the future and complex visuals of science fiction.
Results: Exploration of human-computer interaction beyond screen. It existed as a foil to the volume of digital content in the gallery space.

150 FAMILY EVOLUTION | Design Firm: Troxler Scott
Designers: Niklaus Troxler, Christopher Scott | Client: Worldwide Graphic Designers (WGD)
Assignment: Worldwide Graphic Designers are happy to announce their next project, under the title, "Family Evolution, the cornerstone of society in a new era." The International Day of Families provides an opportunity to promote awareness on issues relating to families and to increase cognition of the social, economic and demographic processes affecting them. ■ In order to participate in our new project, you have to find a partner from a different country and together create a poster that will reflect your cultural heritages diversity in relation to the theme of the project. There are no regulations or restrictions on the style that you can use. It is flexible and up to your imagination.
Approach: The approach was an experimental method on the topic of family evolution. Within this evolution are families develop around circles and forms using a vibrant color scheme and playful composition to represent that family gives people life and color.
Results: The poster will be part of an international exhibition in various countries such as Iran, Ecuador, Indonesia, Greece and more.

151 LOVE — TAKE 5 | Design Firm: Steiner Graphics | Designer: Rene V. Steiner
Client: Self-initiated | Photographer: Rene V. Steiner
Assignment: Love is complex, the underlying force of the universe some would argue. It is what brings oftentimes disparate elements together to form a functional whole. I have always equated love with beauty, and it is this sentiment that I attempt to visualize with this imagery. Love is strong — yet vulnerable and fragile.
Approach: The multidimensionality and diversity of love in its many forms is portrayed using botanical photography from the Instagram feed of Steiner Graphics encased in a typographical representation of the word "love," thereby alluding to the reality that love too evolves with the passage of time and the changing of the seasons.
Results: Response, especially on social media, exceeded expectations.

SILVER WINNERS:
154 PREMIER PROPERTIES | Design Firm: Michael Schwab Studio
Designer: Michael Schwab | Client: Premier Properties

154 HAKKA IMPRESSION | Design Firm: Wheels & Waves | Designer: Rikke Hansen
Client: Shenzhen International Poster Festival, China

154 ACTION: NO MORE WORDS | Design Firm: W&CO
Designer: Vijay Mathews | Client: AIANY Global Dialogues

154 SKURMAN ARCHITECTS | Design Firm: Michael Schwab Studio
Designer: Michael Schwab | Client: Skurman Architects

155 PHILLIPS 66 INTERNATIONAL STADIUM POSTER | Design Firm: Bailey Lauerman
Designer: Jim Ma | Client: Phillips 66 | Creative Director: Sean Faden
Art Director: Jim Ma | Copywriter: Carter Weitz | Illustrator/Designer: Casey Stokes

155 TIFFIN MOTORHOMES — DEALER SHOW POSTER CAMPAIGN
Design Firm: Lewis Communications | Designer: Spencer Till | Client: Tiffin Motorhomes
Chief Creative Officer: Spencer Till | Illustrator: Spencer Till

155 BOSCH INTERNATIONAL AEROTWIN UK POSTER | Design Firm: Bailey Lauerman
Designer: Mariah Adams | Client: Bosch International | Creative Director: Carter Weitz
Art Director: Casey Stokes | Copywriter: Michael Johnson | Illustrator: Brandon Oltman

155 2019 BRIDGESTONE POSTER CALENDAR "AGS"
Design Firm: Toppan Printing Co., Ltd. | Designers: Masahiro Aoyagi, Fuyuki Hashizume [TOR DESIGN] | Client: BRIDGESTONE CORPORATION | Creative Director: Kohei Sakamoto [BRIDGESTONE CORPORATION] | Print Designer: Akihiro Takamoto [TOPPAN IDEA CENTER] Photographer: Tomohiro Ichikawa [TOPPAN IDEA CENTER]

156 70 YEARS OF PORSCHE - LATIN AMERICA COUNTRY POSTERS | Design Firm: Markham & Stein | Designers: Jack Bagdadi, Sofia Olarra | Client: Porsche Latin America | Chief Creative Officer: Markham Cronin | Account Director: Diana Nagles | Account Supervisor: Alina Tawil | Copywriter: Karina Bagdadi | Studio: Manny Hernandez | Traffic Manager: Vanessa Doré

156 DIE NIBELUNGEN | Design Firm: Peter Diamond Illustration | Designer: Peter Diamond
Client: Black Dragon Press | Main Contributor: Peter Diamond

156 YEAR OF THE PIG | Design Firm: John Gravdahl Design
Designer: John Gravdahl | Client: Self-initiated

156 EL CHANGO | Design Firm: João Machado Design | Designer: João Machado
Client: BIENAL INTERNACIONAL DEL CARTEL EN MÉXICO (BICM)

157 BOGUCHWALA, 2008–2018, THE ANNIVERSARY OF THE REESTABLISHMENT OF THE TOWN | Design Firm: Wieslaw Grzegorczyk | Designer: Wieslaw Grzegorczyk
Client: Municipal Public Library in Boguchwala

157 OPTIK | Design Firm: Atelier Chasper Würmli
Designer: Chasper Würmli | Client: Spalentor Optik

157 TURNING SOLO | Design Firm: Flomaster
Designer: Orsat Frankovic | Client: Art Workshop Lazareti

157 SPRING DANCE WORKS POSTER | Design Firm: J David Deal Graphic Design
Designer: J David Deal | Client: Purdue Contemporary Dance Company
Photographer: Mark Simons

158 WINTER DANCE WORKS POSTER | Design Firm: J David Deal Graphic Design | Designer: J David Deal | Client: Purdue Contemporary Dance Company | Photographer: Mark Simons

158 CENTER OF DANCE | Design Firm: CAO Design | Designer: Yvonne Cao
Client: Texas Christian University | Photographer: Josh Brewster

158 STUDENT CONFERENCE 2018 "DEFORMER"(FIRE) | Design Firm: Takashi Akiyama Studio | Designer: Takashi Akiyama | Client: Tama Art University Illustration Studies

158 TAMA ART UNIVERSITY POSTGRADUATE ILLUSTRATION STUDIES, GRADUATE EXHIBITION 2018 | Design Firm: Takashi Akiyama Studio | Designer: Takashi Akiyama
Client: Tama Art University Postgraduate Illustration Studies

159 UNIVERSAL DECLARATION OF HUMAN RIGHTS POSTER
Design Firm: ThoughtMatter | Designers: Annie Kozak, Jee-Eun Lee | Client: Arte

159 STUDENT CONFERENCE 2018 "DEFORMER"(DOGS) | Design Firm: Takashi Akiyama Studio | Designer: Takashi Akiyama | Client: Tama Art University Illustration Studies

159 DE MOESTUIN (THE VEGETABLE GARDEN) | Design Firm: Art Collart Office
Designer: Art Collart | Client: Villa Zebra | Typeface: Kapra (Typoforge Studio)

159 PARIS | Design Firm: Randy Clark | Designer: Randy Clark
Client: MGC School of Design, Wenzhou Kean University

159 THINKING REAL | Design Firm: Hansung University Design & Arts Institute
Designer: Seung Min Han | Client: Self-initiated

159 TYLER SCHOOL OF ART - JAPAN WORKSHOP | Design Firm: 21XDESIGN
Designers: Dermot MacCormack, Patricia McElroy | Client: Tyler School of Art
Main Contributor: Dermot MacCormack, Patricia McElroy

159 YEAR OF THE DOG GRAD POSTER | Design Firm: Tivadar Bote Illustration
Designer: Tivadar Bote | Client: Alberta College of Art and Design

159 OPEN STUDIOS PROMOTIONAL POSTER | Design Firm: Sarah Edmands Martin
Designs | Designer: Sarah Edmands Martin | Client: Indiana University

160 10. MESSAGE ILLUSTRATION POSTER IN NAGAOKA | Design Firm: Takashi Akiyama Stuido | Designer: Takashi Akiyama | Client: Tama Art University Illustration Studies

160 16. MESSAGE ILLUSTRATION POSTER 2018 | Design Firm: Takashi Akiyama Studio
Designer: Takashi Akiyama | Client: Tama Art University Illustration Studies

160 CAPTIVE STATE | Design Firm: ARSONAL | Designer: ARSONAL
Client: Focus Features | Creative Director: ARSONAL, Blair Green (Focus Features)
Art Director: ARSONAL | Copywriter: Linda Castillo | Photographer: Parrish Lewis

160 GET SHORTY - SEASON 2 | Design Firm: Cold Open
Designer: Cold Open | Client: Epix

161 TULLY | Design Firm: ARSONAL | Designer: ARSONAL | Client: Focus Features
Creative Director: ARSONAL, Blair Green (Focus Features) | Art Director: ARSONAL
Copywriter: ARSONAL | Illustrator: ARSONAL | Photographer: Kimberly French

161 BOBCAT GOLDTHWAIT'S MISFITS & MONSTERS | Design Firm: ARSONAL
Designer: ARSONAL | Client: truTV, Kim Kahne, Sr. Director, Creative Operations, Arianny
Rodriguez, Sr. Manager, Creative Operations | Creative Directors: ARSONAL, Jim Read (truTV)
Art Directors: ARSONAL, Noël Claro (truTV), Kyle Moriwaki, Associate Art Director (truTV)
Copywriter: Michael Carnes | Marketing: Puja Vohra, EVP, Marketing & Digital (truTV), Joe
Hadari, SVP, Brand Marketing & Strategy (truTV), Leah Rubner, Director Marketing (truTV), Ali
Hayes, Sr. Manager, Marketing (truTV), Jennifer Savrides, Manager, Marketing (truTV)

161 POSE - ELEKTRA | Design Firm: ARSONAL | Designer: FX Networks / ARSONAL
Client: FX Networks | Creative Directors: ARSONAL, Todd Heughens (Senior Vice President,
Print Design, FX Networks), Stephanie Gibbons (President, Creative, Strategy & Digital,
Multi-Platform Marketing, FX Networks) | Art Director: Michael Brittain (Vice President, Print
Design, FX Networks) | Design Manager: Laura Handy (FX Networks)
Photographer: Pari Dukovic | Production: Lisa Lejeune (FX Networks)

161 WINCHESTER | Design Firm: Cold Open | Designer: Cold Open | Client: CBS Films

162 THE NUTCRACKER AND THE FOUR REALMS | Design Firm: Cold Open
Designer: Cold Open | Client: Walt Disney Co.

162 SEASON 2 KEY ART FOR THE EXORCIST ON FOX | Design Firm: Fox | Designer:
Phillip Bates | Client: Fox Broadcast Network | Chief Creative Director: Tom Morrissey | Creative
Director: Mitch Strausberg | Chief Creative Officer: Tommy Gargotta | Chief Marketing Officer:
Shannon Ryan | Art Director: Phillip Bates | Photographer: Mathieu Young | Retouchers: Moises
Cisneros, John Crawford | Artist: Thom Schillinger | Project Manager: Caitlin McGowen

162 CAPTIVE STATE | Design Firm: ARSONAL | Designer: ARSONAL
Client: Focus Features | Creative Director: ARSONAL, Blair Green (Focus Features)
Art Director: ARSONAL | Copywriter: ARSONAL

162 TROY: FALL OF A CITY | Design Firm: Cold Open | Designer: Cold Open | Client: Netflix

163 THE MUSTANG | Design Firm: ARSONAL | Designer: ARSONAL
Client: Focus Features | Creative Director: ARSONAL, Blair Green (Focus Features)
Art Director: ARSONAL | Copywriter: Linda Castillo | Photographer: Tara Violet Niami

163 MANIAC | Design Firm: Cold Open | Designer: Cold Open | Client: Netflix

163 TINY TIGHT PANTS TEXAS TED BIRTHDAY ANNOUNCEMENT
Design Firm: Ted Wright Illustration & Design | Designer: Ted Wright | Client: Self-initiated

164 THE AFTER PARTY | Design Firm: Cold Open | Designer: Cold Open | Client: Netflix

164 THIS GIANT BEAST THAT IS THE GLOBAL ECONOMY | Design Firm: Cold Open
Designer: Cold Open | Client: Amazon Studios

164 THE CURSE OF LA LLORONA | Design Firm: Cold Open
Designer: Cold Open | Client: Warner Bros. Pictures

164 HELL FEST | Design Firm: Cold Open | Designer: Cold Open | Client: CBS Films

164 BOY ERASED - GLAAD | Design Firm: Cold Open
Designer: Cold Open | Client: Focus Features

164 MAYANS M.C. - OSCAR MAGALLANES | Design Firm: FX Networks
Designer: FX Networks / Oscar Magallanes | Client: Self-initiated
Design Manager: Laura Handy (FX Networks) | Creative Directors: Michael Brittain (Vice
President, Print Design, FX Networks), Stephanie Gibbons (President, Creative, Strategy &
Digital, Multi-Platform Marketing, FX Networks), Todd Heughens (Senior Vice President, Print
Design, FX Networks) | Art Director: Sur Keath Moon (Art Director, Print Design, FX Networks)
Illustrator: Oscar Magallanes | Production: Lisa Lejeune (FX Networks)

164 HOMECOMING | Design Firm: ARSONAL | Designer: ARSONAL | Clients: Amazon Prime
Video, Michael Dawson, Campaign Manager, Evan Otis, Brand Manager | Creative Director:
ARSONAL, Mark Scheider, Executive Creative Director (Amazon Prime Video), Melissa Eccles,
Group Creative Director (Amazon Prime Video), Steve Chan (Amazon Prime Video)
Art Director: ARSONAL | Photographer: Marco Grob

164 COBRA KAI | Design Firm: Cold Open | Designer: Cold Open | Client: YouTube Originals

164 HILLSBORO RODEO | Design Firm: Ted Wright Illustration & Design
Designer: Ted Wright | Client: Hillsboro Rodeo Association

165 TRUE DETECTIVE S3 | Design Firm: ARSONAL | Designer: ARSONAL
Clients: HBO PROGRAM MARKETING, Zach Enterlin, EVP, HBO Marketing, Sono Mitchell, VP,
HBO Marketing, Alex Diamond, Director, HBO Marketing, Zach Krame, Manager, HBO Marketing
Creative Director: ARSONAL | Art Director: ARSONAL

165 EVERYBODY KNOWS | Design Firm: ARSONAL | Designer: ARSONAL
Client: Focus Features | Creative Director: ARSONAL, Blair Green (Focus Features)
Art Director: ARSONAL | Photographer: Teresa Isasi

165 MAYANS M.C. - EL MAC | Design Firm: FX Networks | Designer: FX Networks / El Mac
Client: Self-initiated | Design Manager: Laura Handy (FX Networks) | Creative Directors:
Stephanie Gibbons (President, Creative, Strategy & Digital, Multi-Platform Marketing, FX
Networks), Todd Heughens (Senior Vice President, Print Design, FX Networks), Michael Brittain
(Vice President, Print Design, FX Networks) | Art Director: Sur Keath Moon (Art Director, Print
Design, FX Networks) | Illustrator: El Mac | Production: Lisa Lejeune (FX Networks)

165 THE DARKEST MINDS - INT'L KEY ART | Design Firm: Cold Open
Designer: Cold Open | Client: 20th Century Fox

166 COMPLACENT | Design Firm: elevate design | Designer: Kelly Salchow MacArthur
Client: Self-initiated | Photographer: Kathy Salchow

166 LEAVING IMPRESSIONS | Design Firm: Superunion
Designer: Scott Lambert | Client: Self-initiated | Creative Team: Ben Ong
Account Manager: Charlotte Cheong | Translator: Jie Ni Lew

166 OCEAN X PLASTIC = DEATH | Design Firm: Jie-Fei design
Designer: Jie-Fei Yang | Client: VIDAK

166 TEMPERATURE INCREASE | Design Firm: Onur Aşkın
Designer: Onur Aşkın | Client: NBH Award

167 BUILD GREEN | Design Firm: May & Co. | Designer: Douglas. D. May
Client: VIDAK - Visual Information Design Association of Korea

167 FUTURE ENERGY | Design Firm: Tsushima Design
Designer: Hajime Tsushima | Client: World Expo Museum

167 THERE IS NO SUCH THING AS GLOBAL WARMING
Design Firm: Marlena Buczek Smith | Designer: Marlena Buczek Smith | Client: Self-initiated

167 PLASTIC OCEANS | Design Firm: Code Switch
Designer: Jan Šabach | Client: Self-initiated

168 THE EMPEROR'S NEW CLOTHES | Design Firm: Daisuke Kashiwa | Designer: Daisuke
Kashiwa | Client: Japan Book Design Award 2018 | Illustrator: Daisuke Kashiwa

168 FALLAS FROM VALENCIA | Design Firm: Yinsen | Designer: Lorena Sayavera,
María Pradera | Client: Valencia City Council, Generalitat Valenciana, Metro Valencia
Photo Editor: Lorena Sayavera | Photographer: Juan Vicent

168 MIXED_MELTED, GLOBAL ILLUSTRATION SHOW | Design Firm: DAEKI & JUN design
studio | Designer: Daeki Shim | Client: Seoul Illustration Fair - SIF | Art Director: Daeki Shi

168 TRIPLE PLAY SPECTACULAR | Design Firm: Launch Agency | Designer: Carolyn Sexton
Client: Texas Rangers and Park Place | Creative Director: David Wilgus | Associate Creative
Director: Alex Slotkin | Account Executive: Zach Deutsch | Project Manager: Alexa Perez

169 BICEBÉ 2009–2019: 10 YEARS BIENNIAL OF POSTER BOLIVIA
Design Firm: Daisuke Kashiwa | Designer: Daisuke Kashiwa
Client: The Biennial of the Poster Bolivia BICeBé | Illustrator: Daisuke Kashiwa

169 ARRÒS AMB JAZZ | Design Firm: Ibán Ramón
Designer: Ibán Ramón | Client: Grupo La Sucursal

169 VINTAGE DIMESTORE COWBOY TED WRIGHT | Design Firm: Ted Wright Illustration &
Design | Designer: Ted Wright | Client: Self-initiated | Illustrator: Ted Wright

169 SNACKMIX APOCALYPSE | Design Firm: Randy Clark | Designer: Randy Clark
Client: MGC School of Design, Wenzhou Kean University

170 SIMULTANEOUS OPENINGS | Design Firm: anacmyk | Designer: Ana Alves da Silva
Client: Porto Lazer / CMP | Photographer: Paulo Cunha Martins

170 5TH ANNUAL JURIED ART SHOW POSTER | Design Firm: Fishel Design
Designer: Peter Fishel | Client: Piedmont Center for the Arts

170 A SPOT IN THE UNIVERSE | Design Firm: dGwaltneyArt
Designer: David H Gwaltney | Client: The Virginia Museum Of Contemporary Art
Art Director: Richard Pulley | Graphic Designers: Amber White | Artist: David H Gwaltney

170 WKU OPEN HOUSE | Design Firm: Randy Clark
Designer: Randy Clark | Client: Wenzhou Kean University

171 BRAVO! 2018–2019 SERIES | Design Firm: Kunstwerk | Designer: Douglas Thomas
Client: BYU Arts | Art Director: Nick Mendoza | Typography Design: Commercial Type

171 DINNER MEETING CANOEISTS | Design Firm: xose teiga, studio.
Designer: Xose Teiga | Client: Club Naval

171 DESIGNTHINKERS - SPEAK THE TRUTH | Design Firm: Zulu Alpha Kilo
Designers: Jack Curtis, Saadia Kardar, Ryan Booth, Gala Tanaskovic
Client: Association of Registered Graphic Designers (RGD) | Design Director: Ryan Booth
Creative Director: Zak Mroueh | Art Directors: Ryan Booth, Michael Romaniuk,
Charline Fauche-Simon | Digital Artists: Greg Heptinstall, Anna Harju, Ashleigh OBrien
Copywriters: Angeline Parsons, Patrick Godin, Mark Delisi | Agency Producer: Teresa Bayley
Account Services: Erin McManus, Mike Johnson | Ad Agency: Zulu Alpha Kilo

171 JUNZO TERADA THE EXHIBITION AT URAN-DOU GALLERY 2018
Design Firm: Libido inc.& Linda Graphica | Designers: Linda Ritoh, Junzo Terada
Client: Uran-dou Gallery | Art Director: Linda Ritoh | Illustrator: Junzo Terada

172 WARHOL. THE ART OF BEING FAMOUS | Design Firm: Venti caratteruzzi
Designer: Carlo Fiore | Client: Fondazione Sant'Elia - Rosini Gutman Gallery

172 PEACE LOVE | Design Firm: Randy Clark
Designer: Randy Clark | Client: Taiwan Poster Design Association

172 EAST/WEST | Design Firm: Melchior Imboden |
Designer: Melchior Imboden | Client: International Invited Poster Exhibition in Moscow

172 16TH MESSAGE ILLUSTRATION POSTER EXHIBITION 2018
Design Firm: Daisuke Kashiwa | Designer: Daisuke Kashiwa
Client: Illustration Studies, Tama Art University | Illustrator: Daisuke Kashiwa

173 THE STUDY OF SYMBOLS | Design Firm: STUDY LLC.
Designer: Takahiro Eto | Client: Self-initiated

173 BYOUNG-IL SUN POLAND EXHIBITION | Design Firm: Namseoul University
Designer: Byoung-il Sun | Client: Poland PJAIT University

173 TOUCH | Design Firm: Russell & Russell Co. | Designer: Ryan Russell
Client: Penn State University, Dept. of Integrative Arts

173 VIVID AND STRANGE: DAISUKE KASHIWA ILLUSTRATIONS | Design Firm: Daisuke
Kashiwa | Designer: Daisuke Kashiwa | Client: Self-initiated | Illustrator: Daisuke Kashiwa

174 DAS KAPITAL IST WEG – WIR SIND DAS KAPITAL | Design Firm: studio lindhorst-emm
Designer: Sven Lindhorst-Emme | Client: Zwischenraum Schaffhausen (Switzerland)

174 TRIBUTE TO ERNESTO CABRAL | Design Firm: Finn Nygaard
Designer: Finn Nygaard | Client: Bienal Internacional del Cartel en Mexico

174 POSTER FOR UOU X KSU 20TH ANNIVERSARY INVITATIONAL EXHIBITION
Design Firm: Choong Ho Lee | Designer: Choong Ho Lee
Client: University of Ulsan | Art Director: Choong Ho Lee

174 DEAR PAPER | Design Firm: DAEKI & JUN design studio
Designers: Hyojun Shim, Daeki Shim | Client: Doosung Paper / Doosung in the Paper Gallery
Art Directors: Hyojun Shim, Daeki Shim

175 LOVE | Design Firm: Randy Clark
Designer: Randy Clark | Client: Taiwan Poster Design Association

175 LIFE—LINDA RITOH, THE EXHIBITION WITH PHOTOGRAPHERS, 2018, OSAKA
Design Firm: Libido inc.& Linda Graphica | Designer: Linda Ritoh | Client: Uran-dou Gallery
Art Director: Linda Ritoh | Copywriter: Linda Ritoh | Artist: Linda Ritoh (Objects)
Photographers: Hiroshi Nonami (series 1/4, 2/4, 3/4, 4/4), Koichi Okuwaki (series 2/4)

175 10 YEARS DESIGN SUMMER HANGZHOU, CHINA | Design Firm: Melchior Imboden
Designer: Melchior Imboden | Client: Design Summer Hangzhou

175 WIESLAW GRZEGORCZYK – PAINTED AND PRINTED POSTERS
Design Firm: Wieslaw Grzegorczyk | Designer: Wieslaw Grzegorczyk
Client: Office of Art Exhibitions in Rzeszow

175 SNF PHILANTHROPY POSTER PROJECT EXHIBITION @ SVA
Design Firm: Attic Child Press, Inc. | Designer: Viktor Koen
Client: Stavros Niarchos Foundation and School of Visual Arts | Illustrator: Viktor Koen

175 BETWEEN SYMBOLS AND ILLUSTRATIONS | Design Firm: STUDY LLC.
Designer: Takahiro Eto | Client: Tokyo Polytechnic University

175 GO WEST! | Design Firm: Peter Diamond Illustration | Designer: Peter Diamond
Client: designforum Wien | Art Director: Severin Filek | Main Contributor: Peter Diamond

175 "CHAPAS SÍNICAS" - CHINESE DOCUMENTS OF MACAO THE QING DYNASTY, PORTUGUESE TRANSLATED COPIES (MEMORY OF THE WORLD REGISTER)
Design Firm: Cultural Affairs Bureau of the Macao S.A.R. Government
Designer: Kuokwai Cheong | Client: Macao S.A.R. Government | Art Director: Kuokwai Cheong

175 16. MESSAGE ILLUSTRATION POSTER 2018 | Design Firm: Yohei Takahashi
Designer: Yohei Takahashi | Client: Illustration Studies, Tama Art University

176 40 ANOS CINANIMA | Design Firm: João Machado
Designer: João Machado | Client: Cooperativa Nascente

176 MVFF2018 | Design Firm: BSSP | Designer: Mike Hughes | Client: Mill Valley Film Festival
Chief Creative Officer: John Butler | Ad Agency: BSSP

176 GLOBAL CITIZEN NYC CONCERT POSTER | Design Firm: Emerson, Wajdowicz Studios
Designers: Jurek Wajdowicz, Manny Mendez | Client: Global Citizen
Art Directors: Jurek Wajdowicz, Lisa LaRochelle

176 CINANIMA 19 | Design Firm: João Machado Design
Designer: João Machado | Client: Cooperativa Nascente

177 ALEX | Design Firm: Erman Yılmaz | Designer: Erman Yılmaz | Client: Selman Nacar

177 MAR DE TERRA | Design Firm: xose teiga, studio.
Designer: Xose Teiga | Client: Kepa Junkera

177 42ND PORTLAND INTERNATIONAL FILM FESTIVAL Design Firm: Sandstrom Partners
Designer: Steve Sandstrom | Client: Northwest Film Center/Portland Art Museum
Project Manager: Robin Olson | Printer: Image Pressworks

177 MI CAMPO TEQUILA SCREEN-PRINTED POSTER (14 COLORS)
Design Firm: Sandstrom Partners | Designer: Steve Sandstrom | Client: Mi Campo/Constellation
Brands | Illustrator: Raul Urias | Project Manager: Robin Olson | Printer: 75 Grados

178 ENSHUYA | Design Firm: BULLET Inc. | Designer: Aya Codama | Client: ENSHUYA.,Inc
Art Director: Aya Codama | Photographer: Shinjiro Yoshikawa

178 CACHE VALLEY GARDENERS MARKET POSTER '18
Design Firm: Design SubTerra | Designer: R.P. Bissland
Client: Cache Valley Gardener's Market Association | Chief Marketing Officer: Mary Laine

178 VESTRI IPA POSTER | Design Firm: Ventress Design Works
Designer: Tom Ventress | Client: Asgard Brewing Company | Illustrator: Tom Ventress

178 USA2018SASHA | Design Firm: SVIDesign | Designer: Sasha Vidakovic | Client: Missouri
State University | Creative Director: Sasha Vidakovic | Typographer: Sasha Vidakovic

179 21ST DÜSSELDORF INTERNATIONAL ENDOSCOPY SYMPOSIUM
Design Firm: Elsenbach Design | Designer: Nicole Elsenbach, Helmut Rottke
Client: COCS GmbH - Congress Organisation C. Schäfer and Prof. Dr. Horst Neuhaus

179 STAMP OUT STIGMA | Design Firm: FleishmanHillard | Designer: Buck Smith | Client:
AT&T with FleishmanHillard | Design Director: Ryan Bennett | Account Directors: Elaine
Branding, Tricia Anagnos | Account Executives: Erin Cicotte, Sarah McCallion, Maggie Quinn

179 JAZZ KICKS BAND PLAY LATIN | Design Firm: Design SubTerra
Designer: R.P. Bissland | Client: Jazz Kicks Band | Director: Larry Smith

179 THE CINAMATIC ORCHESTRA | Design Firm: Synopsis | Designer: Ovidiu Hrin
Client: JazzTM Festival | Art Director: Ovidiu Hrin | Photographer: Ovidiu Hrin

180 B-LIST COMPOSTERS | Design Firm: Chemi Montes
Designer: Chemi Montes | Client: AU Department of Performing Arts

180 MUSIC MASTERS POSTER SERIES | Design Firm: Marcos Minini Design
Designer: Marcos Minini | Client: Music Masters

180 FLOCK OF KEYS | Design Firm: 12 points
Designer: Mikhail Puzakov | Client: Moscow Symphony Orchestra

180 LYLE LOVETTE AND HIS BIG BAND BOW TIE WORLD TOUR | Design Firm: Ted
Wright Illustration & Design | Designer: Ted Wright | Client: Lyle Lovett | Art Director: Ron Clark

180 LOST LAKES/JOSH HARTY REVERSIBLE POSTER | Design Firm: Jorel Dray
Designer: Jorel Dray | Client: Lost Lakes & Josh Harty

180 SOUTHSIDE JOHNNY AND THE ASBURY JUKES AT THE STONE PONY
Design Firm: Bob Delevante Studios | Designer: Bob Delevante | Client: Southside Johnny
Photo Illustrator: Bob Delevante | Printer: Kangaroo Press

180 FIRST THURSDAY CONCERT POSTER | Design Firm: Kaveh Haerian
Designer: Kaveh Haerian | Client: WTMD Radio

180 GREGORY PORTER | Design Firm: Synopsis | Designer: Ovidiu Hrin | Client: JazzTM
Festival | Art Director: Ovidiu Hrin | Project Manager: Silvia Hrin | Photographer: Paula Duta

181 LA SONNAMBULA | Design Firm: Haller Metalwerks | Designer: Carmit Makler Haller
Client: Self-initiated | Photo Illustrator: Eyal Orlee Studio | Photographer: danchooalex

181 LA FORZA DEL DESTINO | Design Firm: Gunter Rambow | Designer: Gunter Rambow
Client: Oper Frankfurt | Creative Team: Angelika Eschbach-Rambow

181 POLLICINO (OPERA FOR CHILDREN) | Designer: Stephan Bundi
Client: TOBS Theater Biel Solothurn

182 IOLANTA, OEDIPUS REX | Design Firm: Gunter Rambow | Designer: Gunter Rambow
Client: Oper Frankfurt | Creative Team: Angelika Eschbach-Rambow

182 DALIBOR | Design Firm: Gunter Rambow | Designer: Gunter Rambow
Client: Oper Frankfurt | Creative Team: Angelika Eschbach-Rambow

182 TRI SESTRY | Design Firm: Gunter Rambow | Designer: Gunter Rambow
Client: Oper Frankfurt | Creative Team: Angelika Eschbach-Rambow

182 THE POSTER OF LINSHANG BANK | Design Firm: UNISAGE
Designers: Chak Kin, Jeff Poon | Client: Linshang Bank

183 THE BOUNTIFUL YEAR | Design Firm: Column Five | Designer: Andrew Effendy
Client: Post Ratio | Creative Director: Nate Butler | Executive Creative Director: Joshua Ritchie
Editors: Erika Imberti, Katy French | Photographer: Andrew Effendy

183 TYPE FOR WEARING | Design Firm: National Taiwan University of Science and
Technology | Designer: ken-tsai lee | Client: TAIWAN TECH

184 DAEKI & JUN DESIGN STUDIO | Design Firm: DAEKI & JUN design studio | Designers:
Hyojun Shim, Daeki Shim | Client: Self-initiated | Art Directors: Hyojun Shim, Daeki Shim

184 AMNEX POSTERS | Design Firm: Two | Designer: Siddharth Khandelwal
Client: Amnex Technologies | Creative Director: Siddharth Khandelwal
Art Director: Swati Paranjpe | Copywriter: Eamonn Ennis

184 GET IT? | Design Firm: nikkeisha, inc. | Designer: Hiroyuki Nakamura | Client: Japan
Advertising Agencies Association | Creative Director: Hidetaka Sugiyama | Art Director: Hiroyuki
Nakamura | Photographer: Tetsuro Ikejima | Copywriter: Naoto Miyazaki

184 BUSINESS OF DESIGN WEEK | Design Firm: Next | Designer: Adeline Kim
Client: Self-initiated | Creative Director: Lee Selsick | Illustrator: Adeline Kim

185 IMPRESSIONS OF HUIZHOU | Design Firm: Leo Lin Design
Designer: Leo Lin | Client: An-Hui Graphic Design Association

185 JUGULAR POSTER 6 | Design Firm: IF Studio | Designers: Toshiaki Ide, Hisa Ide
Client: J Squad | Design Director: Hisa Ide | Logo Designer: Zoe Pu
Creative Directors: Hisa Ide, Toshiaki Ide | Art Directors: Kumiko Ide, Athena Azevedo
Executive Producers: Amy Frankel, Lucia Braggion | Editors-In-Chief: Max Zambelli,
Maurizio Marchiori | Managing Editor: Francesca Maltauro | Artist: Todd Murphy

185 DIZAJNERSKA FARSA | Design Firm: SVIDesign | Designer: Sasha Vidakovic
Client: Self-initiated | Creative Director: Sasha Vidakovic | Photographer: Sasha Vidakovic

185 PEACE | Design Firm: Goodall Integrated Design
Designer: Derwyn Goodall | Client: Self-initiated

185 WONDER | Design Firm: Goodall Integrated Design
Designer: Derwyn Goodall | Client: Self-initiated

185 BEAUTY | Design Firm: Goodall Integrated Design
Designer: Derwyn Goodall | Client: Self-initiated

185 AFTERIMAGE | Design Firm: DAEKI & JUN design studio | Designers: Hyojun Shim,
Daeki Shim | Client: Gallery Show & Tell | Art Directors: Hyojun Shim, Daeki Shim

185 BIBLIOTECA PALERMO "LIBRO-BIBLIOTECA" | Design Firm: Estudio Pep Carrió
Designer: Pep Carrió | Client: Artes Gráficas Palermo | Photographer: Antonio Fernández

185 WELCOME 2019 | Design Firm: Estudio Pep Carrió | Designer: Pep Carrió
Client: Self-initiated | Photographer: Antonio Fernández

186 WONDERFUL PRINT | Design Firm: Owen Gildersleeve
Designer: Owen Gildersleeve | Client: Self-initiated

186 SUMMER/WINTER 2018 | Design Firm: John Sposato Design & Illustration
Designer: John Sposato | Client: Self-initiated

186 EVERYTHING GETS BETTER | Design Firm: Zulu Alpha Kilo
Designer: Ryan Booth | Client: ParticipACTION | Creative Directors: Catherine Allen, Ian Simpson
Art Director: Manali Kulkarni | Chief Creative Officer: Zak Mroueh | Digital Artists: Anna Harju,
Brandon Dyson | Agency Producer: Teresa Bayley | Copywriter: Dylan Verwey
Ad Agency: Zulu Alpha Kilo | Account Services: Robyn Morrissey, Lauren Boultwood

187 EQUAL JUSTICE INITIATIVE - BUS STOP POSTER
Design Firm: Turner Duckworth: London, San Francisco, New York
Designers: Naomie Ross, Melissa Chavez, Linka Lin, Amelia Irwin | Client: Equal Justice Initiative
Heads of Design: Bruce Duckworth, David Turner | Creative Director: Andy Baron
Executive Creative Director: Sarah Moffat | Implementation Director: Jeff Jones
Account Managers: Michelle Farhang, Kate Monahan | Brand Video: Naomie Ross
Production Director: Mike Scelza

187 EQUAL JUSTICE INITIATIVE - CHAIN POSTER
Design Firm: Turner Duckworth: London, San Francisco, New York
Designers: Linka Lin, Naomie Ross, Amelia Irwin, Melissa Chavez | Client: Equal Justice Initiative
Heads of Design: Bruce Duckworth, David Turner | Creative Director: Andy Baron
Executive Creative Director: Sarah Moffat | Implementation Director: Jeff Jones
Account Manager: Michelle Farhang | Brand Video: Naomie Ross
Production Director: Mike Scelza | Head of Client Services: Jordana Roberts Marcus
Senior Account Manager: Kate Monahan

188 POLAR PLUNGE 2019 POSTER | Design Firm: Bailey Lauerman
Designer: Mariah Adams | Client: Special Olympics of Nebraska | Creative Director: Carter Weitz
Art Director: Casey Stokes | Illustrator: Casey Stokes | Copywriter: Marlee Cowdrey

188 ORANGE NO. 45 | Design Firm: Thinkdavethink | Designer: Dave Roberts
Client: Orange No. 45 | Copywriter: Dave Roberts | Photographer: Studio Schulz

188 MY SHOES POSTER DESIGN | Design Firm: Selcuk Cebecioglu
Designer: Selcuk Cebecioglu | Client: Charles Simic - Poet

189 KINELY | Design Firm: Hoyne | Designers: Ruby Aitken, George Coltman
Client: Intrapac | Creative Director: Nichole Trionfi | Illustrator: Eirian Chapman

189 WESTWORKS | Design Firm: Hoyne | Designer: Alex McGeechan | Client: JVMC

189 WHARFSIDE | Design Firm: Hoyne | Designer: Carrie Retallack
Client: Mirvac | Photographer: Lauren Bamford

189 500 WEST MADISON DIRECT MAIL POSTER | Design Firm: Pivot Design
Designer: Tess Beltran | Client: KBS | Design Director: Heather Kintner | Executive Creative
Director: Brock Haldeman | Writer: Katharine Cikanek | Account Supervisor: Kelli Michaelis

190 INCORE | Design Firm: Hoyne | Designers: Ziggy Huang, Carrie Retallack | Client: Incore

190 TRUTH UNDER ASSAULT | Design Firm: STEINER GRAPHICS
Designer: Rene V. Steiner | Client: Self-initiated

190 CURRENT | Design Firm: Keith Kitz Design | Designer: Keith Kitz | Client: Self-initiated

190 HOMESICK. | Design Firm: Elsenbach Design | Designer: Nicole Elsenbach
Client: Self-initiated | Image Source: Photocase, coralie; Fotolia, Blickfang

191 TOLERANCE TRAVELING SHOW | Design Firm: Finn Nygaard
Designer: Finn Nygaard | Client: Micko Ilic, New York

191 "GERMANY FOR THE GERMANS" - AGAINST RACISM | Design Firm: Gunter Rambow
Designer: Gunter Rambow | Client: Stiftung für die Internationalen Wochen gegen Rassismus
Creative Team: Angelika Eschbach-Rambow | Writer: Angelika Eschbach-Rambow

191 YEAR OF TROY | Design Firm: Wheels & Waves | Designer: Rikke Hansen
Client: Çanakkale Onsekiz Mart University

191 HUMAN RIGHTS | Design Firm: João Machado Design
Designer: João Machado | Client: CTT - Correios de Portugal

192 TOLERANZ | Design Firm: Ariane Spanier Design
Designer: Ariane Spanier | Client: Tolerance Traveling Poster Show by Mirko Ilić

192 V IS FOR VOTE | Design Firm: The Heads of State
Designer: Jason Kernevich | Client: The Poster Project

192 IGNORANCE | Design Firm: Carmit Design Studio | Designer: Carmit Makler Haller | Client:
Self-initiated | Photo Illustrators: Eyal Orlee Studio | Photographers: MinC. Chiu, Ian Mcdonnell

192 HOW TO INVENT CLICHÉ | Design Firm: Yunji Jun
Designer: Yunji Jun | Client: Calarts GD MFA

193 EARTHQUAKE AND CHIYODA WARD, TOKYO | Design Firm: Yohei Takahashi | Designer:
Yohei Takahashi | Client: Junior Chamber International Tokyo, Chiyoda Ward Committee

193 40 MILLION | Design Firm: Martin French Studio
Designer: Martin French | Client: Self-initiated

193 STANDBY | Design Firm: Marlena Buczek Smith
Designer: Marlena Buczek Smith | Client: Self-initiated

193 HEDGEHOGS DILEMMA | Design Firm: Dankook University
Designer: Hoon-Dong Chung | Client: Self-initiated | Art Director: Hoon-Dong Chung

194 POOR BRADFORD'S WISE SAYINGS | Design Firm: Brad Holland | Designer: Brad
Holland | Client: Poor Bradford's Almanac | Artist: Brad Holland | Writer: Brad Holland

194 ENCASED CITY | Design Firm: Zulu Alpha Kilo | Designer: Ryan Booth
Client: Coalition For Gun Control | Creative Director: Zak Mroueh | Art Director: Michael
Romaniuk | Copywriter: Patrick Godin | Creative Strategist: Spencer MacEachern
Digital Artists: Greg Heptinstall, Brandon Dyson | Agency Producer: Laura Dubcovsky
Account Services: Rob Feightner, Matt McGrath | Ad Agency: Zulu Alpha Kilo
Printer: Performance Solutions | Video Link: https://youtu.be/wQS08Mdxjrw

195 VOTE: MIDTERMS MATTER | Design Firm: Virginia Tech
Designer: Meaghan A. Dee | Client: Design for Democracy

195 WOMEN'S MARCH POSTERS | Design Firm: ThoughtMatter
Designers: Jee-Eun Lee, Wednesday Krus, Cara Budner, Steve Baust, Johan Vipper
Client: Self-initiated | Creative Director: Ben Greengrass | Typographer: Tet Marti

195 STRANGER | Design Firm: Andrew Sloan | Designer: Andrew Sloan | Client: Self-initiated

195 FAKE NEWS | Design Firm: Yossi Lemel | Designer: Yossi lemel | Client: Self-initiated

195 GAME OF DEATH | Design Firm: Dalian RYCX Advertising Co., Ltd.
Designer: Yin Zhongjun | Client: BICeBe | Creative Director: Yin Zhongjun

195 FAMILIES | Design Firm: Underline Studio | Designer: Fidel Peña
Client: Self-initiated | Creative Director: Fidel Peña, Claire Dawson

195 GUNS GONE | Design Firm: Code Switch | Designer: Jan Šabach | Client: Self-initiated

195 BEYOND | Design Firm: Toyotsugu Itoh Design Office | Designer: Toyotsugu Itoh
Client: Japan Graphic Designers Association Inc.

195 LINES BREAKING | Design Firm: Underline Studio | Designer: Fidel Peña
Client: Self-initiated | Creative Directors: Claire Dawson, Fidel Peña | Writer: Elizabeth Brandt

196 DOCTRINES | Design Firm: Luis Antonio Rivera Rodriguez
Designer: Luis Antonio Rivera Rodriguez | Client: VARIOUS

196 EARTHQUAKE POSTER SUPPORT PROJECT | Design Firm: Yohei Takahashi
Designer: Yohei Takahashi | Client: Earthquake Poster Support Project, Tama Art University

196 WE BELIEVE | Design Firm: Carmit Design Studio
Designer: Carmit Makler Haller | Client: Self-initiated | Photographer: D-Keine

197 MORE LOVE | Design Firm: Flomaster | Designer: Orsat Frankovic | Client: Self-initiated

197 VOTE FOR WOMEN | Design Firm: Code Switch
Designer: Jan Šabach | Client: Self-initiated

197 LOVE HARMONIZES LIFE | Design Firm: Symbiotic Solutions
Designer: Chris Corneal | Client: Self-initiated

197 FORMEXICO! | Design Firm: Genaro Design, LLC | Designer: Genaro Solis Rivero | Client:
FORMEXICO! | Art Director: Genaro Solis Rivero | Graphic Designer: Christopher C. Castillo

197 DEMOCRACY IN DANGER | Design Firm: Marlena Buczek Smith
Designer: Marlena Buczek Smith | Client: Mykola Kovalenko

197 TOO MANY FISHES, TOO FEW LOAVES | Design Firm: Houda Bakkali
Designer: Houda Bakkali | Client: Self-initiated

197 1917-2017, CCCP-RUSSIA | Design Firm: Kari Piippo Oy
Designer: Kari Piippo | Client: Golden Bee in Moscow

197 NASHVILLE–A CAUTIONARY TALE | Design Firm: DNA Creative Marketing
Designer: Dale Addy | Client: TwangTownTattlers | Copywriter: April Bonner Addy

197 TRIGGER CHANGE | Design Firm: Zulu Alpha Kilo | Designer: Ryan Booth
Client: Coalition For Gun Control | Creative Director: Zak Mroueh | Art Directors: Andrea Por,
Michael Romaniuk | Copywriters: Christina Roche, Patrick Godin | Creative Strategist: Spencer
MacEachern | Digital Artists: Greg Heptinstall, Pavel Petrycki, Brandon Dyson, Anna Harju
Agency Producer: Laura Dubcovsky | Ad Agency: Zulu Alpha Kilo
Account Services: Rob Feightner, Matt McGrath | Printer: Flash Reproductions

198 SAW | Design Firm: BVK | Designer: Scott Krahn | Client: Footstock National Endurance
Barefoot Water Ski Championships | Creative Director: Gary Mueller | Art Director: Scott Krahn
Copywriter: Nick Pipitone | Retoucher: Anthony Giacomino | Photographer: Anthony Giacomino

198 HIT THE FLOOR | Design Firm: BET Networks | Designer: Lina Almansa
Client: Self-initiated | Creative Director: Marcelle Karp | Senior Vice President: Kendrick Reid
Vice Presidents Brand Creative: Adrian Hilton, Josh Pelzek | Directors of Project Management:
Seida Saidi, Rebecca Heineman | Project Manager: Martha Tobar | Photographer: Sophy Holland

198 AMERICAN SOUL | Design Firm: BET Networks | Designer: Lina Almansa
Client: Self-initiated | Creative Director: Allison Caviness | Art Director: Lina Almansa
Senior Vice President: Kendrick Reid | Vice Presidents Brand Creative: Josh Pelzek,
Adrian Hilton | Directors of Project Management: Seida Saidi, Rebecca Heineman
Project Manager: Martha Tobar | Photographer: Sophy Holland

199 BET AWARDS | Design Firm: Sibling Rivalry | Designer: Lina Almansa
Client: BET Networks | Creative Director: Jerome Ford | Senior Vice President: Kendrick Reid
Vice Presidents Brand Creative: Josh Pelzek, Adrian Hilton | Directors of Project Management:
Seida Saidi, Rebecca Heineman | Project Manager: Martha Tobar

199 PREACHER SEASON 3 | Design Firm: Leroy & Rose | Client: AMC

199 THE BOBBY BROWN STORY | Design Firm: BET Networks
Designer: Alfredo Palermo | Client: Self-initiated | Creative Director: Jerome Ford
Senior Vice President: Kendrick Reid | Vice Presidents Brand Creative: Josh Pelzek,
Adrian Hilton | Directors of Project Management: Seida Saidi, Rebecca Heineman
Project Manager: Martha Tobar | Retoucher: Mandy Strong | Photographer: Kareem Black

199 THE GREAT AMERICAN READ | Design Firm: SJI Associates | Designer: SJI Associates
Client: PBS | Art Director: David O'Hanlon | President: Suzy Jurist | Illustrator: Miyako Taguchi

200 THE MARVELOUS MRS. MAISEL SEASON 2
Design Firm: Leroy & Rose | Client: Amazon

200 COUNTRY MUSIC, A FILM BY KEN BURNS | Design Firm: SJI Associates
Designer: David O'Hanlon | Client: PBS | Art Director: David O'Hanlon | President: Suzy Jurist
Copywriter: Carole Mayer

200 DREW MICHAEL | Design Firm: Leroy & Rose | Client: HBO

200 YUGOSLAV DRAMA THEATRE POSTERS | Design Firm: Mirko Ilic Corp.
Designer: Mirko Ilic | Client: Yugoslav Drama Theatre

201 THE VISIT | Design Firm: Carmit Design Studio
Designer: Carmit Makler Haller | Client: Haller Metalwerks | Photographer: neoblues

201 REVIVAL THEATRE COMPANY - OKLAHOMA!
Design Firm: Dennard, Lacey & Associates | Designer: James Lacey
Client: Revival Theatre Company | Illustrator: James Lacey

201 POPOCH – DIE ARBEIT DES LEBENS | Designer: Stephan Bundi | Client: Neuestheater

201 DANTON'S DEATH | Design Firm: EGGRA | Designer: Ngadhnjim Mehmeti
Client: The Albanian Theatre Skopje | Photo Illustrator: Igor Nastevski

202 BLOOD WEDDING | Design Firm: Chemi Montes | Designer: Chemi Montes
Client: AU Department of Performing Arts

202 CONCERT HALL ETIQUETTE POSTER | Design Firm: CHOE Gon
Designer: CHOE Gon | Client: Self-initiated

202 LIKAH! | Design Firm: Jay Advertising | Designer: Tim Winter | Client: Deep Arts
Creative Director: Lisa Kreienberg | Print Producer: Corey Fountain

202 BOOTYCANDY | Design Firm: Langrand
Designer: Spencer Strickland | Client: The Catastrophic Theatre

202 MIMMA | Design Firm: Dessein | Designer: Dessein
Client: Orana Productions | Photographer: Dessein

202 ANIMAL FARM | Designer: Stephan Bundi | Client: Theater Orchester Biel Solothurn

202 TOAST | Design Firm: Langrand
Designer: Spencer Strickland | Client: The Catastrophic Theatre

202 OTHELLO | Design Firm: Kate Resnick Design
Designer: Kate Resnick | Client: Katzen Arts Center

202 MOLIÈRE'S "TARTUFFE" | Design Firm: L.S. Boldsmith
Designer: Leila Singleton | Client: University of California, Berkeley — Department of Theater,
Dance & Performance Studies | Illustrator: Leila Singleton

203 CREATIVITY IS IN THE AIR | Design Firm: MullenLowe Los Angeles
Designer: Florencio Zavala | Client: EVA Air | Design Director: Florencio Zavala
Creative Director: Mike Czako Executive Creative Director: Margaret Keene
Associate Creative Director: Natasha Hugeback Chief Creative Officer: Mark Wenneker
Senior Designer: Patrice Liu | Project Manager: Ina Lewin | Head of Production: Lisa Setten
Managing Director: Cameron McNaughton | Art Producer: Karen Youngs
Executive Producer: Alli Taylor | Illustrator: Peter Greenwood Agency Producer: Van Corsa
Account Director: Rebecca Wojcicki | Account Executive: Lauren Kelley
Brand Strategy: Tom Donovan | Strategists: Angelica Luchini, Samantha Schaitberger
Photography Studio: Dan Howell | Director of Integrated Design: Mike Molinaro
Business Affairs Manager: Nickie Kolb | Business Affairs Director: Davina Turnbull
Chief Executive Officer: Lee Newman

203 OCEAN BEACH | Design Firm: Michael Schwab Studio
Designer: Michael Schwab | Client: Golden Gate National Park Conservancy

203 MORE GRATITUDE | Design Firm: Keith Kitz Design
Designer: Keith Kitz | Client: Self-initiated

203 ARE YOU READY TO RECOVER? | Design Firm: THERE IS
Designers: Sean Freeman, Eve Steben | Client: Business In the Community
Creative Director: Paula Amaral | Art Producer: Eve Steben | Agency Producer: Elodie Macey
Ad Agency: McCANN LONDON | Typographer: Sean Freeman | Photographer: Sean Freeman
Model Maker: Eve Steben | Art Buyer: Sophie Chapman-Andrews

204 GGG2XG WORKSHOP-TALK | Design Firm: Thomas Kühnen
Designer: Thomas Kühnen | Client: Folkwang UdK

204 MY EMOTIONS | Design Firm: Wheels & Waves
Designer: Rikke Hansen | Client: The 2nd Exhibition and Conference on "Awareness"

204 24 SOLAR TERMS | Design Firm: TUNGFANG DESIGN UNIVERSITY | DESIGN CENTER
Designer: CHIA-HUI LIEN | Client: Self-initiated | Creative Director: CHIA-HUI LIEN

204 INKC | Design Firm: Studio LD | Designer: Fred Machuca
Client: LD Products | Graphic Designer: Aldo Mardueno

CLIENTS

EXECUTIVE CREATIVE DIRECTORS/CREATIVE DIRECTORS/ASSOCIATE CREATIVE DIRECTORS

ART DIRECTORS

DESIGN DIRECTORS

PHOTOGRAPHERS

COPYWRITERS/WRITERS

PLATINUM

ARSONAL
www.arsonal.com
3524 Hayden Ave.
Culver City, CA 90232
United States
Tel +1 310 815 8824
cynthia@arsonal.com

Carmit Design Studio
www.creativehotlist.com/challer
2208 Bettina Ave.
Belmont, CA 94002
United States
Tel +1 650 283 1308
carmit@carmitdesign.com

FX Networks
www.fxnetworks.com
10201 W. Pico Blvd.,
Bldg. 103, Rm. 3549
Los Angeles, CA 90064
United States
Tel +1 310 369 5983
sarit.snyder@fxnetworks.com

Gunter Rambow
www.gunter-rambow.com
Domplatz 16
D-18273 Guestrow
Germany
GunterRambow@web.de

Iconisus
www.iconisus.com
10000 Venice Blvd.
Culver City, CA 90232
United States
Tel +1 310 202 1600
contact@iconisus.com

João Machado Design
www.joaomachado.com
Rua Padre Xavier Coutinho, 125
Porto 4150-751
Portugal
Tel +351 226103772
geral@joaomachado.com

Lewis Communications
www.lewiscommunications.com
2030 First Ave. North
Birmingham, AL 35203
United States
Tel +1 205 789 6481
lisa@lewiscommunications.com

Marcos Minini Design
www.marcosminini.com
Dr. Manoel Pedro 227, ap 172
Curitiba, PR 80035-030
Brazil
Tel +55 41 999 710 860
minini@marcosminini.com

OGAWAYOUHEI DESIGN
www.ogawayouhei.com
Shinsaka Building No.108
Edobori 1-23-14 Nishi-ku, Osaka
Japan
Tel +81(6)6282 7783
ogawayouhei.dd@gmail.com

Stephan Bundi
www.atelierbundi.ch
Schlossstrasse 78
Boll, Berne CH-3067
Switzerland
Tel +41 31 981 00 55
bundi@atelierbundi.ch

Studio Hinrichs
www.studio-hinrichs.com
86 Graham St.
Ste. 120 The Presidio of San Francisco
San Francisco, CA 94109
United States
Tel + 415 543 1776
reception@studio-hinrichs.com

Studio Pekka Loiri
Messitytonkatu 1 C 43
Helsinki, - 00180
Finland
Tel +358 503 512104
pekka.loiri@pp.inet.fi

Visual Arts Press, Ltd.
220 East 23 St.
Suite 311
New York, NY 10010
United States
Tel +1 212 592 2380
vapress@sva.edu

GOLD

21XDESIGN
www.21xdesign.com
2713 S. Kent Road
Broomall, PA 19008
United States
Tel +1 610 325 5422
info@21xdesign.com

Andrea Castelletti
www.acastelletti.com
Via Breno 2
Milan, MI 20139
Italy
Tel +39 393 6274 111
andrea@acastelletti.com

Andrew Sloan
33 Fairlawn Drive
Woodford Green
Essex, London IG8 9AW
United Kingdom
Tel +44 7985 949 100
andysloan03@gmail.com

Angry Dog
www.angrydog.com.br
Rua. Dias de Tolêdo, 64 - 48 - Saúde
São Paulo - SP, 04143-030
Brazil
rafael@angrydog.com.br

Ariane Spanier Design
www.arianespanier.com
Oranienstr. 22
Berlin, Berlin 10999
Germany
Tel +49 30 44033923
mail@arianespanier.com

ARSONAL
www.arsonal.com
3524 Hayden Ave.
Culver City, CA 90232
United States
Tel +1 310 815 8824
cynthia@arsonal.com

Attic Child Press, Inc.
www.viktorkoen.com
310 East 23rd St., #11J
New York, NY 10010
United States
Tel +1 212 254 3159
viktor@viktorkoen.com

BET Networks
1540 Broadway
New York, NY 10036
United States
josh.pelzek@bet.net

BVK
250 W. Coventry Court, Suite 300
Milwaukee, WI 53217
United States
Tel +1 414 247 2104
stacey.soden@bvk.com

Carmit Design Studio
www.creativehotlist.com/challer
2208 Bettina Ave.
Belmont, CA 94002
United States
Tel +1 650 283 1308
carmit@carmitdesign.com

Caselli Strategic Design
34 West 27th St.
New York, NY 10001
United States
Tel +1 203 550 1432
toshi@ifstudiony.com

Chase Body
www.chasebody.com
3100 Fallscliff Road
Baltimore, MD 21211
United States
Tel +1 410 301 7185
chasebody@me.com

Chemi Montes
Katzen Arts Center
American University
4400 Massachusetts Ave. NW
Washington, DC 20016
United States
Tel +1 703 864 8767
cmontes@american.edu

Creplus Design
www.behance.net/creplus
Shanghai
China
creplus@163.com

Daisuke Kashiwa
www.kashiwadaisuke.net
#402, Lumiere-karakida
1-54-18, Karakida
Tama-city, Tokyo 2060035
Japan
Tel +81 80 3556 4640
kassy0105@gmail.com

Dalian RYCX Advertising Co., Ltd.
A6-12 No.419 Minzheng St.
Shahekou District
Dalian, Liaoning 116021
China
Tel +86 411 84519866
rycxcn@163.com

Dankook University
Room 317, College of Arts,
Dankook University,
126, Jukjeon, Suji Yongin,
Gyeonggi 448-701
South Korea
+82 31 8005 3106
finvox3@naver.com

Dextro.org
www.dextro.org
Weidengasse 2
Biedermannsdorf, 2362
Austria
dextro@dextro.org

Dogan Arslan Studio
Turkey
Tel +90 532 155 0779
doganaslan@yahoo.com

EGGRA
St. 141 No: 17
Tetovo, 1200
Macedonia
Tel +389 70389144
eggra.pars@gmail.com

Erman Yılmaz
www.ermanyilmaz.com
Cihangir mahallesi Pürtelaş Sokak 31/4
İstanbul, 34433
Turkey
info@ermanyilmaz.com

Finn Nygaard
www.FinnNygaard.com
Strandvænget 62
Mors 7900
Denmark
Tel +45 4847 5310
fn@finnnygaard.com

FleishmanHillard
200 N. Broadway
St. Louis, MO 63102
United States
Tel +1 314 982 8781
pam.thomas@fleishman.com

For Good Measure
www.forgoodmeasure.us
119 Ingraham St., #224
Brooklyn, NY 11237
United States
Tel +1 917 882 0686
kevin@forgoodmeasure.us

Gottschalk+Ash Int'l AG
www.ga-z.com
Böcklinstrasse 26
Zurich, Zurich 8032
Switzerland
Tel +41 44 382 18 50
s.loetscher@ga-z.com

Graphic Communication Laboratory
Lexel Garden makuhari 209
5-417-325, Makuhari-cho
Hanamigwa-ku, Chiba-city
Chiba 262-0032
Japan
Tel +81 43 351 5033
kasai.noriyuki@nihon-u.ac.jp

Gunter Rambow
www.gunter-rambow.com
Domplatz 16
Guestrow D-18273
Germany
GunterRambow@web.de

Gutsulyak.Studio
www.gutsulyak.studio
365 Church St., Unit 2607
Toronto, Ontario M5B 0B5
Canada
Tel +1 416 878 0957
yurko@gutsulyak.studio

H.Tuncay Design
www.haluktuncay.com
Omer Rustu Pasa Sokak,
Birlik Apt. 26/8 Besiktas, Istanbul
Turkey
Tel +905 325 883747
haltuncay@gmail.com

Hansung University Design & Arts Institute
116, Samseongyo-ro 16-gil
Hansung University of Design &
Art Institute, Seongbuk-gu
Seoul 02876
South Korea
Tel +82 10 8272 1265
hanart24@naver.com

hufax arts
www.facebook.com/HufaxArts
15/F, No.120,
Chien-Kuo North Road, Sec 2,
Taipei City, 104
Taiwan
Tel +8862 25030158#11
hufa@ms12.hinet.net

Ibán Ramón
www.ibanramon.com
ban@ibanramon.com
C. Rio Segre, 1 pta 1
Valencia, 46025
Spain

Icon Arts
10201 W. Pico Blvd
Los Angeles, CA 90064
United States
Tel +1 310 369 8592
sarit.snyder@fxnetworks.com

IF Studio
34 W. 27th St.
New York, NY 10001
United States
Tel +1 203 550 1432
toshi@ifstudiony.com

João Machado Design
www.joaomachado.com
Rua Padre Xavier Coutinho, 125
Porto 4150-751
Portugal
Tel +351 226103772
geral@joaomachado.com

Kari Piippo
www.piippo.com/kari
Katajamäenkatu 14
Mikkeli 50170
Finland
Tel +358 15 162187
kari@piippo.com

Keith Kitz Design
1945 Commonwealth Ave., Unit 2
Boston, MA 02135-5905
United States
Tel +1 857 321 0957
keith.kitz@gmail.com

Lewis Communications
www.lewiscommunications.com
2030 First Ave. North
Birmingham, AL 35203
United States
Tel +1 205 789 6481
lisa@lewiscommunications.com

Marcos Minini Design
www.marcosminini.com
Dr. Manoel Pedro 227, Ap 172
Curitiba, PR 80035-030
Brazil
Tel +55 41 999 710 860
minini@marcosminini.com

Mark Sposato Graphic Design
www.marksposato.com
179 Hudson Terrace
Piermont, NY 10968
United States
Tel +1 845 596 7891
marksposato1@gmail.com

Melchior Imboden
Eggertsbühl
CH-6374 Buochs
Switzerland
j@2xgoldstein.de

Michael Schwab Studio
108 Tamalpais Ave.
San Anselmo, CA 94960
United States
Tel +1 415 257 5792
studio@michaelschwab.com

Monash University
www.monash.edu/mada
900 Dandenong Road
Caulfield East, Victoria 3145
Australia
Tel +619 903 2018
genetombawden2@gmail.com

Moniker
www.monikersf.com
2169 Folsom St. Studio M101
San Francisco, CA 94110
United States
Tel +415 741 7006
jay@monikersf.com

Namseoul University
Cheonansi, Chungnam 31020
South Korea
sunbi155@naver.com

OGAWAYOUHEI DESIGN
Shinsaka Building No.108
Edobori 1-23-14 Nishi-ku
Osaka
Japan
Tel +81(6)6282 7783
ogawayouhei.dd@gmail.com

Owen Gildersleeve
Studio F12
23 - 27 Arcola St.
London, E8 2DJ
United Kingdom
Tel +44 (0)7932331841
hello@owengildersleeve.com

Peter Diamond Illustration
www.peterdiamond.ca
Seidlgasse 15/1
Vienna, 1030
Austria
peter@peterdiamond.ca

Photon Snow LLC
314 North 12th St.
Unit 801
Philadelphia, PA 19107
United States
Tel +1 505 489 0007
photonsnowdesign@gmail.com

Pirtle Design
www.pirtledesign.com
506 Union St.
Hudson, NY 12534
United States
Tel +1 845 417 4611
woody@pirtledesign.com

Randy Clark
1400 Palmnold Circle W
Fort Worth, TX 76120
United States
randyclarkmfa@icloud.com

Rose
www.rosedesign.co.uk
The Old School
70 St. Marychurch St.
London SE16 4HZ
United Kingdom
Tel +44 207 3942800
hello@rosedesign.co.uk

Sandstrom Partners
www.sandstrompartners.com
808 S.W. 3rd, #610
Portland, OR 97204
United States
Tel +1 503 248 9466
stacy@sandstrompartners.com

Splash Worldwide
www.curious-productions.co.uk
27 Ingersoll Road
Shepherd's Bush
London, W12 7BE
United Kingdom
Tel +44 (0)785 2229751
jfairley@curious-productions.co.uk

Steiner Graphics
www.renesteiner.com
155 Dalhousie St., Suite 1062
Toronto, ON M5B 2P7
Canada
Tel +1 416 792 6969
rene@steinergraphics.com

Stephan Bundi
Schlossstrasse 78
Boll Berne CH-3067
Switzerland
Tel +41 31 981 00 55
bundi@atelierbundi.ch

Studio Geray Gencer
www.geraygencer.com
19 Mayıs Cad. Golden PlazaNo: 1 Kat: 10
Şişli Istanbul, 34360
Turkey
Tel +90 533 630 87 84
geraygencer@yahoo.com

Studio Hinrichs
www.studio-hinrichs.com
86 Graham St.
Ste. 120 The Presidio of San Francisco
San Francisco, CA 94109
United States
Tel + 415 543 1776
reception@studio-hinrichs.com

Studio Pekka Loiri
Messitytonkatu 1 C 43
Helsinki, - 00180
Finland
Tel +358 503 512104
pekka.loiri@pp.inet.fi

Superunion
www.superunion.com
6 Brewhouse Yard
London, EC1V 4DG
United Kingdom
Tel +44 (0)7551 142 348
meghan.claridge@superunion.com

Synopsis
www.synopsismedia.com
Str. Evlia Celebi Nr.5 Ap.11
Timisoara, Timis 300226
Romania
Tel +40 723 152138
ovidiu@synopsismedia.com

Tatum Design
www.tatumdesign.com
1747 Reese Street, Suite 211
Birmingham, AL 35209
United States
Tel +1 205 978 1179
travis@tatumdesign.com

Ted Wright Illustration & Design
1705 N. Woodlawn Ave.
Ladue, MO 63124
United States
twrightart@aol.com

The Chris Aguirre
www.theChrisAguirre.com
955 Tuxedo Blvd
St. Louis, MO 63119
United States
Tel +1 314 517 6227
theChrisAguirre@gmail.com

Toppan Printing Co., Ltd.
9F, 1-3-3, Suido, Bunkyo-ku
Tokyo, 112-8531
Japan
Tel +81 3 5840 2192
mescal@mac.com

Toyotsugu Itoh Design Office
www.facebook.com/toyotsuguoffice
402 Royal Villa Tsurumai
4-17-8 Tsurumai,Showa-ku
Nagoya, Aichi Prefecture 466-0064
Japan
Tel +81 52 731 9747
toyo-ito@ya2.so-net.ne.jp

Traction Factory
www.tractionfactory.com
247 S. Water St.
Milwaukee, WI 53204
United States
Tel +1 414 944 0900
tf_awards@tractionfactory.com

Troxler Scott
www.christopherscottdesigner.com
Av. Mañosca y Occidental
Conjunto Torres de Santa Cruz
Torre 4, PH piso apartamento 45d
Quito, Ecuador, Pichincha EC170150
Ecuador
Tel +0979 185 183
csgraphi@hotmail.co.uk

Tsushima Design
www.tsushima-design.com
1-17-204,1-17,Matsukawa-cho
Minami-ku, Hiroshima
Hiroshima 7320826
Japan
Tel +81 82 567 5586
info@tsushima-design.com

Underline Studio
247 Wallace Ave., 2nd Floor
Toronto, ON M6H 1V5
Canada
Tel +1 416 341 0475
kristin@underlinestudio.com

VBAT
www.vbat.com
Pilotenstraat 41a
Amsterdam,
North Holland 1231 NK
Netherlands
Tel +31 207 503000
connie.fluhme@vbat.com

W&CO
www.winfieldco.com
155 Water St.
Brooklyn, NY 11201
United States
Tel +646 468 8953
vijay@winfieldco.com

Wheels & Waves
www.wheelsandwaves.dk
Klovtoftvej 32
Roedding, 6630
Denmark
Tel +45 23313560
rh@wheelsandwaves.dk

Woosuk University
www.woosuk.ac.kr
66 Daehak-ro
Gyoseong-ri, Jincheon-eup,
Jincheon-gun
Chungcheongbuk-do, 27841
South Korea
Tel +82 43 531 2806
mijung6@nate.com

xosé teiga, studio.
www.xoseteiga.com
Rua Nova de Abaixo, 5 bajo
Pontevedra, Pontevedra 36002
Spain
Tel +34 607 155 211
xoseteiga@gmail.com

Yossi Lemel
www.yossilemel.com
13 Dubnov St.
Tel Aviv
Israel
Tel +00 972 54 5360151

ZhaoChao Design
Room 412 (South), Building 3
XinGe Residential Quarters
FuTian Distinct,
Shenzhen,Guangdong 518049
China
Tel +86-13510982301
zhaochao-06@163.com

Zulu Alpha Kilo
260 King Street E., Suite B101
Toronto, ON M5A 4L5
Canada
Tel +1 416 777 9858
awards@zulualphakilo.com

SILVER

12 points
www.behance.net/12punktov
Yubileynaya 3a, 28
Moskovskaya oblast
Elektrostal 144009
Russia
Tel +7 903 006 31 52
mikhail@puzakovm.ru

21XDESIGN
www.21xdesign.com
2713 S. Kent Road
Broomall, PA 19008
United States
Tel +1 610 325 5422
info@21xdesign.com

Anacmyk
www.anacmyk.com
Rua de Elisio de Melo N28 11
Porto, 4000-196
Portugal
Tel +35 196 644 9064
anacmyk@gmail.com

Andrew Sloan
33 Fairlawn Drive
Woodford Green
Essex, London IG8 9AW
United Kingdom
Tel +44 7985 949 100
andysloan03@gmail.com

Ariane Spanier Design
www.arianespanier.com
Oranienstr. 22
Berlin, Berlin 10999
Germany
Tel +49 30 44033923
mail@arianespanier.com

ARSONAL
www.arsonal.com
3524 Hayden Ave.
Culver City, CA 90232
United States
Tel +1 310 815 8824
cynthia@arsonal.com

Art Collart Office
www.artcollart.nl
de Savornin Lohmanlaan 120 A
Rotterdam, 3038 NS
Netherlands
Tel +31(0)6 41 93 54 17
art@artcollart.nl

Atelier Chasper Würmli
www.chasperwuermli.ch
Elsässerstrasse 248
Basel, Basel Stadt 4056
Switzerland
info@chasperwuermli.ch

Attic Child Press, Inc.
www.viktorkoen.com
310 East 23rd St., #11J
New York, NY 10010
United States
Tel + 212 254 3159
viktor@viktorkoen.com

Bailey Lauerman
www.baileylauerman.com
1299 Farnam St., 9th Floor
Omaha, NE 68102
United States
Tel +1 402 514 9400
tirvin@baileylauerman.com

BET Networks
1540 Broadway
New York, NY 10036
United States
josh.pelzek@bet.net

Bob Delevante Studios
www.bobdelevante.com
PO Box 120501
Nashville, TN 37212
United States
Tel +1 615 400 0296
thestudio@bobdelevante.com

Brad Holland
www.bradholland.net
New York City
United States
Tel +1 212 226 3675
brad-holland@rcn.com

BSSP
www.bssp.com
20 Liberty Ship Way
Sausalito, CA 94965
United States
Tel +1 415 331 6049
pkiss@bssp.com

BULLET Inc.
www.bullet-inc.jp
SPACE-M 302
1-30-15, Higashinakano
Nakano-ku, Tokyo 164-0003
Japan
Tel +81 0359373555
codama@bullet-inc.jp

BVK
250 W. Coventry Court, Suite 300
Milwaukee, WI 53217
United States
Tel +1 414 247 2104
stacey.soden@bvk.com

CAO Design
2608 San Jacinto Drive
Euless, TX 76039
United States
Tel +1 225 223 8211
yvecao@gmail.com

Carmit Design Studio
www.creativehotlist.com/challer
2208 Bettina Ave.
Belmont, CA 94002
United States
Tel +1 650 283 1308
carmit@carmitdesign.com

Chemi Montes
Katzen Arts Center
American University
4400 Massachusetts Ave. NW
Washington, DC 20016
United States
Tel +1 703 864 8767
cmontes@american.edu

CHOE Gon
308, 5-24-11
Hashimoto, Midori-ku, Sagamihara-shi
Kanagawa 252-0143
Japan
Tel +81 80 3504 1674
gon.choe@gmail.com

Choong Ho Lee
100 Pyeongchon-daero 40beon-gil
Dongan-gu, Anyang-si
Gyeonggi-do, 14105
South Korea
Tel +82 31 425 7074
sw20lee@yahoo.co.kr

Code Switch
www.codeswitchdesign.com
262 Crescent St.
Northampton MA 01060
United States
Tel +1 718 310 8966
jansabach@mac.com

Cold Open
www.coldopen.com
1313 Innes Place
Venice, CA 90291
United States
Tel +1 310 399 3307
reception@coldopen.com

Column Five
www.columnfivemedia.com
150 Paularino Ave., Suite 170
Costa Mesa, CA 92626
United States
Tel +1 949 614 0759
aeffendy@columnfivemedia.com

**Cultural Affairs Bureau
of the Macao S.A.R. Government**
www.jocdesign.com
Rua Evora S/N
Edf. Lei Hau 37 Andar E Taipa
Macau Macau Macao S.A.R. nil MO
Macao
Tel +853 66681230
joaquimcheong@gmail.com

DAEKI & JUN design studio
www.daekiandjun.com
3F, Hannam-Dong
Seoul
South Korea
Tel +82 (0)2 332 0222
win.daekiandjun@gmail.com

Daisuke Kashiwa
www.kashiwadaisuke.net
#402, Lumiere-karakida
1-54-18, Karakida
Tama-city, Tokyo 2060035
Japan
Tel +81 80 3556 4640
kassy0105@gmail.com

Dalian RYCX Advertising Co., Ltd.
A6-12 No.419 Minzheng St.
Shahekou District
Dalian, Liaoning 116021
China
Tel +86 411 84519866
rycxcn@163.com

Dankook University
Room 317, College of Arts,
Dankook University,
126, Jukjeon, Suji Yongin,
Gyeonggi 448-701
South Korea
+82 31 8005 3106
finvox3@naver.com

Dennard, Lacey & Associates
www.dennardlacey.com
13740 Midway Road, Suite 802
Dallas, TX 75244
United States
Tel +1 972 233 0430
james@dennardlacey.com

Design SubTerra
1590 Canyon Road
Providence, UT 84332
United States
Tel +1 435 753 0593
rain9@xmission.com

Dessein
www.dessein.com.au
130 Aberdeen St.
Northbridge, Perth
Western Australia 6003
Australia
Tel +61 89228 0661
geoff@dessein.com.au

dGwaltneyArt
www.dgwaltneyart.com
5437 Branchwood Way
Virginia Beach, VA 23464
United States
Tel +1 757 581 1701
dgwaltneyart@gmail.com

DNA Creative Marketing
www.dnacreative.com
904 Pheasant Run Court S.
Brentwood, TN 37027
United States
Tel +1 615 371 0916
info@dnacreative.com

EGGRA
St. 141 No: 17
Tetovo, 1200
Macedonia
Tel +389 70389144
eggra.pars@gmail.com

Elevate Design
www.elevatedesign.org
2600 Roseland Drive
Ann Arbor, MI 48103
United States
Tel +1 734 827 4242
ksalchow@aol.com

Elsenbach Design
www.elsenbach-design.de
Südstraße 12
Hückeswagen NRW 42499
Germany
Tel +49 (0)2192 9367948
Mail@elsenbach-Design.de

Emerson, Wajdowicz Studios
www.designews.com
530 West 25th St., Suite 301
New York NY 10001
United States
Tel +1 212 807 8144
studio@designews.com

Erman Yılmaz
www.ermanyilmaz.com
Cihangir mahallesi Pürtelaş Sokak 31/4
İstanbul, 34433
Turkey
info@ermanyilmaz.com

Estudio Pep Carrió
www.pepcarrio.com
C/ Génova, 11, 7°D
Madrid, Madrid 28004
Spain
Tel +34 913 080 668
info@pepcarrio.com

Finn Nygaard
www.FinnNygaard.com
Strandvænget 62
Mors 7900
Denmark
Tel +45 4847 5310
fn@finnnygaard.com

Fishel Design
www.behance.net/Fishel
20 Muir Ave.
Piedmont, CA 94610
United States
Tel +1 415 672 5859
fisheldesign@gmail.com

FleishmanHillard
200 N. Broadway
St. Louis, MO 63102
United States
Tel +1 314 982 8781
pam.thomas@fleishman.com

Flomaster
Zeleni trg 1
Zagreb, 10000
Croatia
Tel +385 1 606 1512
alenka@flomaster.hr

Fox Broadcast Network
www.philbates.com
10201 W Pico Blvd., Bldg 100, 2009C
Los Angeles, CA 90064
United States
Tel +1 310 369 7612
phil@philbates.com

FX Networks
www.fxnetworks.com
10201 W. Pico Blvd., Bldg. 103, Rm. 3549
Los Angeles, CA 90064
United States
Tel +1 310 369 5983
sarit.snyder@fxnetworks.com

Genaro Design, LLC
www.genarodesign.com
13526 George Road, Suite 209
San Antonio, TX 78230
United States
Tel +1 210 455 4900
design@genarodesign.com

Goodall Integrated Design
www.goodallintegrated.com
51 Wolseley Street
Toronto ON M5T 1A4
Canada
Tel +1 416 435 3653
derwyn@goodallintegrated.com

Gunter Rambow
www.gunter-rambow.com
Domplatz 16
Guestrow D-18273
Germany
GunterRambow@web.de

Hansung University Design & Arts Institute
116, Samseongyo-ro 16-gil
Hansung University of Design &
Art Institute, Seongbuk-gu
Seoul 02876
South Korea
Tel +82 10 8272 1265
hanart24@naver.com

Houda Bakkali
www.hbakkali.es
Barcelona
Spain
hi@hbakkali.es

Hoyne
www.hoyne.com.au
Level 5, 99 Elizabeth St.
Sydney, NSW 2000
Australia
Tel +61 419290768
andrew@hoyne.com.au

Ibán Ramón
www.ibanramon.com
C. Rio Segre, 1 pta 1
Valencia, 46025
Spain
ban@ibanramon.com

IF Studio
34 W. 27th St.
New York, NY 10001
United States
Tel +1 203 550 1432
toshi@ifstudiony.com

J David Deal Graphic Design
www.jdaviddeal.com
110 S 3rd St., Apt 3
Lafayette, IN 47901
United States
david@jdaviddeal.com

Jay Advertising
www.behance.net/twinter
170 Linden Oaks
Rochester, NY 14625
United States
Tel +1 585 264 3644
twinter5@hotmail.com

Jie-Fei design
www.behance.net/jiefeidesign
4F., No.59, Tianmu E. Road
Shilin Dist Taipei, Taiwan 11153
Republic of China (ROC)
Tel +886 955875579
jiefeidesign@gmail.com

João Machado Design
www.joaomachado.com
Rua Padre Xavier Coutinho, 125
Porto 4150-751
Portugal
Tel +351 226103772
geral@joaomachado.com

John Gravdahl Design
Dept Art & Art History,
Colorado State Univ.
Fort Collins, CO 80523
United States
Tel +1 970 491 5482
john.gravdahl@colostate.edu

John Sposato Design & Illustration
www.johnsposato.carbonmade.com
179 Hudson Terrace
Piermont, NY 10968
United States
Tel +1 845 300 7591
johnsposatodesign@gmail.com

Jorel Dray
www.joreldray.com
Madison, WI
United States
joreldray@gmail.com

Kari Piippo Oy
www.piippo.com/kari
Katajamäenkatu 14
Mikkeli 50170
Finland
Tel +358 15 162 187
kari@piippo.com

Kate Resnick Design
2665 Prosperity Ave., #139
Fairfax, VA 22031
United States
Tel +1 202-487-1414
kater314@gmail.com

Kaveh Haerian
www.kavehhaerian.com
5731 Ridgedale Road
Baltimore, MD 21209
United States
kaveh.haerian@gmail.com

Keith Kitz Design
1945 Commonwealth Ave., Unit 2
Boston, MA 02135-5905
United States
Tel +1 857 321 0957
keith.kitz@gmail.com

Kunstwerk
883 North 1200 East
Provo, UT 84604
United States
Tel +1 810 369 7854
dougthomas31@gmail.com

L.S. Boldsmith
www.leilasingleton.com
Vancouver, British Columbia
Canada
leila@leilasingleton.com

Langrand
www.thinklangrand.com
5120 Woodway Drive, Suite 7029
Houston, TX 77056
United States
Tel +1 713-225-5900
awards@thinklangrand.com

Launch Agency
www.launchagency.com
4100 Midway Road, Suite 2110
Carrollton, TX 75007
United States
Tel +1 972-818-4100

Leo Lin Design
11F, No 64, 700th Lane,
Chung-Cheng Road
Hsintien, Taipei 231
Taiwan
Tel +886 2 8218 1446
leoposter@yahoo.com.tw

Leroy & Rose
www.leroyandrose.com
1522 Cloverfield Blvd., Suite F
Santa Monica, CA 90404
United States
Tel +1 310 310 8679

Lewis Communications
www.lewiscommunications.com
2030 First Ave. North
Birmingham, AL 35203
United States
Tel +1 205 789 6481
lisa@lewiscommunications.com

Libido inc.& Linda Graphica
www.libido-design-inc.com
Uran-Dou Gallery
9-13 Ishibanecho,
Nishinomiya,, Hyogo 662-0074
Japan
Tel +81 798 56 8690
books@uran-dou.com

Luis Antonio Rivera Rodriguez
www.monokromatic.com
Privada 10"A" Sur 1507 letra "A"
colonia motolinia
Puebla, Puebla 72538
Mexico
Tel +044 222 1271581
knife555@hotmail.com

Marcos Minini Design
www.marcosminini.com
Dr. Manoel Pedro 227, ap 172
Curitiba, PR 80035-030
Brazil
Tel +55 41 999 710 860
minini@marcosminini.com

Markham & Stein
www.markhamandstein.com
527 Holiday Drive
Hallandale Beach, FL 33009
United States
jackbagdadi@hotmail.com

Marlena Buczek Smith
www.marlenabuczek.com
United States
marlenabuczeksmith@gmail.com

Martin French Studio
www.martinfrench.com
511 N.W. Broadway
Portland, OR 97209
United States
Tel +1 503 926 2809
studio@martinfrench.com

May & Co.
www.mayandco.com
6316 Berwyn Lane,
Dallas, TX 75214
United States
Tel +1 214 536 0599
dougm@mayandco.com

Melchior Imboden
Eggertsbühl
CH-6374 Buochs
Switzerland
j@2xgoldstein.de

Michael Schwab Studio
108 Tamalpais Ave.
San Anselmo, CA 94960
United States
Tel +1 415 257 5792
studio@michaelschwab.com

Mirko Ilic Corp.
www.mirkoilic.com
207 E 32nd St., 4th Floor
New York, NY 10016
United States
Tel +1 212 481 9737

MullenLowe
www.us.mullenlowe.com
2121 Park Place
El Segundo, CA 90245
United States
Tel +1 818 519 1829
jayme.shuman@mullenlowe.com

Namseoul University
Cheonansi, Chungnam 31020
South Korea
sunbi155@naver.com

National Taiwan University of Science and Technology
17# 31 Lane 49 Alley Chung Cheng St.
Peitou, Taipei 112
Taiwan
Tel +0983086172
leekentsai1@yahoo.com

Next
www.nextbrand.design
Unit 107, 3 Male St.
Brighton
Melbourne, VIC 3186
Australia
Tel +61 3 9008 8988
lee@nextbrand.design

nikkeisha, inc.
7-13-20 Ginza
Chuo-ku, Tokyo 1048176
Japan
Tel +81 90 1121 5422
nakamu02@gmail.com

Onur Aşkın
www.onuraskin.com
Turkey
onuraskin@yahoo.com.tr

Owen Gildersleeve
Studio F12
23 - 27 Arcola St.
London, E8 2DJ
United Kingdom
Tel +44 (0)7932331841
hello@owengildersleeve.com

Peter Diamond Illustration
www.peterdiamond.ca
Seidlgasse 15/1 (Gassenlokal)
Vienna 1030
Austria
peter@peterdiamond.ca

Pivot Design
www.pivotdesign.com
321 N. Clark St., Suite 600
Chicago, IL 60654
United States
Tel +1 312 787 7707
kathryn@pivotdesign.com

Randy Clark
1400 Palmnold Circle W
Fort Worth, TX 76120
United States
randyclarkmfa@icloud.com

Russell & Russell Co.
195 Brynwood Drive
Port Matilda, PA 16870
United States
Tel +1 814 880 6377
rer190@psu.edu

Sandstrom Partners
www.sandstrompartners.com
808 S.W. 3rd, #610
Portland, OR 97204
United States
Tel +1 503 248 9466
stacy@sandstrompartners.com

Sarah Edmands Martin Designs
www.sarahedmandsmartin.com
211 South Lincoln St.
Bloomington, IN 47408
United States
Tel +1 301 467 1464
sarahedmandsmartin@gmail.com

Selcuk Cebecioglu
www.cebdesign.com
321 Senlac Road
Toronto, Ontario M2R 1R2
Canada
Tel +1 416 435 0970
info@cebdesign.com

Sibling Rivalry/BET Networks
1540 Broadway
New York, NY 10036
United States
josh.pelzek@bet.net

SJI Associates
www.sjiassociates.com
1001 Avenue of the Americas, Ste. 2300
New York, NY 10018
United States
Tel +1 212 391 7770
david@sjiassociates.com

Steiner Graphics
www.renesteiner.com
155 Dalhousie St., Suite 1062
Toronto, ON M5B 2P7
Canada
Tel +1 416 792 6969
rene@steinergraphics.com

Stephan Bundi
Schlossstrasse 78
Boll, Berne CH-3067
Switzerland
Tel +41 31 981 00 55
bundi@atelierbundi.ch

Studio LD/FM Three
www.fmthree.com
5475 E Colorado St.
Long Beach, CA 90814
United States
Tel +1 562 353 3118
fred@fmthree.com

studio lindhorst-emme
www.lindhorst-emme.de
Glogauer Str. 19.
studio lindhorst-emme,
1 Hinterhof links
Berlin, Berlin 10999
Germany
Tel +49 30 69564018
mail@lindhorst-emme.de

STUDY LLC.
www.studyllc.tokyo
1-7-1-202, Wakaba
Tokyo, 160-0011
Japan
eto.t.study@gmail.com

Superunion
www.superunion.com
6 Brewhouse Yard
London, EC1V 4DG
United Kingdom
Tel +44 (0)7551 142 348
meghan.claridge@superunion.com

SVIDesign
www.svidesign.com
242 Acklam Road, Studio 124
London W10 5JJ
UNITED KINGDOM
Tel +44 2075247808
sasha@svidesign.com

Symbiotic Solutions
3118 Granview Lane
Dewitt, MI 48820
United States
Tel +1 517 862 2337
corneal@msu.edu

Synopsis
www.synopsismedia.com
Str. Evlia Celebi Nr.5 Ap.11
Timisoara, Timis 300226
Romania
Tel +40 723 152138
ovidiu@synopsismedia.com

Takashi Akiyama Studio
3-14-35
Shimo-Ochiai
Shinjuku-ku, Tokyo 161-0033
Japan
Tel +81 3 3565 4316
akiyama@t3.rim.or.jp

Ted Wright Illustration & Design
1705 N. Woodlawn Ave.
Ladue, MO 63124
United States
twrightart@aol.com

The Heads of State
www.theheadsofstate.com
448 North 10th St.
Philadlephia, PA 19123
United States
Tel +1 215 240 8841
studio@theheadsofstate.com

THERE IS
www.thereis.co.uk
London
United Kingdom
Tel +44 0 757 246 0707
eve@thereis.co.uk

Thinkdavethink
www.greenhaus.com
2660 First Ave.
San Diego, CA 92103
United States
Tel +1 619 744 4024
spongedave@hotmail.com

Thomas Kühnen
www.thomaskuehnen.de
Dorotheenstr. 2
Wuppertal, NRW 42105
Germany
Tel +49 (0)172 2557620
hallo@thomaskuehnen.de

Tivadar Bote Illustration
527 31 Street N.W.
Calgary, AB T2N 2V6
Canada
bote.t@shaw.ca
Tel +1 403 703 9683

Toppan Printing Co., Ltd.
9F, 1-3-3, Suido
Bunkyo-ku
Tokyo, 112-8531
Japan
Tel +81 3 5840 2192
mescal@mac.com

Toyotsugu Itoh Design Office
www.facebook.com/toyotsuguoffice
402 Royal Villa Tsurumai
4-17-8 Tsurumai
Showa-ku, Nagoya
Aichi Prefecture 466-0064
Japan
Tel +81 52 731 9747
toyo-ito@ya2.so-net.ne.jp

Tsushima Design
www.tsushima-design.com
1-17-204,1-17, Matsukawa-cho,
Minami-ku, Hiroshima
Hiroshima 7320826
Japan
Tel +81 82 567 5586
info@tsushima-design.com

**Tungfang Design University
Design Center**
www.tf.edu.tw/tw
No.110, Dongfang Road.,
Hunei Dist., Kaohsiung City
Taiwan (R.O.C.) 82941
Taiwan
Tel +886 929360129
superpolly0217@gmail.com

Turner Duckworth:
London, San Francisco, New York
www.turnerduckworth.com
615 Battery St.
6th floor
San Francisco, CA 94111
United States
Tel +1 415 675 7777
michael.hope@turnerduckworth.com

Two
www.twodesign.co.in
202, 2nd Floor
Saptarshi CHS,
Mumbai 400053
India
Tel +098 337 25624
siddharth@twodesign.co.in

Underline Studio
247 Wallace Ave.
2nd Floor
Toronto, ON M6H 1V5
Canada
Tel +1 416 341 0475
kristin@underlinestudio.com

UNISAGE
Hong Kong
jeffpoon@126.com

Venti caratteruzzi
www.venticaratteruzzi.com
via Regione Siciliana 2507
Palermo, Italy 90145
Italy
Tel +39 0919820530
carlo@venticaratteruzzi.com

Ventress Design Works
www.ventress.com
PO Box 158544
Nashville, TN 37215
United States
Tel +1 615 833 2108
tom@ventress.com

Virginia Tech
www.meaghand.com
2306 San Marcos St.
Blacksburg, VA 24061
United States
Tel +1 541 632 4426
meaghan.dee@gmail.com

W&CO
www.winfieldco.com
155 Water St.
Brooklyn, NY 11201
United States
Tel +1 646 468 8953
vijay@winfieldco.com

Wheels & Waves
www.wheelsandwaves.dk
Klovtoftvej 32
Roedding, 6630
Denmark
Tel +45 23313560
rh@wheelsandwaves.dk

Wieslaw Grzegorczyk
www.facebook.com/wg.artdesign
ul. Jagiellonska 32/6
Rzeszow, 35-025
Poland
Tel+48 603373085
wieslaw@grzegorczyk.eu

xose teiga, studio.
www.xoseteiga.com
Rua Nova de Abaixo,5 bajo
Pontevedra, Pontevedra 36002
Spain
Tel +34 607 155 211
xoseteiga@gmail.com

Yinsen
www.yinsenstudio.com
Bonifaci Ferrer 5, 1°2
Valencia, Valencia 46007
Spain
Tel +34 629 060 181
info@yinsenstudio.com

Yohei Takahashi
www.yoheitakahashi.com
3-14-26-A-301
Shimoochiai
Shinjuku-ku Tokyo 161-0033
Japan
yohhey219@gmail.com

Yossi Lemel
www.yossilemel.com
13 Dubnov St.
Tel Aviv
Israel
Tel +00 972 54 5360151

Yunji Jun
www.yunjijun.com
818 Saratoga Ave.
San Jose, CA 95129
United States
Tel +1 310 710 3769
yunjijun@gmail.com

Zulu Alpha Kilo
260 King Street E., Suite B101
Toronto, ON M5A 4L5
Canada
Tel +1 416 777 9858
awards@zulualphakilo.com

I gravitated towards work that was conceptually driven, well executed, and had something to say.
There were many entries that fit into those criteria.

Dermot Mac Cormack, *Co-founder, 21xdesign*

Throughout time, posters stand as enduring reflections of the moment they were designed. This year's Graphis archive is no exception, for it too will serve the future practitioner as a record of the early 21st century poster.

Rick Valicenti, *Founder & Design Director, Thirst*

235 WINNERS BY COUNTRY

Visit Graphis.com to view the work within each Country, State or Province.

Scan the QR Code for the Graphis Journal Store and subscribe to Inspiration!

Graphis Journal presents an international group of highly accomplished talents in Design, Advertising, Photography, and Art/Illustration, each of whom reveal themselves in their interviews.

We often feature outstanding Graphis Masters in these disciplines who have been consistent Graphis Platinum and Gold Award Winners.

Each feature story includes full-page images of their work, in-depth Q&A interviews, and testimonials from their peers and clients in the profession.

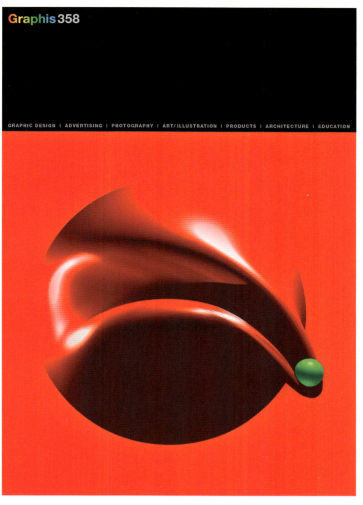

Graphis 358

GRAPHIC DESIGN | ADVERTISING | PHOTOGRAPHY | ART/ILLUSTRATION | PRODUCTS | ARCHITECTURE | EDUCATION

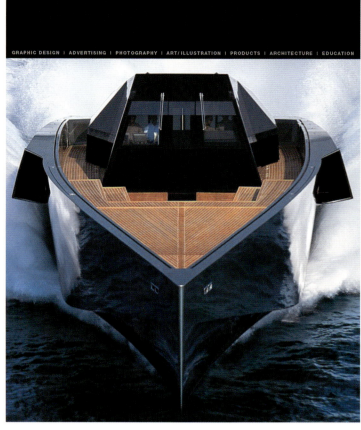

Graphis 359

GRAPHIC DESIGN | ADVERTISING | PHOTOGRAPHY | ART/ILLUSTRATION | PRODUCTS | ARCHITECTURE | EDUCATION

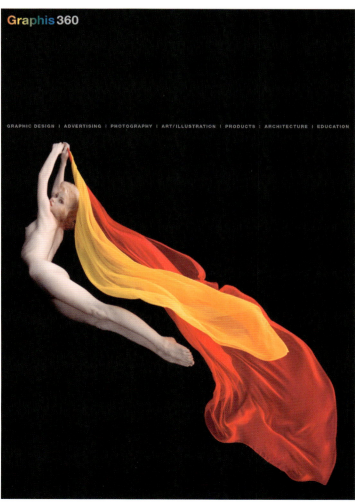

Graphis 360

GRAPHIC DESIGN | ADVERTISING | PHOTOGRAPHY | ART/ILLUSTRATION | PRODUCTS | ARCHITECTURE | EDUCATION

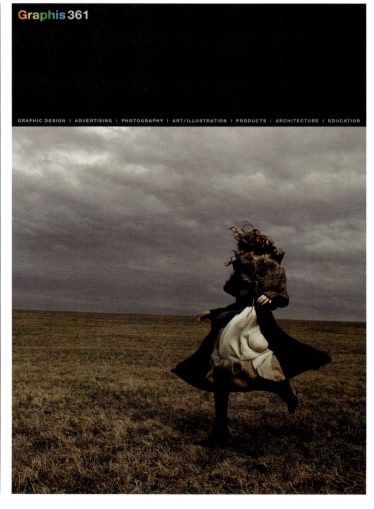

Graphis 361

GRAPHIC DESIGN | ADVERTISING | PHOTOGRAPHY | ART/ILLUSTRATION | PRODUCTS | ARCHITECTURE | EDUCATION

Photography Annual 2019

2019
Hardcover: 256 pages
200-plus color illustrations
Trim: 8.5 x 11.75"
ISBN: 978-1-931241-75-5
US $ 90

Awards: 12 Platinum, 105 Gold, and 184 Silver Awards, along with 146 Honorable Mentions.

Platinum Winners: Athena Azevedo, Caldas Naya, Curious Productions, Jonathan Knowles, Parish Kohanim, Stan Musilek, Joseph Saraceno, Michael Schoenfeld and Staudinger + Franke.

Judges: Graphis Masters Adam Voorhes and Christopher Wilson, as well as Kah Poon and Gregory Reid.

Content: Full-page images of Platinum & Gold Award-winning work from talented Photographers. Silver Award-winning work is also displayed and Honorable Mentions are listed. Up to 500 Platinum, Gold, Silver, and Honorable Mention award-winning entries are archived on graphis.com. This Annual is a valuable resource for Photographers, Design Firms, students, and Photography enthusiasts.

New Talent Annual 2019

2018
Hardcover: 256 pages
200-plus color illustrations
Trim: 8.5 x 11.75"
ISBN: 978-1-931241-66-3
US $ 90

This Annual presents award-winning Instructors and students.
Platinum: Advertising: Frank Anselmo, Josh Ege, Larry Gordon, Seung-Min Han, Patrick Hartmann, Kevin O'Neill, Dong-Joo Park, Hank Richardson, Eileen Hedy Schultz, and Mel White. Design: Brad Bartlett, Devan Carter, Eszter Clark, Carin Goldberg, Seung-Min Han, Marvin Mattelson, Kevin O'Callaghan, Dong-Joo Park, Adrian Pulfer, Ryan Russell, and Kristin Sommese. **Gold:** Advertising: 88; Design: 85; Photography: 5; Film: 36. **Silver:** Advertising: 95; Design: 185; Photography: 9; Film: 40. We award up to 500 Honorable Mentions, encouraging new talent to submit. All winners are equally presented and archived on our website. This book is a tool for teachers to raise their students' standards and gauge how their school stacks up.

Advertising 2019

2018
Hardcover: 240 pages
200-plus color illustrations
Trim: 8.5 x 11.75"
ISBN: 978-1-931241-74-8
US $ 90

Awards: 16 Platinum, 122 Gold, and 310 Silver Awards, totaling more than 600 Winners, along with 197 Honorable Mentions.

Platinum Winners: 21X Design, Earnshaw's Magazine, Entro, Fred Woodward, hufax arts, IF Studio & Magnus Gjoen, Ken-tsai Lee Design Lab/Taiwan Tech, Michael Pantuso Design, Morla Design, Shadia Design, Steiner Graphics, Stranger & Stranger, Studio 5 Designs Inc., Toppan Printing Co., Ltd., and Traction Factory.

Judges: Ronald Burrage of PepsiCo Design & Innovation, Randy Clark, John Ewles, William J. Gicker, Matthias Hofmann, John Krull, and Carin Stanford.

Content: Designs by the Judges and award-winning student work.

Branding 7

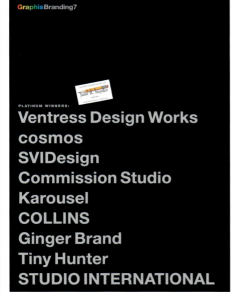

2018
Hardcover: 240 pages
200-plus color illustrations
Trim: 8.5 x 11.75"
ISBN: 978-1-931241-73-1
US $ 90

Awards: 10 Platinum, 73 Gold, and 194 Silver Awards, totaling nearly 500 winners, along with 124 Honorable Mentions.

Platinum Winners: Tiny Hunter, COLLINS, cosmos, Ventress Design Works, Karousel, SVIDesign, Ginger Brand, Commission Studio, and STUDIO INTERNATIONAL.

Judges: All entries were judged by a panel of highly accomplished, award-winning Branding Designers: Adam Brodsley of Volume Inc., Cristian "Kit" Paul of Brandient, and Sasha Vidakovic of SVIDesign.

Content: Branding designs from New Talent Annual 2018, award-winning designs by the Judges, and Q&As with this year's Platinum Winners, along with some of their additional work.

Design 2019

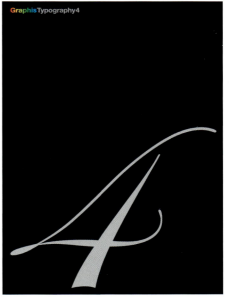

2018
Hardcover: 256 pages
200-plus color illustrations
Trim: 8.5 x 11.75"
ISBN: 978-1-931241-71-7
US $ 90

Awards: 16 Platinum, 122 Gold, and 310 Silver Awards, totaling nearly 500 winners, along with 197 Honorable Mentions.

Platinum Winners: 21X Design, Earnshaw's Magazine, Entro, Fred Woodward, hufax arts, IF Studio & Magnus Gjoen, Ken-tsai Lee Design Lab/Taiwan Tech, Michael Pantuso Design, Morla Design, Shadia Design, Steiner Graphics, Stranger & Stranger, Studio 5 Designs Inc., Toppan Printing Co., Ltd., and Traction Factory.

Judges: Ronald Burrage of PepsiCo Design & Innovation, Randy Clark, John Ewles of Jones Knowles Ritchie, William J. Gicker of The United States Postal Service, Matthias Hofmann of hofmann.to, John Krull of Shine United, and Carin Standford of Shotopop.

Content: Designs by the Judges and award-winning student work.

Type 4

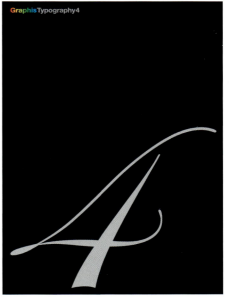

2018
Hardcover: 256 pages
200-plus color illustrations
Trim: 8.5 x 11.75"
ISBN: 978-1-931241-68-7
US $ 90

Awards: This year, Graphis awarded 18 Platinum, 150 Gold, 219 Silver, and 116 Merit Awards, totaling over 500 winners.

Platinum Winners: ARSONAL, Chemi Montes, DAEKI & JUN, Hufax Arts, Jones Knowles Ritchie, McCandliss & Campbell, Ron Taft Design, SCAD, Selman Design, Studio 32 North, Traction Factory, Umut Altintas, Atlas, Jamie Clarke Type, Jones Knowles Ritchie, Linotype, SVA, and Söderhavet.

Judges: Entries were judged by highly accomplished Type Designers: Nadine Chahine (LB), Akira Kobayashi (JP), and Dan Rhatigan (US).

Content: A documentation of the history of typeface design from the 5th Century B.C. to 2018, as well as informative articles on Typeface Design Masters Matthew Carter and Ed Benguiat.